The Cubists

PAUL WALDO
SCHWARTZ

152 illustrations
28 in colour

THAMES AND HUDSON
LONDON

First published in 1971 by Thames and Hudson Ltd, London

Printed in Great Britain by Jarrold and Sons Ltd, Norwich

ISBN 0 500 18117 9 *clothbound*
ISBN 0 500 20111 0 *paperbound*

Contents

CHAPTER ONE
Cubism: Evolution and Revolution 7

CHAPTER TWO
Towards Cubism: Picasso and *Les Demoiselles d'Avignon* 15

CHAPTER THREE
Picasso, Braque, Apollinaire: the Magic Triangle 31

CHAPTER FOUR
Lines Parallel, Lines Tangent 59

CHAPTER FIVE
The Circle Widens: Room 41 71

CHAPTER SIX
New Perspectives, New Realities 91

CHAPTER SEVEN
Juan Gris: the Music of Silence 119

CHAPTER EIGHT
Cubist Language, Cubist Theatre 135

CHAPTER NINE
The Response in Sculpture 147

CHAPTER TEN
Kinships and Consummations 163

CHAPTER ELEVEN
Echoes and Refractions 183

Notes on the text 199

Select bibliography 203

List of illustrations 206

Index 215

Cubism: Evolution and Revolution

During the first decade of the twentieth century, a group of young painters in France developed an aesthetic that was to revolutionize modern art. The geometrical character of their early works quickly attracted the epithet 'Cubist', and the term gained general currency. But 'Cubism' proved to be a more profound and complex manifestation that both belies its name and resists any other. Though the Cubist vision seemed audacious – to some inadmissible – the painters themselves stressed its place in the direct tradition of European art. 'Cubism,' Picasso said, 'is no different from any other school of painting. The same principles and the same elements are common to all.' And he went so far as to associate his works with those of David, Ingres, and even Bouguereau.[1]

Yet it was through the most revolutionary advances that Picasso and Braque, who initiated the movement, were able to renew that tradition significantly. Picasso re-estimated the meaning of primitive and archaic art and went on to construct, within wholly western terms, an art that was opposed to romanticism and even questioned certain humanistic concepts. He has been quoted thus:

> It was really the manifestation of a vague desire on the part of those of us who participated in it to get back to some kind of order. . . . We were trying to move in a direction opposite to Impressionism. That was the reason we abandoned colour, emotion, sensation, and everything that had been introduced by the Impressionists, to search again for an architectonic basis in the composition, trying to make an order of it . . .
>
> People didn't understand very well at the time why very often we didn't sign our canvases. Most of those that are signed we signed years later. It was because . . . we felt the temptation, the hope of an anonymous art, not in its expression but in its point of departure. . . . We were trying to set up a new order and it had to express itself through various individuals. Nobody needed to know that it was so-and-so who had done this or that painting. But individualism was already too strong and that resulted in a failure, because after a few years all Cubists who were any good at all were no longer Cubists. Those who remained Cubists were those who weren't true painters.[2]

Within the purely historical context, the aims and directions of Cubism can be broadly sketched; they proceeded from the work of Cezanne – whose

7

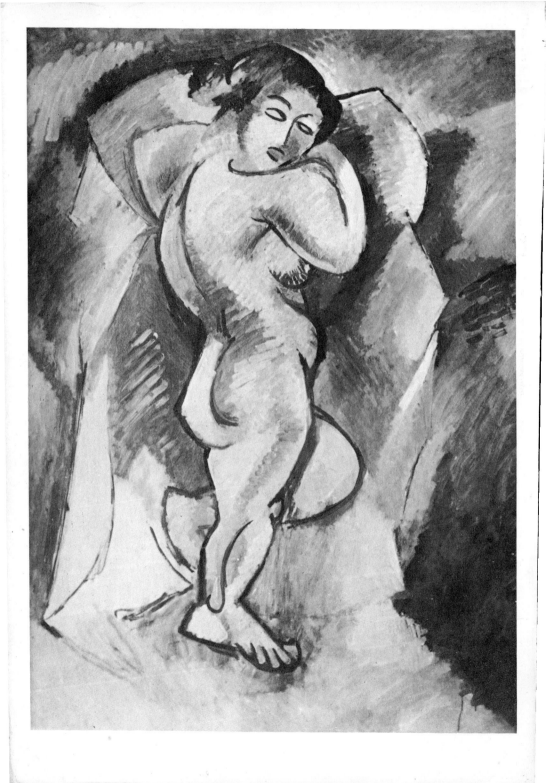

principles were to be amalgamated with the revelations of African and archaic expression – and from his statement that, 'everything in nature is formed in correspondence to the sphere, the cone, and the cylinder....'[3] Cézanne died in 1906, the year before Picasso, at the age of twenty-six, produced an extraordinary conceptual explosion, *Les Demoiselles d'Avignon*, the introduction to the Cubist experience; it was in 1908 that Georges Braque painted what is generally considered the first Cubist painting.

Ill. 1

The movement implied an encounter with structure and the anatomy of form. During 1908 and through 1911, Picasso, Braque, and a small band of allies variously explored what has become known as *Analytical Cubism*. They re-examined the possibilities of structure and found that the eye's 'normal' perspective, systematized for art during the Renaissance, was neither an exclusive nor an ideal mode of vision; that any three-dimensional form, be it a human head, wineglass, or hat, might be seen from two or more angles simultaneously, and that once analyzed in terms of pure volumes, of structural dynamics, its potentialities surpassed the accidents of vision. Almost at once, these men being poets and not researchers, the analysis produced a cogent synthesis, and Cubism developed not as a formalistic proposition but as art. As in any genuine poetic resolution, the whole proved greater than the sum of its parts; the end absorbed the means.

At the same time, a tide of discovery in science evoked strangely analogous ideas; the atom was found to be not a solid body, as previously supposed, but a complex of positively and negatively charged particles held in cohesion by their opposing energies. One implication of this discovery is that if all the atoms that make up a human being were to be concentrated into a solid mass, the human being would occupy an area about the size of a pinhead. This interplay of unperceived energy is all-important to the structure and nature of the perceived, usually considered explicable in terms of mass.

In retrospect it seems inevitable that *Analytical Cubism* should give way to a subsequent major phase, generally called *Synthetic Cubism* and often considered a fulfilment of Cubist ambitions, especially in collage and *papier collé*.

During the analytical phase the object was broken down, examined and distilled to elements of structure, while in Synthetic Cubism pure forms were used to engender their own vocabulary and even to create objects of their own.*

* The terms *Analytical* and *Synthetic* are generally used but are at best approximate. The Synthetic works incorporate analytical processes, and the earlier Cubist works incorporated syntheses of form and conception. Pierre Daix prefers the terms *Geometrical* and *Creative Cubism*; these avoid the original confusion but are equally interchangeable.

9

1 GEORGES BRAQUE, *Grand Nu*, 1908

In collage, a scrap of fabric or newspaper is cut to represent a glass or bottle; a process which Picasso described as trompe-l'esprit, as opposed to trompe-l'œil. Juan Gris, who entered the movement during the synthetic period, observed: 'Cézanne turns a bottle into a cylinder, but I begin with a cylinder and . . . make a bottle – a particular bottle – out of a cylinder. Cézanne tends towards architecture, I tend away from it.'[4]

The Salon des Indépendants (Room 41), and the Salon d'Automme of 1911 were the occasions for the recognition of Cubism as a movement; in August 1914, under the pressure of the First World War, when Picasso and Gris returned to Spain, and Braque and Fernand Léger joined the French ranks, that solidarity broke down, although Cubism was to survive in a changed Europe. Apart from such movements as Orphism, Constructivism, and Futurism, closely related to the precepts of Cubism, no subsequent art movement of major dimensions has functioned altogether independently of the visual insights Cubism developed.

Cézanne's statement emphasizing the primacy of geometrical volume indicates his importance to the Cubists, and in his last works his own use of resonant form almost qualifies his purest distillations as Cubist themselves. In fact, in his handling of perspective and anti-perspective in the late still-lifes, he anticipated much that Picasso and Braque were about to develop, but with one generic and significant difference: he never mentioned the cube, the solid rectangle, or the pyramid at all. The shapes he cited as fundamental – sphere, cone, and cylinder – were all curved, for the reason that there are no straight lines in nature. Cézanne not only worked towards architecture, but towards a purity of form independent of its subject; yet neither were removed from the context of nature. For him the human being, the apple, the mountain, were always essential, whereas Picasso and Braque exalted the force and dignity of the straight line. The distinction represents a shift from appearance to essence, from the natural to the anti-natural.

The Cubists abandoned the traditional perspective of Renaissance painting in favour of the flattened, ideated formalism suggested by African art. This is true. But it has to be emphasized that while doing this they did not become 'primitives' themselves or merely employ a mock-primitive vocabulary, but incorporated their conclusions into the western framework in a wholly apposite way. The vision they upset had reached a logical extreme only during the Late Renaissance. Raphael had said, in effect: 'here is man seen in his corporeal humanity and manifest individuality, and here is nature as seen through the human eye'. But the Cubists said, in effect: 'no, let's look beyond man and let's question the testimony of the eye in its entirety through the

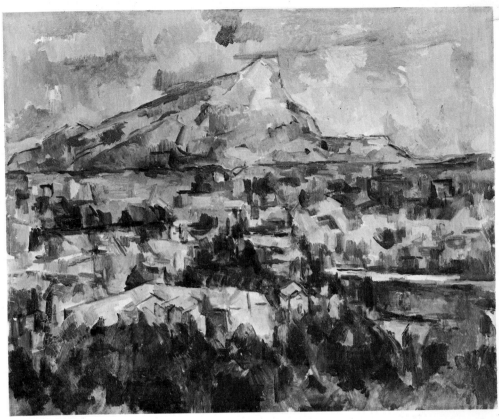

2 PAUL CÉZANNE, *Mont Ste Victoire*, 1904–06

medium of mind.' And in doing so – though the clues may have come from the primitives – Cubism rediscovered qualities that were still central to art in the early Renaissance, in which the hieratic and formalized Byzantine vision was still alive, and in which naturalism was sublimated to a conceptual purity.

Note that in the painting of the earlier Italian masters of Venice, Florence and Siena, who have themselves been doubtfully labelled 'primitives', a distinct formalism survived not only through Giotto but on into the work of Piero della Francesca. In their painting the straight line and the architectural references define a spiritual rather than a physical truth or circumstance; the arch and columns through which, say, an angel appears to Mary in an Annunciation by Duccio, are not a setting but an ethos, and the statement – psychologically – is produced through an austerity of proportion and space as well as through

11

precise limitation of colour – which is again true of the Cubists. The icono-graphy of religious art had nothing to do with Cubism, of course, and the narrative element was quite opposed to Cubist precepts, yet in its devotion to harmonics and revelations beyond personality, Cubism might be thought of as a religious art without religious doctrine.

In the Italian Renaissance the ideal of a spiritualized personal anonymity gradually changed to one of singular individuality; the Cubist impulse moved in the opposite direction, towards an expression and an order transcending the individual. Cubism was also a revolt against romanticism, a dynamic force in European art and thought during the previous century. The Cubists were thinking in terms of what they hoped to construct rather than of what they hoped to undo, but to think of the task as a simultaneous struggle on two fronts against Romanticism and Impressionism is to put the movement in a particularly apt, and indeed awesome perspective.

Indeed, the curves Cubism reacted against were not all nature's or Impres-sionism's. Montmartre, at that time (as well as all Paris and most of Europe) *Ill. 3* was enveloped in curves and volutes and tendrils and loops. This was the epoch of Art Nouveau. Restaurant mirrors coiled themselves into elliptically ovoid postures, and even the ironwork entrances to utilitarian Métro stations were graced with swirling patterns. The succinct linear principles of the

3 VICTOR
PROUVE, *Bowl:
Night*, 1894

12

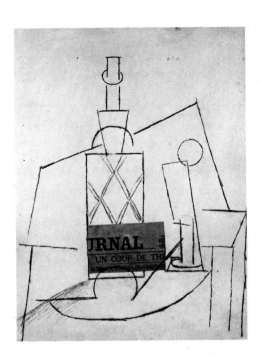

4 PABLO PICASSO,
Un Coup de Théâtre, 1912

currently admired Japanese art were adapted to the most decorative of purposes. Picasso remarked that he and his allies were part of all that as well, precisely because they reacted directly against the tide. To rebel against a given order means that one is being affected by it.

Still, individuality in Cubist painting was never entirely suppressed – the work of the young painters bore the stamp of their personal drives, tastes, convictions. It is true that years later Picasso and Braque, despite their temperamental differences, had difficulty in establishing which of them had painted certain early canvases, so closely had they worked – but such confusions were exceptional. Indeed, the four men who seem in retrospect to have been the key figures in the movement are remarkable for their personal diversity. Braque was a Norman, a northerner of cool temperament, a lover of subtleties, fascinated all his life by the aesthetic possibilities of harmony. Picasso was the Mediterranean, the intensely solar personality and congenital revolutionary, whose creative force and protean vision are the most expansive that modern art, perhaps all art, has ever known. Juan Gris was a Spaniard of another kind,

13

painfully shy, intellectually rigid, temperamentally reserved. Fernand Léger was the robust proletarian who brought the rough red wine of the zinc counter and the thunder of industry to art.

Cubism, however rational, was by no means systematic; its theoretical basis, tempered and serious as it was, could not obscure the life force that gives it meaning.

Ill. 4 Jean Cocteau has told an illuminating story . . . One summer, Picasso made a *papier collé* that incorporated a fragment of newspaper. He clipped the words *Un Coup de Théâtre* from a headline and pasted them in place after amputating the last syllables, so that the fragment then read *Un Coup de Thé*. The theatrical shock had been metamorphosed into a cup of tea. This was, of course, a testament of Cubist faith as well as a bit of Picasso's whimsy. In the language of Cubism, the cup of tea, be it a wine label, pipe, newspaper, or whatever – was ideal in its anonymity to serve as a vehicle of the spirit. A coup de thé was coup de théâtre enough. But as it turned out, the newspaper appeared in August 1914, and the paste had scarcely dried when the war began. The Belle Epoque was over, its illusions irrecoverable. And after the cataclysm, Picasso's Coup de Thé was to prove in many ways prophetic.

Towards Cubism: Picasso and *Les Demoiselles d'Avignon*

Even before Cubism came to be, the evolution of Picasso's early work from 1900 to 1907 described an underlying progression from outer presence to inner shape, from colour to structure, and from a modified romanticism to a deepening formalism.

Picasso was nineteen when he arrived in Paris from Barcelona in 1900, and he was immediately attracted by all that seemed most French, or rather most Parisian. He already knew the work of Toulouse-Lautrec and Steinlen, men whose colour and line reflected the bright and bitter atmosphere of Montmartre. Lautrec was a great realist, a great stylist, and a great satirist all at once, qualities certain to impress Picasso. The young painter saw life as a passionate experience in which tragedy was never to be denied; he could be astringent as well as mellow; a certain detachment may have resulted from the bracing shock of a first encounter with Paris. Eventually, indigenous traits prevailed. Picasso made two trips back to Spain, and his friends saw these as occasions of troubled introspection. As of 1901, the light of his work deepened in key often to a piercing indigo, and took the form of a tragic poem expatiated in variations of blue. In the stained glass of the Gothic cathedral windows blue had been employed as the colour of heaven: in the Picasso work of the Blue Period it became the stage-light of an earthly hell. But plastically, Picasso began to work with a new firmness. His forms became flattened, and the impressionistic light *Ill. 6* of 1900 gave way to a far crisper definition. It was this increased plasticity that opposed the melodrama and what might have become in other hands the sentimentality – of the thematic material.

In 1905, a similar process occurred in another form, at the height of the Rose Period. The subject was harlequin, the colour dulcet, the aura of circus *Ill. 5* figures posed in open space largely romantic. Yet, in contradiction – and Picasso's career is a skein of contradictions dynamically resolved – the real profit of that year came with new advances in line and structure. A new solidity developed, and Picasso took a big step towards the Cézannesque structure that was to be vital to Cubism.

In 1906 he made another trip to Spain, this time to the Catalan village of Gosol, with Fernande Olivier, his new mistress. Her opulent body is said to

15

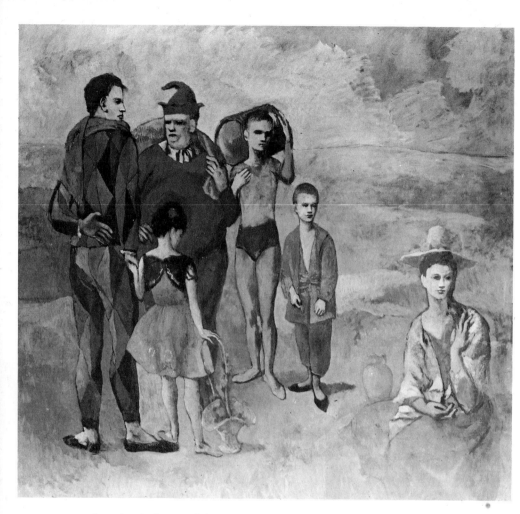

have inspired a transformation in Picasso's work from the slender Rose Period women to the architectural masses of 1906, but possibly the shift in vision determined the choice in mistresses. In any case the Gosol experience confirmed a considerable advance. As Fernande has reported, Picasso became expansive in the renewed contact with the rough, unequivocal rhythm of Catalonia, and, back in Paris, he achieved a redefinition of his inner aims. The work of the previous five years had been prodigious, and markedly the product of an inter-action of Picasso and Paris, of a young and brilliant Spanish painter at the

16

5 PABLO PICASSO,
Family of Acrobats, 1905

6 PABLO PICASSO,
La Vie, 1903

heart of Europe's creative activity. The return from Gosol precipitated a new equilibrium, with a relatively greater indifference to place. Picasso would continue to be a Spaniard and French art would continue to exert a formative influence, but the amalgam would rely upon intellectual discretion and less upon the impact of circumstance. From 1900 until the months preceding Gosol there had been an uneasiness over the choice of metaphor in Picasso's work, however dramatic the result. Now, Picasso had become acclimatized to the French context and had rediscovered his Iberian attachments. As a result the artist

17

7 PABLO PICASSO,
Nude Girl with Long Hair,
1906

8 PAUL CÉZANNE, ▶
Boy in the Red Vest,
1894–95

was freer in mind to adopt the powerful and elegant detachment that made Cubism possible.

His earlier interest in light, mood, and expressive metaphor had brought about certain advances in plasticity and structure, but now an architectural solidity became the primary aim, and in its three-dimensionality the link to Cézanne was solidly forged and the approach to Cubism delineated.

In his still-lifes, Cézanne had introduced structural devices which Picasso and Braque were to develop radically. Often, Cézanne would maximize the volume of an object, an apple, or bottle, by viewing it from an unexpected angle, out of normal perspective, or would uplift a table-top so that it no longer

18

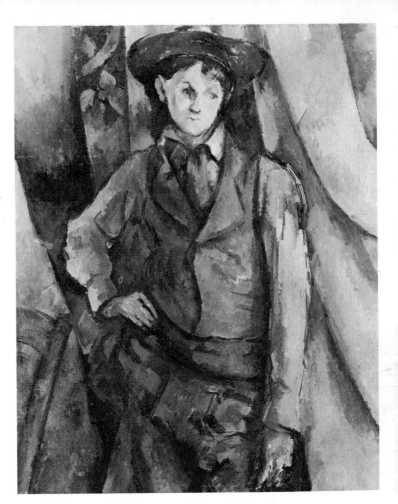

showed as a receding three-dimensional object but as a massive frontal plane. Picasso and Braque utilized these means assiduously as early as 1908 and historians have made much of this specific influence. Yet, the earlier Cézannesque massiveness of the 1906 figures, already magnified by dynamic distortions, was an even deeper connection, and one that helped Picasso to grasp the architectural principle linking ancient Iberian Osuna sculpture and Cézanne's painting.

It is interesting to compare Picasso's *Nude Girl with Long Hair* (1906) with Cézanne's *Boy in the Red Vest* (1894–95). In each case the construction of forms and proportions produce a sense of great volume and monumentality and a

Ill. 7
Ill. 8

19

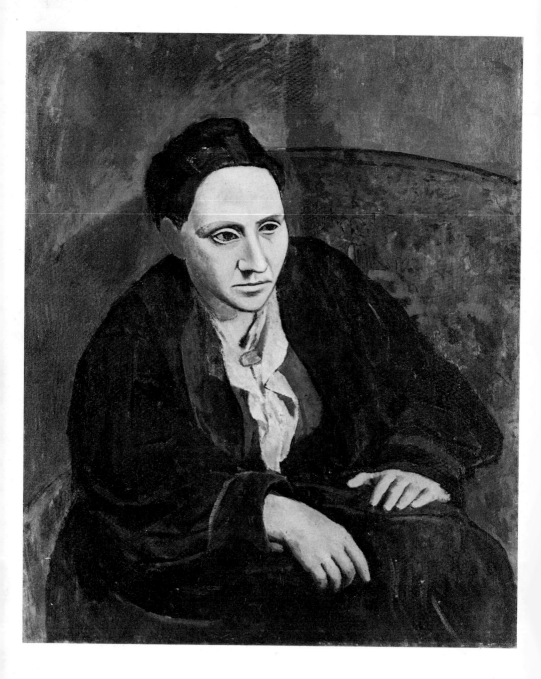

formal presence; the painters touch upon the actual attributes of the subject but only to go far beyond them. In each case it is obvious that an arm is ill-jointed and outrageously disproportionate, and yet miss the fact that all the relative proportions have been radically altered in favour of a concerted power. Both figures have the dignity and the silence of an archaic work, produced as in Egyptian sculpture by the formal interaction of masses.

Cézanne's portrait had no immediate link with archaic sculpture, however; Picasso's nude did. In 1906, the Louvre mounted an exhibition of Iberian or ancient, pre-Spanish sculpture, including a series of archaic reliefs from Osuna, and for Picasso these intensely formalized works were especially influential. They helped crystallize his kinship with archaic expression, be it Iberian, Egyptian, Etruscan, Mesopotamian, or Cycladic Greek. It was surely the almond eyes and flattened countenance of the Osuna vision that affected the visages of Picasso's figures in 1906. That year he struggled with a portrait of Gertrude Stein again and again in successive sittings. Later, without his model, he wiped out the face, began from scratch, and gave it the character and proportions of the Osuna image. The portrait is one of Picasso's most important works, and it has been said that in later life Gertrude Stein came to resemble the portrait more than she did when it was painted. The painting had been resolved through means that were becoming formal, universalized and highly reasoned. The

Ill. 10

Ill. 9

◀ 9 PABLO PICASSO, *Gertrude Stein,* 1906

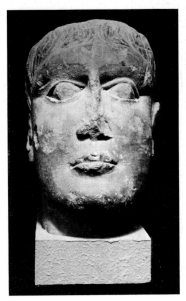

10 Iberian head from Osuna

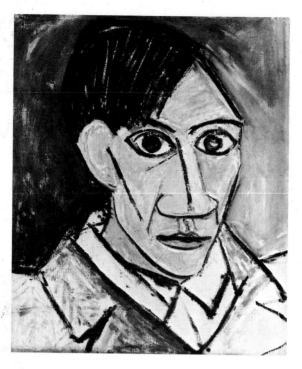

11 PABLO
PICASSO, *Self-portrait*, 1907

12 Mask from the ►
Congo (the Fang
mask), formerly in
Braque's studio

13 Mask of the ►
Likuala tribe,
Gabon, late
nineteenth century

content of the portrait was evoked by and fused with its architectural substance; the emotional factor decreased, the intellectual level rose.

But the process was not an artificial one. During the previous century, Gauguin had been influenced by the art of the South Seas, so different from the art of the west. Picasso's response came as much through a spiritual kinship with archaic and primitive work as through the impact of discovery. For centuries Spain, culturally severed from the rest of Europe, had preserved many of the effects of its African, Oriental and Semitic contacts, and was closer to the concepts and rhythms of archaic and primitive expression than any other country on the Continent. Much of this tradition was native to Picasso; for him neither exoticism nor a refreshing candour were at all the point in regard to primitive art. The word he used to describe the African mask was 'rational', the last one that would have occurred to most Europeans at the time.

Ills. 12, 13

For a primitive sculptor, who carved a ritual object, there was no schism between form and content. The object is not imitative, but embodies its message in forms that create rather than reflect, become rather than describe their subject.

22

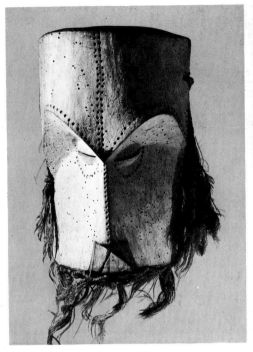
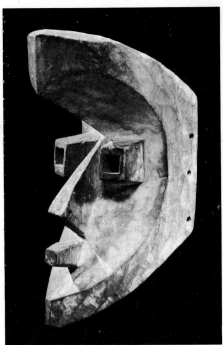

Picasso grasped this at once; it only remained for the example to give that knowledge concrete existence. This awareness and the impact of the Osuna works together constituted a single and important influence – which brought forth Picasso's *magnum opus* of 1907, *Les Demoiselles d'Avignon*.

Ill. 15

It can be argued that *Nude Girl with Long Hair* is as much a precursor of Cubism as *Les Demoiselles*, which complicates the focus on form analytically seen in favour of an audacious stylistic experiment. It might be argued that *Les Demoiselles* is a reference to synthetic ideas in Cubism conjured up before its time. But the painting's greatest achievement is perhaps reflected in Picasso's dictum: 'They speak of naturalism in opposition to modern painting. I would like to know if anyone has ever seen a natural work of art. Nature and art, being two different things, cannot be the same thing. Through art we express our conception of what nature is not.'[1]

In creating *Les Demoiselles* Picasso made this principle the threshold to Cubism. It has been said that Cubism was an experience with reality, not with abstraction; that is true, and not contradictory to Picasso's statement. The point

23

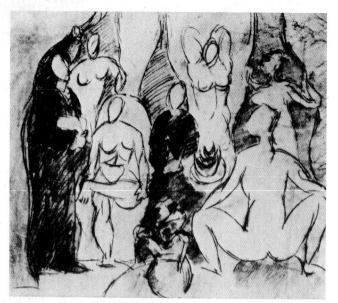

14 PABLO
PICASSO,
*Sketch for 'Les
Demoiselles
d'Avignon'*, 1907

15 PABLO ▶
PICASSO,
*Les Demoiselles
d'Avignon*, 1907
Museum of Modern Art,
New York

is rather that Cubism defined reality as a psychological presence rather than as
a set of external appearances.

When Cézanne died in October 1906, the press responded tepidly or in-
sultingly to the loss. But in October, the Salon d'Automne mounted the
largest Cézanne exhibition ever held, and the same winter, Galerie Bernheim-
Jeune hung a large exhibition of his watercolours. If the general public incom-
prehension remained almost total, the young painters, more importantly, were
impressed. In the same October, the *Mercure de France* published a series of
letters written by Cézanne to Emile Bernard, including the one containing the
testament of the sphere, the cylinder and the cone, which gave Cézanne's con-
tribution further weight in the contemporary scene; but Braque had already
taken the cue, and for Picasso the dual influence of Cézanne and the primitives
was making the production of *Les Demoiselles* a laborious, intense, highly
pressured episode. Picasso worked in solitude, and if any stage of his develop-
ment ever qualified his usually pertinent aphorism, 'I do not seek, I find', it was
this ordeal in perception.

Originally, the idea proceeded from a brothel vignette that in the first version
included two clothed men as well as the five nudes. The title refers not to the
French city but to the Carrer d'Avinyo, a street in the red light district of
Barcelona. The brothel was of course one of Toulouse-Lautrec's favourite

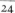

24

Montmartre themes as well, and although Picasso has continually returned to a similar eroticism during his career, it might be said with a thought to the scandalous impact of Manet's 1863 *Le Déjeuner sur l'herbe*, with its nudes and clothed men that *Les Demoiselles* spanned the distance from Lautrec to Cézanne to Cubism in one enormous leap.

25

Ill. 14 The first study for *Les Demoiselles*, which includes all seven figures, is clearly, in form and composition, under the influence of Cézanne, whose great can-vases of bathers (the *Baigneuses* of the Petit Palais, Paris, was very probably the specific inspiration in this case) amalgamated a Gothic formality with a con-tinuous fluidity. The Picasso study began very much in this spirit, but it soon took on a concerted angularity and a distinct ferocity.

Ill. 16 Other studies as well as other paintings that Picasso turned out in 1907, such as the *Dancer of Avignon*, demonstrate more emphatically than the finished work just how captivated he was by the primitive vision. At times it even became dominant, yet while Picasso devoted his perceptive attention to it, his response to other problems in form and composition leapt intuitively rather than methodically ahead. A later study revealed for the first time the nature-conquering quality that later became recognizable as central to Picasso's temperament. In that sense, the *Dancer of Avignon* seems, in retrospect, more advanced than many studies of the two previous years.

Ill. 18 *Nude with Drapery*, on the other hand, dates from 1907 and represents what was probably Picasso's point of greatest polarization or obsession with regard to the primitives. It also represents the hazards that Cubism faced in theory and in practice. It can be said, without mincing words, that *Nude with Drapery* is a failure as a work of art. And this is so precisely because the work's stylistic assumptions overwhelm it. It is true that the Cubists profited from primitive expression, digested its lessons but did not yield to it stylistically. Yet in this case the primitive idiom overwhelmed Picasso, even at a moment of earnest concentration, so that the primitive paraphernalia ended as caricature or more specifically as 'neo-primitivism', which is a self-contradictory term. 'Primitivism' implies spontaneity. 'Neo-primitivism' indicates a stylistic adaptation, which annuls the meaning of the original word. The handling of the forms, with their dense hatching and cross-hatching, does not keep pace with the idiom, whose borrowed weight becomes untenable. During the same

Ill. 17 year Picasso painted a number of still-lifes, including *Les Bols*, which represent his most concerted effort in the Cézannesque direction. The same problem does not arise here, partly because the aim is inherently structural rather than stylistic, and partly because any existing stylistic assumptions in this case lend themselves to the current of western art in which Cubism takes place. In *Les Demoiselles d'Avignon*, the primitive element might be described as influential rather than dominant – though intensive – and even perhaps, intrusive. Here the masks became a dissonant element. John Golding has suggested that Picasso was first struck by primitive art after he had begun working on the painting, and that the masks worked themselves into the composition on

26

16 PABLO PICASSO, *Dancer of Avignon*, 1907 ▶

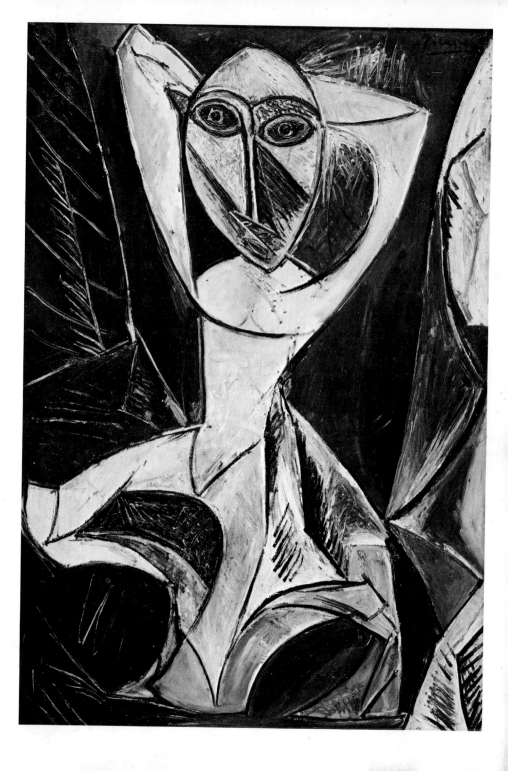

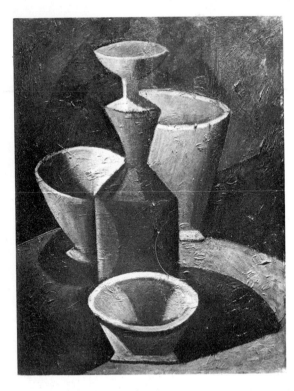

17 PABLO PICASSO,
Carafe and Three Bowls (Les Bols), 1907

18 PABLO PICASSO, ▶
Nude with Drapery, 1907

something of an *a posteriori* basis even though he had almost certainly seen Negro art in 1906, when Matisse and Derain were praising it.*

Cézanne's influence is present in the composition of *Les Demoiselles* in the colour key and in the pre-Cubist forms. The Gosol-Osuna archaic countenance predominates in the two central figures. The masks are a dramatic but disproportionate element, as one can see by blocking them out. Their presence keeps the painting from being fully resolved, but contributes, on the other hand, to the effect of unsettling energy. That potential energy was basic to Picasso's constructive aims at the time, and the will to counter hard-won advances with alternative possibilities has since become evident as a powerful factor in his

*Golding cites Michel Georges-Michel's *Peintres et Sculpteurs que j'ai connus, 1900–1942*. The memoir *implies* that Picasso visited the Trocadero's 1907 exhibition of Negro art with Guillaume Apollinaire, was at first merely amused, and only later greatly impressed. Gertrude Stein's reminiscences also indicate that Picasso had seen this art at that time.

28

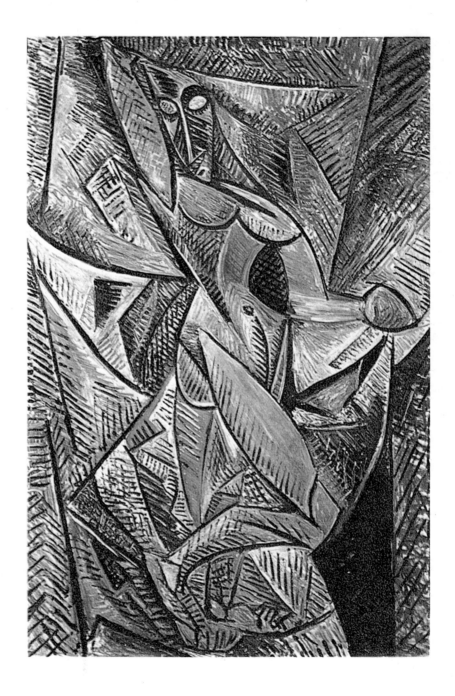

Picasso, Braque, Apollinaire: The Magic Triangle

The period following *Les Demoiselles* was marked by two intellectual pressures – one the abiding presence of Cézanne, the other the promptings of the poet Guillaume Apollinaire. In introducing Braque to Picasso, Apollinaire in effect completed a circuit that would conduct those energies to maximum effect. Picasso was very much the Promethean, Braque very much the Apollonian, and Apollinaire embodied both tendencies in varying proportion. For the Promethean will to art (the name refers to the mortal of the Greek myths who stole fire from the gods for men) implies the desire to conquer nature, to appropriate magic, to harness the power of myth itself. The Apollonian tendency, named after the Greek god of light and the Roman god of poetry, indicates a love of beauty, harmony, equilibrium, for their own sakes.

Perhaps the most effective critical voices in the development of modern art in France were those not of professional critics but rather of creative spirits whose writings on art overflowed from their devotion to literature: Charles Baudelaire on behalf of the romantics, with special attention to Delacroix; Emile Zola on behalf of the realists and Impressionists, especially with regard to Manet; and Apollinaire for the Cubists and their progeny, with special emphasis on Picasso. In each case the creative drive was central to critical perception. André Gide observed that Zola's disintegration as a critic during the period when he turned against Cézanne coincided with his own transition from novelist to social scientist. Certainly, Apollinaire's contribution to the Cubist experience derived from a personal and poetic orientation.

Originally, Apollinaire found it easier to accept *Les Demoiselles* than Braque did. For Braque, 1907 was a time of transition. He had established a reputation as a Fauve painter, an exuberant colourist, whose dominant contemporary influence was Matisse. His accomplishments had been real, but hardly in accord with his cool northern temperament, and in any case the Fauve experience had run its course. For Matisse, a born colourist, the end of Fauvism suggested paths to new concepts; for Braque it presented a dilemma. *Les Demoiselles* in itself could not offer him a concrete solution but together with his discovery of Picasso in general opened up a completely new field of inquiry. For him the painting, though conceptually remote, was plastically challenging: it

31

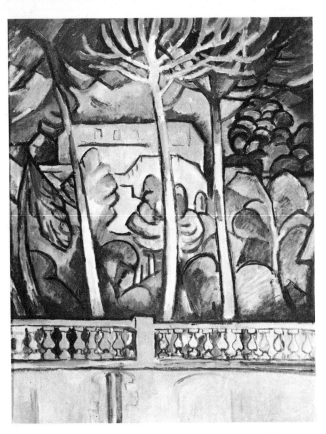

19 GEORGES BRAQUE,
View from the Hotel Mistral,
L'Estaque, 1907

was not the answer, but it adumbrated the significant questions. For Guillaume Apollinaire it was intellectually an answer. The difference in reactions is largely traceable to the pasts of both men.

Braque was born in Argenteuil, the Norman village already famous as a capital of Impressionism. As an apprentice to his father's trade of house painting, the young Braque learned a variety of decorative skills, such as lettering and the skilful imitation of marble, wood, and gilt surfaces. The father was himself a Sunday painter, and was happy to let his son study art in Le Havre. Braque's early artisan training may have inspired his later invention of *papier collé,* yet temperament explains as much as circumstance. For that very respect for artisanship, technique and decorative handling might well have made him succumb to academic temptation when, later, he studied in Paris under the painter Léon Bonnat. Instead he found his new criteria in the Louvre. Egyptian and archaic Greek sculpture captivated him. He inclined to the

32

20 GEORGES BRAQUE, *Houses at L'Estaque*, 1908

then-controversial visions of Matisse and Derain, and, like Picasso, he also responded to African art. Braque was always sensitive to the value of restraint, to the example set by true classicism. He was able to recognize that flatness of form and limitation of subject matter were opportunities for, not obstacles to, the achievement of emotional and intellectual depth, and he was therefore in a position to accept the challenge of Cubism.

Braque was a man whose past implied roots, order, traditions, and a clearly defined individuality; Apollinaire, on the other hand, was a man for whom the possibilities of poetic metaphor took precedence over individual identity. To this day his paternity is a matter of debate, and even his name was the product of his own imagination. From the age of sixteen the schoolboy legally identified as Wilhelm Apollinaris de Kostrowitzky was singing his poetry Guillaume Apollinaire.

Either he never knew his true identity or chose to keep it a mystery. According to one romantic hypothesis, he was the great-grandson of Napoleon Bonaparte and grandson of l'Aiglon. Another speculation involved Francesco Fluigi d'Aspermont, scion of an ancient Swiss family; certain clues suggest a high Vatican official, which led Picasso to sketch the poet with the papal crown and mitre. In any case, the romantic involvements of Olga de Kostrowitzky, Apollinaire's Polish mother, were sufficiently numerous and lustrous to defy definitive conclusions on the subject.

Born in 1880 in Rome and adopted by Paris, calling himself Macabre or Apollinaire according to whim, the young man enjoyed an existential freedom traditionally reserved for bastards. He had weaned himself on poetry, and was singularly equipped to accept a reality defined by metaphor and intuitive revelation; as a poet he functioned very much as a revolutionary.

Apollinaire frequently travelled from Paris to visit his mother, who was living with a companion outside the city. It was in the buffet of the Gare Saint-Lazare that he made the acquaintance, quite by chance, of Pablo Picasso. Apollinaire always cherished the value of accidents, and put his poetic equipment at the disposition of destiny's caprice.

One might say that Apollinaire, like Wilde, put his genius into his life and his talent into his work, even though his poetry is among the most advanced and most lyrical of modern times. His personal qualities dominated the period. His fund of knowledge was vast, eclectic, and totally unpredictable; he was able to quote from esoteric texts, occult sources and little-known poetry. It was he who suggested the literary importance of the Marquis de Sade, which the Surrealists later gratefully acknowledged. Even his taste in poetry (for example, for Verlaine over Musset) exerted a constructive influence. It was Apollinaire

34

who had given currency to the idea, later stressed by André Breton in the Surrealist Manifestos and in *Nadja*, of the vital distinction between poetics and poetry, calling the first sentimental, the second formal and formative.

Intellectually and even physically he was paradoxically analogous to Cubism itself – a man of varying profile, of many facets, of mystery and even of contradiction, and he understood the vitality inherent in poetic ambiguity. 'He had the gift of discovering sources of joy, pleasure, amusement, where others would only have seen platitude and banality',[1] said André Billy, co-founder with Apollinaire of *Les Soirées de Paris*, a periodical devoted to Cubism. Yet his sadness has been perpetuated in the main currents of French poetry since his time. Open-hearted yet sardonic, Apollinaire was, significantly, at once the romantic and the anti-romantic. As a romantic, his poetry concludes the poetic tradition that embraces Gérard de Nerval and Baudelaire. He believed in beauty for beauty's sake and in formal order as an aesthetic prerequisite, but he also believed in surprise for its own sake, in innovation, in chance, in a poetry of sound and allusion totally removed from romantic associations.

Matisse and Derain, Braque's fellow Fauves, had been quick to see Cézanne's importance, and as early as the summer of 1907, Braque too had started in this new direction; its first concrete expression was his *View from the Hotel Mistral*, painted from memory on his return to Paris from La Ciotat – parallel to Picasso's experience with the Gertrude Stein portrait. It too heralded an increasing intellectuality and preoccupation with purely formal and architectural values. The fairly direct confrontation of the subject's external character is still somewhat Fauve, but the forms are flattened and more formalistically developed, and the Cézanne influence is explicit. *Ill. 19*

It was roughly at this point, in late 1907, that Apollinaire brought Braque to the rue Ravignan. No one could then have predicted that Braque, impressed but puzzled by *Les Demoiselles*, would paint the first truly Cubist paintings. 'In art', Braque later wrote, 'progress consists not in extension but in an understanding of limits'.[2]

Apollinaire's sense of *l'esprit nouveau* shaped his influence on the Cubists, on those he dubbed the Orphists and also on those who, after his death, were to adopt another of his observations and call themselves *Surrealists*. Cubism was yet to come, *l'esprit nouveau* was still unformed, and yet the Cubist intelligence was kindled. The term implies a protean vision, and more exactly the shape and tenor of the movement, which was never doctrinaire at its best, but always supple and responsive.

Socially, the Cubist intelligence was first nurtured in an atmosphere of intense and solitary concentration by day, and of gregarious gaiety by night.

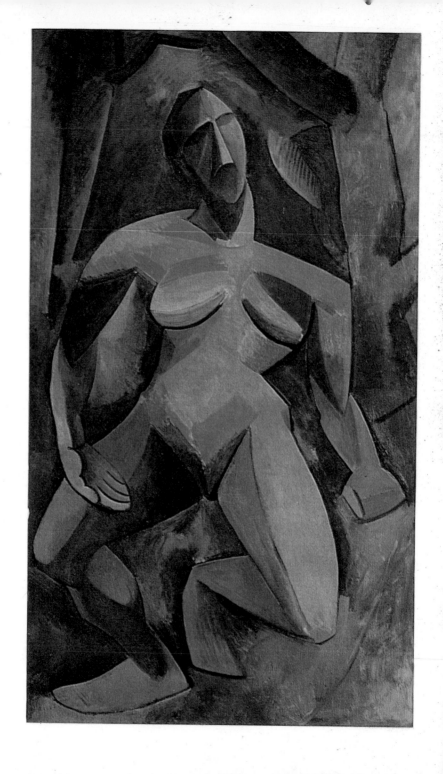

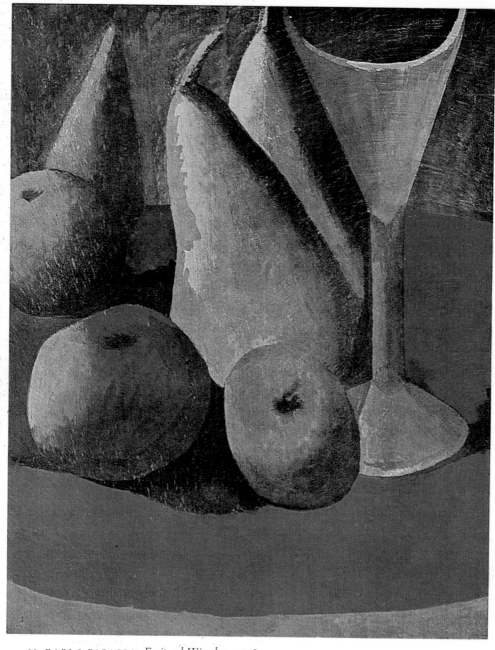

22 PABLO PICASSO, *Fruit and Wineglass*, 1908

◀ 21 PABLO PICASSO, *Nude in the Forest (La Grande Dryade)*, 1908

Its 'headquarters' in Montmartre was the Bateau-Lavoir off the rue Ravignan, so named because the old derelict labyrinth of a building resembled one of the Seine's moored laundry boats. It was in sad shape, and no one who lived in it had the means to improve it except by decorating it with the greatest art of the period. Picasso was the original occupant; Max Jacob, the whimsical and mystical Jewish poet and Catholic convert, and André Salmon, poet, critic, and chronicler of the period, were members of the ensemble. Later Juan Gris joined the group, and Apollinaire, Marie Laurencin (who was for a time his mistress), 'le douanier' Rousseau, Gertrude Stein and Alice Toklas, were frequent guests.

One night in the Cirque Medrano, a favourite haunt of the group, Picasso made a prophetic gesture which Michel Georges-Michel recalled.

> That evening, we went to the circus, Apollinaire, Picasso and I, and without even a sketchbook. But Picasso's mind was at work. A young poet, opposite us, René Fauchois, drew an imaginary circle with his finger in showing the circus to the painter. Whereupon Picasso . . . sketching in his turn, in the air, an imaginary figure . . . drew a square.[3]

The tragi-comic figure of the circus clown was one of Picasso's favourite subjects and a mythic figure in Apollinaire's poetry. One of Apollinaire's most celebrated poems, La Jolie Rousse, reveals the multiple image suggested by the clown's pathos and hermeticism, frivolity and profundity. After high romanticism, after symbolism, a new poetic vocabulary and a new voice were emerging. In this ambience whimsy, curiosity, and wit flourished. Rousseau, naïve and daring, childlike and unnatural, both clown and poet, was to find himself a patron saint of the revolution; the frankness of his dream-world was summoned up in a light that repudiated Impressionism and affirmed the inner life.

At the same time, the pictorial canonization of the bottle and the guitar was beginning. Minor circumstantial phenomena were seen as more important, mysterious, and meaningful than the lofty themes and sentiments long thought to be an inevitable characteristic of great art. The means had not until then been developed to give articulate voice in terms of painting to this blossoming consciousness; when they had, the resulting forms were manifold.

The years 1907–09 represent what might be called the 'labour pains' of Cubism, a most strenuous period of transition, when its inspirations were held to a minimum, its explorations keyed to a series of specific and difficult problems. The first major work done by Braque after his meeting with Picasso and his

38

first sight of *Les Demoiselles*, was the painting known as the *Grand Nu* (1908). *Ill. 1*
Though an oil, it was essentially an ambitious drawing with structural aims.
Matisse still exercised an important influence, and the architectural example of
Cézanne began to be even more apparent. Seen retrospectively, the Picasso
influence is equally determining, but what is most striking about the *Grand Nu*
is its frankly transitional character. One can imagine a number of ways in
which Braque might have extended his power as a colourist and stylist, but
he was more interested in returning to sources, to fundamentals, so as to chart a
new direction. The head of the nude can be traced to primitive sources, but
only tangentially, and the means are more immediately perceivable than the
goal. It would be a mistake to see it as a stylistic problem, for the idea of style
refers specifically to expression, whereas for Braque this attempt was a process
of self-education, an amassing of strength, a probing of possibilities.

In 1908, when Picasso left Paris for the village of Rue des Bois, Braque
travelled to L'Estaque, the site of many of Cézanne's labours, and began a
series of landscapes. The external attributes of the theme had ceased, however,
to be important. These works were to be seen retrospectively as the first truly
Cubist paintings, and it was these very canvases that gave rise to the term itself.

Houses at L'Estaque is the most celebrated of the series. Seen in historical *Ill. 20*
perspective, it appears to have a closer link to naturalism than it seemed to
have at the time. It maintains a certain fidelity to the subject in the light and in
the handling of the trees, but without doubt this painting introduced a
revolutionary formal language. Each of its volumes is honed to a massive and
luminous purity and contributes to a total volume. In *Houses at L'Estaque*,
Fauvism has been entirely discarded. If the colour remains somewhat descrip-
tive it has still been drastically re-directed towards an architectural and psycho-
logical goal. Braque discarded the attitude towards colour that once linked him
to Matisse, and here Cézanne is the overwhelming influence, and Picasso a
catalyst, in daring and direction rather than through specific example.

The L'Estaque paintings were shown at the Kahnweiler Gallery in
November 1908 after they had been turned down by the jury of the Salon
d'Automne. Louis Vauxcelles, though not an arch-conservative, was per-
plexed by what he saw. Braque, he said, was 'a very audacious young man',
and noted Picasso and Derain as sources whose 'disturbing example [had]
emboldened him'; observed Cézanne's influence and referred to the 'static art
of the Egyptians', but then concluded by stating that Braque 'despises form,
reduces everything, sites and figures and houses to geometric schemes, to cubes.'
Nevertheless, he added, with charity, 'Let's not mock, since he is in good faith.
And let's wait.'[4]

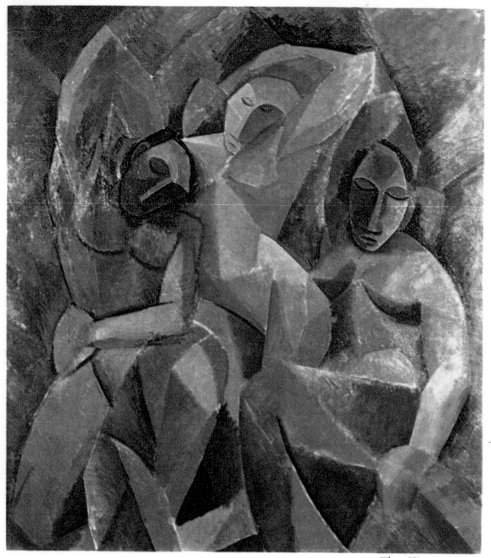

23 PABLO PICASSO, *Three Women*, 1908

24 PABLO PICASSO, *Woman with a Fan*, 1908 ▶

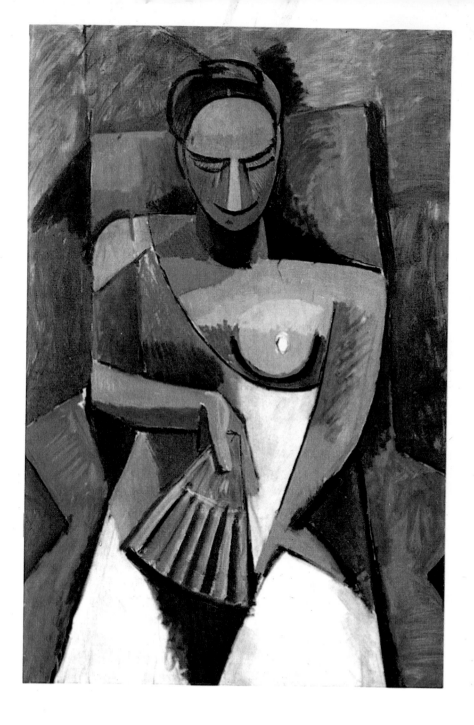

But according to Apollinaire, Matisse first used the word 'cube'. The phrase 'une poésie dite cubiste' followed swiftly and inevitably. In 1908 Braque also painted his *Still-life with Musical Instruments*, which was to remain in his own collection all his life; it was the first Cubist still-life (if we except the foreground of *Les Demoiselles*), and it introduced what was to become a characteristic Cubist motif – musical instruments. Some saw the instruments as symbolic of Braque's interest in harmony, but Apollinaire saw the painting as a purely aesthetic statement inextricably linked to contemporary values. His view of Braque as a twentieth-century modernist in the sense in which Vermeer was a seventeenth-century modernist, and of Braque's art as exemplary of much the same 'tranquil and admirable' magic as Vermeer's, suggests Braque's double role as lyricist and revolutionary. But if Apollinaire saw Braque as a 'verifier' of contemporary spiritual and intellectual values, it was Picasso whom he regarded as the pre-eminent innovator of the age. The distinction is not altogether just in view of the great originality of Braque's accomplishments but is perfectly just, and largely prophetic, seen in the perspective of Picasso's extraordinary advances. In any case, the two men progressed in the same intellectual direction, propelled by greatly varying temperaments. Their poetry diverged, their conclusions converged; in terms of the structural development of Cubism, the researches of Picasso and Braque at this point were in harmony.

Ill. 22 Picasso's interest in Cézanne is especially clear in the still-lifes, and any primitive reference is minimized or absent, but even such a painting as *Fruit and Wineglass* (1908) has links to the monumentality and ferocity of *Les Demoiselles*. Though indebted to French influences and concerned with technical challenges, it is also imbued with Picasso's own dark and rigorous *Ill. 21* Spanish temperament. In *Nude in the Forest* (1908), also known as *La Grande Dryade*, the link to 1907 and *Les Demoiselles* is far more evident, in the primitive head, the construction of the body and the similarly disparate background. But now the primitive allusions were being absorbed into a vision less eclectic and less self-conscious.

Ill. 23 In *Three Women* (1908), the process has been carried further. The painting might even be read as a complete reconstruction of *Les Demoiselles*, but in another key of comprehension and on a level of greater harmony. The three heads are variously handled, the one at right a vestige of the Gosol experience, the other two of primitive mask persuasion but more sculpturally abstracted and more thoroughly integrated into the Cézanne conception of volumes. The geometrical volumes are brilliantly faceted or modulated. On the one hand, their references are entirely sensual and psychological and without descriptive allusion; in this sense, they approach the Cubist ideals. On the other hand, a

42

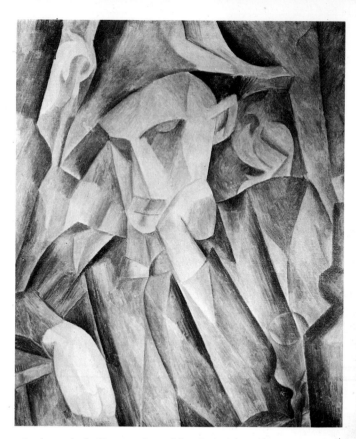

25 PABLO PICASSO,
Harlequin, 1909

Gothic structure is apparent in the arched climaxes formed by the heads and raised arms, a movement echoed in the background; it may also owe something to Cézanne, who used the principle in his great nudes in landscape. The Gothic, the primitive, the archaic, the Cézannesque and the incipient Cubist elements all meet and converge towards the internal purity which was to become the singular goal of Cubist painting.

In opposition to 'the poet to whom the muse dictates his chants . . .' the artist whose hand is guided by an unknown force using him as an instrument, Apollinaire postulated the 'poets and artists who exert themselves constantly, who turn to nature but have no direct contact with her; they must draw everything from within themselves, for no demon, no muse inspires them'. And he concluded that Picasso had been the first type of artist, and that there had never been 'so fantastic a spectacle as the metamorphosis he underwent in becoming an artist of the second type'.[5]

43

The natural and the unnatural, the subject and the object, flesh and imagination, were in the balance. Apollinaire put it this way: 'The object, real or illusory, is doubtless called upon to play a more and more important role. The object is the inner frame of the picture and marks the limits of its profundity, just as the actual frame marks its external limits.'

Braque put the matter in more painterly terms, and associated his efforts with Corot rather than with any deliberately metaphysical aims.

> Before one used the Renaissance framework, largely because of the vanishing point, and the depth helped the illusion. But I have suppressed the vanishing point which is almost always false. A painting should give a desire to live 'within'. I want the public to participate in my painting, for the frame to be behind one's back. . . . Oh, I didn't entirely invent that. Paul Désiré Trouillebert asked Corot one day, 'But where is that tree you are putting in the landscape?' Corot replied: 'Behind me.'[6]

In 1909 the problem of techniques for dealing with positive and negative space, with object and subject were to be definitively resolved. But the line of progress was by no means direct, nor the problem itself clearly expressed. It became evident retrospectively, circuitously, only by way of an approach to a solution; in the process, primitive references were reduced and finally eliminated, and Cézanne's principles became increasingly relevant.

Once again, Picasso and Braque left Paris during the summer, and once again their prodigious advances were strangely parallel. Picasso went to Spain again, this time to Horta de Ebro (known colloquially as Horta de San Juan), Braque to the French village of La Roche-Guyon. What they learned and produced in the period was pivotal, consolidating, and prophetic.

Ill. 24 — Picasso's *Woman with a Fan, Seated Woman* or *Nude Woman*, all of 1908, and Braque's *Still-Life* (also 1908), are phenomena of this time. *Woman with a Fan*, for example, arrives at a diagrammatic anticipation of much later Cubist work. In an upside-down view which reduces the descriptive references, the formal resolution of planes and volumes creates a more sophisticated statement than, say, *La Reine Isabeau* of 1909. But the later painting has edged towards a new set of inquiries, when perspective was to be uprooted and volumes fragmented.

For Picasso, the year 1909 was one of three fairly distinct sets of works: those done in Paris in the spring, the ones done at Horta during the summer and autumn, and finally the developed ones of the winter in Paris, which led to the

Ills. 25, 26 — purer disciplines and freedoms of 1910. In *Harlequin, Bust of a Woman, Woman with a Fan* and *La Reine Isabeau*, all produced in Paris during the spring, or *Nude Woman with a Guitar*, at Horta, Picasso rigorously attacked the problem

44

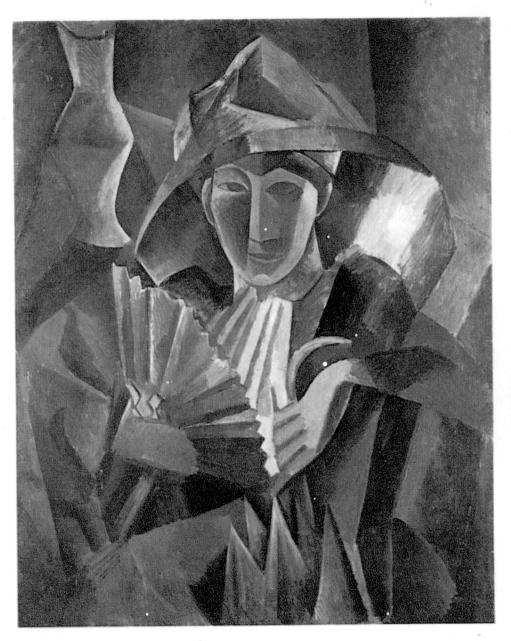

26 PABLO PICASSO, *Woman with a Fan*, 1909

of exploiting volumes to the furthest possible extent. These are disturbing and sometimes awkward paintings, in which Picasso chose to exploit the structure of the object for its own sake, rather than integrate it into a harmonized whole, or transmute it through stylistic modification. In every case, Picasso probed each mass with almost 'surgical' will. His new means utilized as many vantage points as possible, so that he was able to dislocate any given mass and articulate its potentialities to the fullest degree. This freedom (an idea long before initiated by Cézanne) remained a ground rule for Cubism, but it was not a key to Cubist method, only a useful device for rejecting systematization. For Picasso, the process had become a necessity, but in this period especially, he did not follow a line of unbroken evolution. The process was a tidal rhythm of advance and recapitulation in which he successively purified his forms, abandoned subject in relative deference to object, then returned to the full weight of subject only to move forward again with a newly distilled vocabulary.

In landscapes done at Horta he pursued the study of volumes; their means were less demanding than those necessitated by the portrait sequence. *Landscape at Horta de Ebro* is almost a transposition of Cézanne, with its fusion of terrestrial landscape and sky into a great architectonic mass, and its faceting of sky into other, equally crystalline areas: the architectural nature of the theme itself invited an application of Cézannesque principles. Cézanne was also the force directly behind the entire sequence of Horta portraits, and his influence is as immediately evident in the still-life drawings of the period as in the landscapes. *Ill. 30* *The Reservoir* reflects Cézanne less directly but takes Picasso along another, specifically Cubist path. It accentuates the power of volumes and also distributes them so that they interact towards an immediate harmony; they are located rather then dislocated. Synthesis balances analysis and the result, while less dramatic, is freer.

Perhaps the closest approximation to this balance in the portrait series was in *Bust of a Woman*, though it is still painted in a rich Cézannesque manner. But in *Ill. 27* *Woman with Pears* (1909) the physical surface becomes harder and cooler than in the earlier portraits, and the elements of hair, flesh, drapery, are now expressed in a language of pure structure. The drawing of the eyes, for example, as rectangular, indented passages, almost tubes, would have seemed merely artifice if it were not part of a formalized, dramatized conception. In *La Reine Isabeau* and the other spring portraits the union of external references and internal resolutions is jarring, but in *Woman with Pears* it is complete. By covering the face so that only the upper portion of the head and the background are visible, one can see the cogency and power of the work as a formalistic advance. If one covers the upper two-thirds of the painting, from the chin up,

46

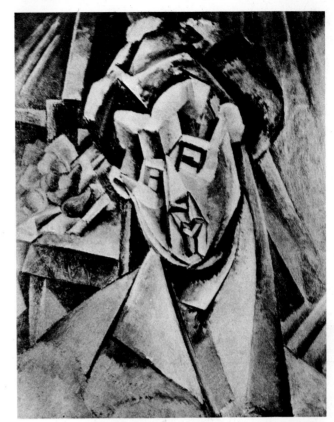

27 PABLO PICASSO,
Woman with Pears, 1909

28 PABLO PICASSO,
Seated Nude, 1909

29 PABLO PICASSO,
Portrait of Braque, 1909

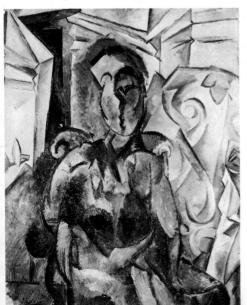

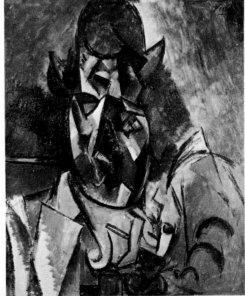

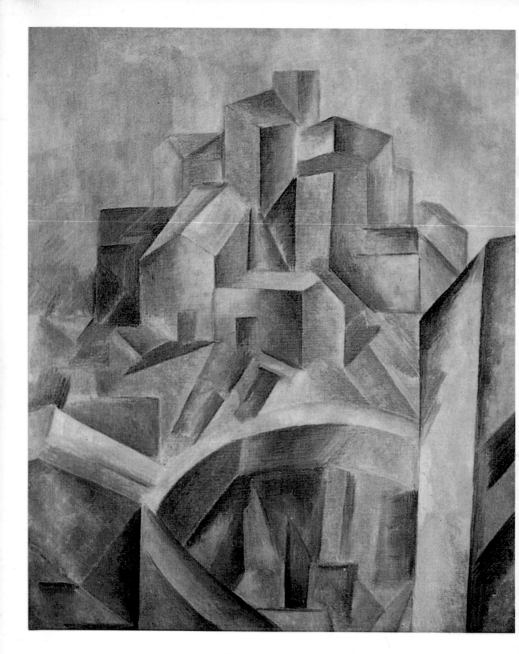

30 PABLO PICASSO, *The Reservoir, Horta de Ebro*, 1909

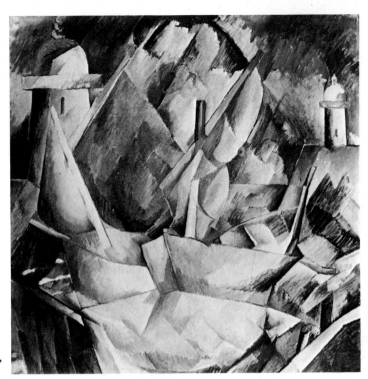

31 GEORGES
BRAQUE, *Le Port*
(*Harbour in Normandy*),
1909

another architectural formulation, almost landscape, becomes visible. Viewed as a whole, the massiveness of the conception as a metaphor suggests not abstraction but a new kind of reality.

In a sense, Picasso had arrived, in his upward, spiralling advance, at a point in direct apposition to his 1906 *Portrait of Gertrude Stein*. The two paintings are companions in monumentality and veracity. But the Stein portrait is remarkable for its penetration from the outside in, whereas in the *Woman with Pears* the external presence is simply the perimeter of an internal force; it was a landmark in the sequence that ended with an abandonment of the exterior. The last portraits of 1909, such as the *Portrait of Braque* and *Seated Nude*, increased the pace of the evolution, and the influence of Braque's work, with which Picasso was in intimate contact, was surely an important factor. *Ills. 28, 29*

The Braque canvases of 1909 seem to be less strenuous exercises than Picasso's but in fact these 1909 landscapes, of which *Le Port* is the most celebrated, were as advanced as Picasso's and often more aesthetically resolved. It is Braque's natural lyricism and that devotion to the painting as a resolved whole, that make his work seem less highly charged. *Ill. 31*

49

While Picasso concentrated on the problem of positive or active volumes, Braque was absorbed in resolving that of positive and negative volumes, shapes and areas between them in interaction throughout the picture plane. He and Picasso were actually developing in depth two aspects of Cézanne; Picasso the side manifest in Cézanne's still-lifes, the monumentality of mass itself; Braque the one evident in the late Mont Sainte-Victoire paintings, in which the emphasis on structure is developed more by way of light than mass. His disruption of volumes, in terms of light and movement anticipates, and for the most part outdistances, the purposes and products of the later Futurist paintings. In the *View of La Roche-Guyon* (1909), for example, Braque enclosed his structural formulations within a whirlwind of motion. Picasso modified his brushwork at Horta in deference to a geometric clarity; Braque chose the opposite solution. Picasso adopted a linear treatment, Braque employed refractions and scintillations, although his method was in no sense Impressionist. At most, it accepts Cézanne's modification of Impressionist techniques, in which the light is not 'local', does not radiate from a single external source, and illuminates an interior objective.

Braque's approach was similar in his *Head of a Woman* (1909). He and Picasso were both moving in the direction of an architecture so universal that the distinction between portrait and landscape was becoming substantially minimized, but Braque was steadfastly concerned with phrasing, an equilibrium of light and a finesse of surface at the same time that he was struggling with structure, and this aspect of his work at La Roche-Guyon appears to have had a decided impact on Picasso's for the remainder of 1909.

In short, although their methods were not theoretically organized or systematic, the two artists in effect arrived at an admirable division of labour, so that in the following months in Paris, Analytical Cubism in its purest state was born.

Picasso's *Portrait of Braque* (1909) moves the sequence of the Gertrude Stein portrait and *Woman with Pears* into a new dimension. The subject has now been engulfed; the volumes and their resonances assume an independent, self-sufficient existence. In its handling the Braque portrait is almost an amalgam of Picasso's own hard, cool definition in *Woman with Pears* and Braque's nervous refractions. It is significant that Braque never sat for this portrait; neither, however, can it be said to have been done from memory. It bears no resemblance to Braque as a physical being; the title may well be only a tribute to Braque's influence. It is also a renewed homage to Cézanne. In doing the Stein portrait Picasso found that an awareness of plastic aims was of greater help than the continued presence of his subject. So too, in *Woman with Pears*, he subordinated memory and even immediate perception to conceptual demands.

50

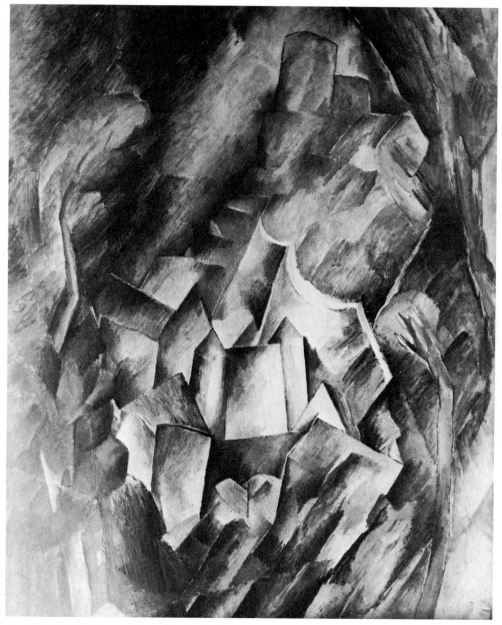

32 GEORGES BRAQUE, *View of La Roche-Guyon*, 1909

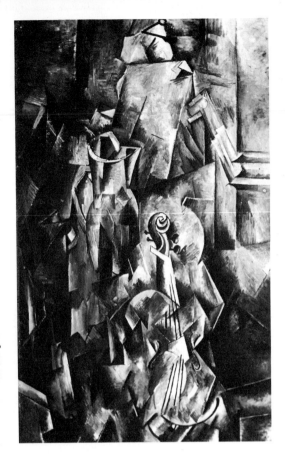

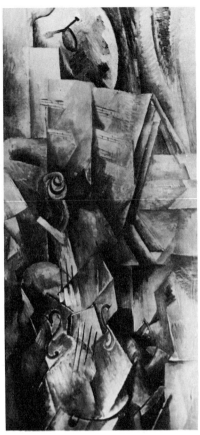

Another of the Picasso portraits of the winter of 1909, *Lady with Black Hat*,
perhaps most clearly reflects the influence of Braque in concept and in handling.

Ills. 34, 33 For Braque, the still-lifes, *Violin and Palette* (1909–10) and *Violin and Pitcher*
(1909–10) represent a similar achievement. These are entirely harmonic works,
in which the Cubist volumes are developed in terms of a full-fledged vocabulary,
so that the dialogue of linear determinations and three-dimensional references
changes in tone and articulation. Each faceting of plane and cube is handled
with a new subtlety calculated to function not only individually but in terms
of its participation in the entire surface.

In the *Violin and Pitcher* painting, the pitcher, if taken out of context, main-
tains its objective presence, but Braque has transformed it by means of trans-
parency, making it at once convex and concave; it becomes its own foreground

52

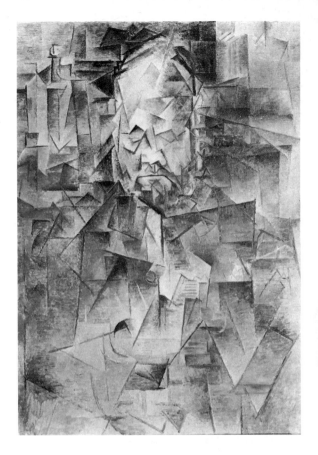

◀ 33 GEORGES BRAQUE,
Violin and Pitcher, 1910

◀ 34 GEORGES BRAQUE,
Violin and Palette, 1910

35 PABLO PICASSO,
Portrait of Ambroise Vollard,
1910

and background, and fulfils a function of light and space. The violin, on the other hand, is transmuted like a musical theme in a fugue. Like the atom, an apparent solidity has been re-defined as a ceaseless play of energy.

Picasso's *Portrait of Ambroise Vollard* (1909–10), the art dealer, crystallized the same energies in another way. The head, an uncanny likeness of the subject compared to the *Portrait of Braque*, is conjured up in a confluence of Cubist passages, a fugue of light; the painting is an ingenious amalgam of the internal and external presences. This is Vollard as vividly as he appears in portraits by Renoir or Bonnard down to gesture, stance, the sense of weighty repose. The painting is remarkable in its expression of intensity through entirely formal means. It is interesting to compare the Vollard portrait (which, like Braque's *Violin and Pitcher*, was not finished until 1910) with *Seated Woman*, completed

Ill. 35

53

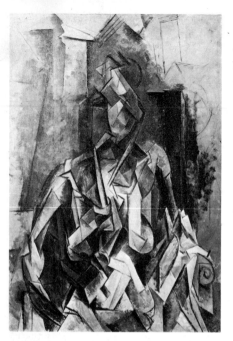

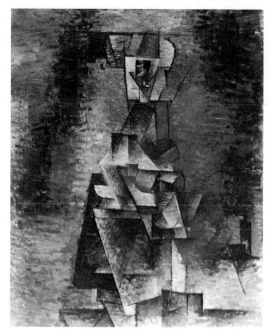

36 PABLO PICASSO,
Seated Woman, 1909

37 PABLO PICASSO, *Female Nude*, 1910

38 PABLO PICASSO, *Portrait of Daniel-Henry Kahnweiler*, 1910 ▶

Art Institute of Chicago

Ill. 36 in 1909. The *Seated Woman* is a revelation, the Vollard a consummation. The first is dynamically an anti-portrait, deliberately obliterating characterization in favour of an organic monumentality, but both are thoroughly architectural. Again, the *Seated Woman* insists upon the force or thrust of its volumes; the Vollard portrait stresses an equilibrium instead – what Juan Gris later called a perfect balance of the emotional and the intellectual.

During 1910–11, Picasso and Braque consistently reaffirmed their fidelity to subject. At Cadaqués, where Picasso spent the summer of 1910, he painted his most purely geometric constructions to date, but he was overtly unhappy with them. On his return to Paris he reasserted the importance of subject, identifying this contact as 'the joy of discovery, the pleasure of the unexpected'. The varying

54

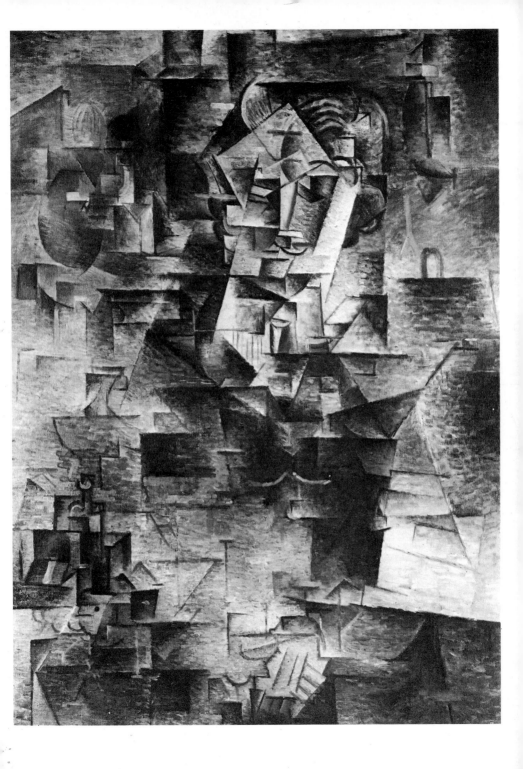

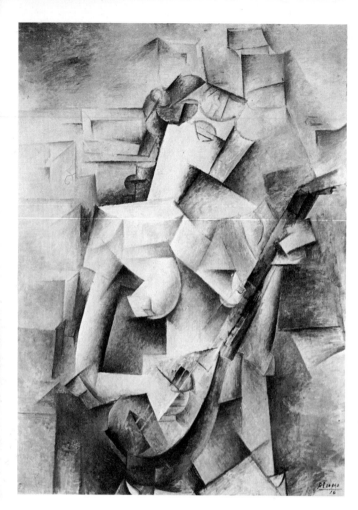

39 PABLO
PICASSO,
Girl with Mandolin,
1910

40 GEORGES ▶
BRAQUE, *Woman
with Mandolin,* 1910

equations of object-subject (with their implied conceptual parallels of emotion-intellect, external-internal) implicit in the 1910 paintings describe an exploration of what can be called the classic vision.

Ills. 39, 40
 Compare, because of their identity of subject, three versions of the woman-with-mandolin theme, one by Picasso, two by Braque, produced in 1910. In the Picasso, the subject is the most striking of the three, and yet simply by covering the eye, the elbow, the guitar face and the hand on the frets, thus eliminating external reference points, a pure abstraction is created. One might say that the subject has been retained so that it might yield yet another dimension, introduce

56

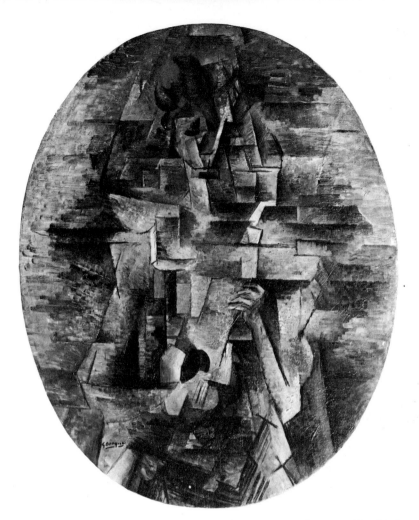

a magic beyond that of total abstraction. The entire mass from shoulder-blade to breast is powerful in itself, but also acquires a luminous, highly spiritualized, even Greco-like quality as a pictorial function of the human nude.

Throughout 1910 this double concern provoked deliberate fluctuations in his treatment of the nude. The paintings of the *Seated Nude* or *Seated Woman* series were all depersonalized, monumentalized; balance being minimized in favour of a tremendous thrust. Sheer volume again became the dominant concern, to far greater effect than in the early 1909 portraits, because of the shedding of local or external fidelities. On the other hand, the series typified by

57

Ill. 38 the Vollard portrait and the *Portrait of Daniel-Henry Kahnweiler* restrained the aggressive effect, moved closer to a substitution of planes for volumes and secured expressiveness through balance. The work which perhaps exemplifies a point exactly between the two, in terms of object and subject, volume and
Ill. 37 plane, thrust and balance, was the remarkable *Female Nude* of autumn 1910.

 Braque, however, moved more directly into the domain of purely abstract
Ill. 40 form. In the oval version of the *Woman with Mandolin*, the face and hand refer specifically to the theme; the arms participate effectively but less distinctly. The subject and object are far more submerged than in the 1910 Picasso works but serve as landmarks that give the formal tensions and masses an expressive geography. In the rectilinear version, subject and object have been almost entirely sublimated. The hand alone almost artificially states the theme. And yet the object is still there, in weight, in bearing, in structural formality. In effect, Braque has reversed the roles of the visible and the invisible.

 On varying levels, Picasso and Braque created both a classical equilibrium and a fugitive magic. In the months to follow these two aspects were to be further developed. First came the intense plastic purity of the Analytical Cubist period, then the exploration of the possibilities of the imagination in Synthetic Cubism. The fact that the two were able to co-exist gracefully and organically is a testament to the power and validity of the movement.

Lines Parallel, Lines Tangent

Picasso and Braque were proving themselves successful in the fundamental goal of art, the renewal of a rich tradition through original and revolutionary means. Had they tried to be innovators above all else, they could never have arrived at the deeper classical solution and could never have produced such painterly works. They painted as Chardin (always a favourite of Braque's) painted, as Poussin (always an inspiration to Cézanne) painted, and as Cézanne (their own progenitor) painted, and they acknowledged it freely.

Yet the jolt their paintings gave to the current notions of the 'real' or the 'poetic' can be described as total, and the intellectual implications of their work were as real as their explicit intentions. Apollinaire was most excited by these, and despite the Apollonian side to his character, praised or blamed the Cubists according to the fluctuations of their revolutionary energies.

Though he has always been associated with the Cubist movement, and his own poetry has been referred to as 'Cubist', Apollinaire had a broader devotion to the concept of *l'esprit nouveau*, which accounts for his interest in the Cubists, in those he termed Orphic (the Greek mystic cult of Orphism took the mythical Orpheus, who descended to Hades – lyre in hand – to secure the return of Eurydice, to be a source of sacred poems and a symbol of poetic force), and in those he later called Surrealist. When his revised critical writings were published in collected form in 1913, his publisher, aware of the value of controversial current interest in the Cubist movement, insisted upon the title, *Les Peintres Cubistes*, with the sub-title, *méditations esthétiques*. But Apollinaire's original title bore the two in reverse order.

The scholar L.-C. Breunig neatly summed up Apollinaire's critical stance between the Romantic and the emerging anti-Romantic vision:

One can compare the famous observation of Proust: 'The world was not created one single time but as often as an original artist comes upon it', with that of Apollinaire: 'The great poets and the great artists have as their social function to incessantly renew the appearance that redresses nature in the eyes of men.' And when one of those artists, Picasso, said, 'I paint objects as I think them, not as I see them', he expressed a doctrine which, though it had existed in poetry since Baudelaire, was revolutionary in painting. It was

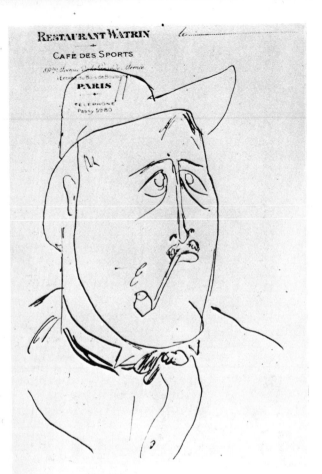

41 MAURICE DE VLAMINCK,
*Guillaume Apollinaire au
Restaurant Watrin*, 1905

natural, then, for Apollinaire to approve the aesthetic method of Cubism
in the largest sense, defining it as 'the art of painting new ensembles with
elements borrowed, not according to the reality of vision but according to the
reality of conception.'[1]

In speaking of Picasso, Apollinaire wrote that, '... Picasso had looked upon
human images that floated in the azure of our memories and which participate
in divinity to damn the metaphysicians.'[2]

Apollinaire inclined naturally to movement, flux, new forms, and there is
something paradoxical in his finding them, if only temporarily, in the Cubist

drive towards a new equilibrium. In part, Apollinaire served as a catalyst to the Cubists because his own perspective, being basically different, was a source of enrichment. In *La Victoire*, of the series, *Calligrammes* (1918), he wrote:

O bouches l'homme est à la recherche d'un nouveau langage
Auquel le grammairien d'aucune langue n'aura rien à dire

Et ces vieilles langues sont tellement près de mourir
Que c'est vraiment par habitude et manque d'audace
Qu'on les fait encore servir à la poésie

Mais elles sont comme des malades sans volonté
Ma foi les gens s'habitueraient vite au mutisme
La mimique suffit bien au cinéma

 Mais entêtons-nous à parler
 Remuons la langue
 Lançons des postillons

On veut de nouveaux sons de nouveaux sons
On veut des consonnes sans voyelles
Des consonnes qui pèsent sourdement

Les divers pets labiaux rendraient aussi vos discours clairvoyants

O mouths man is searching for a new language
To which the grammarian of no language will have a reply

And these old tongues are so near to death
That only by habit and lack of audacity
Are they made to serve poetry still

But they are like invalids without will
Lord, but people would quickly grow accustomed to muteness
Mimicry does fine for the cinema

 But let's insist upon speaking
 Let's shake up the language
 Let's sponsor splutterings

We want new sounds new sounds new sounds
We want consonants without vowels
Consonants that weigh heavily

The various labial farts would also render your speeches clairvoyant

The last line is significant. Apollinaire speaks of language, then introduces the idea of clairvoyance, plasticity on the one hand, psychology and magic on the other. Here is the meeting-point of Cubism and Surrealism. In addition, between Cubism's formal intensity and metaphorical promise there was a humour which became evident during the synthetic period and was already prefigured in the turning away from grandiloquent themes, from *les beaux sentiments*. The trivial and the obscure took on charm and mystery, and became oblique passageways to a deeper poetic source. The pipe, the bottle, the hat, the playing-card were quite literally marvellous objects to Apollinaire. Michel Georges-Michel reported an encounter in 1907 in Paris at which Apollinaire launched into a whimsical object-demonstration of his modern poetic method – a precocious equivalent of Synthetic Cubism, which did not emerge until six years later.

'Look, let's write, for example, *Impression of Saint-Germain des Prés*. We're seated on the terrace. Let's write:

> Assis à la terrasse
> Il y a non loin de nous
> Un prêtre au nez rouge
> Couleur
> Il lit un journal dont l'angle frôle le siphon
> Un cycliste manque d'être écrasé
> Par un omnibus à bande verte
> Un vert de chemin de fer

Railway makes me think of *la Ceinture*, of all my travels. I write:

> Belt railway
> Bourgeois, artists
> Sur la même banquette tachée de suie
> Arbres et maisons de la banlieue
> Barrière

And suddenly I see 'La Gandara qui passe.' I write that.

> La Gandara qui passe
> Il est fier comme un hidalgo
> J'aime mieux son port de tête
> Que sa peinture
> Bien qu'elle soit honorable
> Il achète un journal au kiosque et paie
> D'un geste
> Distingué

I detach the word 'distinguished' just as his gesture is detached, you see.

> Il n'ira pas chez Lipp
> En face
> Malgré la bonne bière
> Et rentre chez lui
> D'un pas choisi
> Mais voici venir
> Mieux sous les arbres
> Voici Picasso
> Avenir . . .

– And Picasso sat down with us.[3]

The structure of the language in Apollinaire's impromptu poem and his method of juxtaposing images were to become characteristic of those 'Cubist poets' who mixed with the painters and whose work attempted to parallel theirs. But the 1907 date creates a certain ambiguity in cause and effect, and underlines the significance of the phrase 'Cubist intelligence' as opposed to 'Cubist method'. A new lucidity was evolving, a paring away of excess and a growing interest in the mystery of language – or of formal planes and volumes. The words *couleur*, *barrière* and *avenir* are sharply abstracted from the normal sequence of language and reconstituted, by juxtaposition, in a new logic of pure elements. The sequence of images are that of a cyclist nearly crushed by a passing bus with a green stripe which, in turn, suggests railway green. The colour immediately evokes travel associations, and suddenly the idea of physical travel (therefore distance) shifts to the moral distance between bourgeois and artists in the same railway compartments, at which point the concept of an invisible barrier brings the passage to its coda. The references, in short, tend to be immediately evocative and poetically self-explanatory rather than descriptive.

In 1909, Apollinaire wrote a poem in the series he entitled *Alcools* in which he described a woman in terms of direct confrontation of the romantic and anti-romantic visions:

> Elle avait un visage aux couleurs de France
> Les yeux bleus les dents blanches et les lèvres très rouges
> Elle avait un visage aux couleurs de France

> She had a face the colours of France
> Blue eyes, white teeth and very red lips
> She had a face the colours of France.

63

The features and colours are drastically simplified to the emblematic flatness of a flag; sentiment is eliminated, the image formalized.

Ill. 42 In *Calligrammes*, Apollinaire arranged his lines typographically so as to oppose their logical sequence and create visual patterns related to Cubist forms. In one sense this was no more than whimsy and in another the development of a mode Mallarmé had initiated long before, in *Un Coup de Dés* and in other poems. It was in *Zone*, also in the *Alcools* series, that Apollinaire gave voice to his faith in perception through language itself. He begins with an appeal to modernity:

> A la fin tu es las de ce monde ancien
> Bergère O tour Eiffel le troupeau des ponts bêle ce matin
> Tu en as assez de vivre dans l'antiquité grecque et romaine
> Ici même les automobiles ont l'air d'être anciennes
>
> La religion seule est restée toute neuve la religion
> Est restée simple comme les hangars de Port-Aviation
>
> After all, you are tired of this ancient world
> Shepherdess O Eiffel Tower the flock of bridges bleat this morning
> You have had enough of living in Greek and Roman antiquity
> Here, even the automobiles seem to be ancient
>
> Only religion has remained brand new religion
> Has remained simple as the airport hangars

And almost immediately following:

> Tu lis les prospectus les catalogues les affiches qui chanteut tout haut
> Voilà la poésie ce matin et pour la prose il y a les journaux
>
> You read the pamphlets the catalogues the posters that sing out
> Such is poetry this morning and for prose there are newspapers

The coherence, the poetic awareness of Apollinaire's words, come from a juxtaposition, almost a collage, of images, allusions, sensations, ideas. But this process had its most potent effect in his last, poignant verses written from the Belgian trenches where he was gravely wounded, in which realities and unrealities are intertwined, death imminent, invisible but tangible. And his own images were shadows to which he gave lasting form. In *Love, Disdain and Hope*, he wrote:

Et c'est en vain maintenant que j'essaye d'éteindre ton esprit
Il fuit il me fuit de toutes parts comme un nœud de couleuvres qui se
 denoue
Et tes bras sur l'horizon lointain sont les serpents couleur d'aurore qui se
 lèvent en signe d'adieu

And now it is in vain that I try to extinguish your spirit
It flees it flees me everywhere like a knot of serpents who uncoil
And your beautiful arms on the far horizon are serpents the colour of
 dawn who entwine in sign of farewell

The poem ends:

La barque nous attend c'est notre imagination
Et la réalité nous rejoindra un jour si les âmes sont rejointes
Pour le trop beau pèlerinage

The bark awaits us it is our imagination
And reality will rejoin us one day if souls are rejoined
For the too beautiful pilgrimage

The image is addressed to life rather than to art, yet it suggests the dividing
point between the Cubist and Surrealist ideals. Cubism stressed the conscious,
Surrealism the subconscious, but each postulated realities accessible only via
the imagination. What I think, not what I see, was Picasso's principle; what
I dream, not what I think, was in effect the Surrealists'. But the bark, the vessel,
which bears both tendencies, has its original harbour in the imagination as,
quite literally, in a harbour of images. And the reality can only be known when
perceptions are joined in a common pilgrimage of creator and spectator. The
Cubists were fundamentally devoted to art; the Surrealists declared that magic
existed beyond art. Apollinaire found the single, luminous point of conver-
gence for the two credos manifest in Picasso's Cubist work.

Apollinaire, who so loved the powers of coincidence and accident, was
denied the final irony: immediately after his death on 9 November 1918,
crowds of jubilant Parisians marched past his window on the boulevard
Saint-Germain crying 'A bas, Guillaume' (the French version of Wilhelm,
the German Kaiser). When Picasso heard, on the telephone, that Apollinaire
was dead, he turned, saw his own bereaved face in a mirror, and at once
sketched it. 'Pity', Apollinaire had written, 'rendered Picasso harsher.'

Even his admirers differ about the character of Apollinaire's legacy. Mar-
guerite Bonnet, for example, said:

He searches out new domains for art, not the enlargement of the conscious-
ness; he attempts an expression more total than real, not its enlargement,

65

M
O
le der HI nier des
CANS
fu va son
mer ca
? i c. lu
me
t

voici l'H O M ME le plus
em
...
dan
t
du sa
quar tour
tier née
qui des
fait bars

Pi c a sso N
ble ble
Pa pou
nu ce
con à
bien la
teur main
sculp droi
turs te
pein
du

P
eti
TE
bou
teille
où mons
ieur Ba
ty cons
erve l'
antique
NECTAR

A
rbre
qui fut ja
dis planté par
V
I
C
T
O
R
H
U
G
O

P O O R T N E
l'in
que aus
peut prèn
s't dre pour
le " Dôme qui se trouve en face

A
mé ni cai né apprenant
la
pein
tu
re
la sculp
ture la gra
vure la couture
l'architecture
la caricature
l'agriculture
la litterature
et faisait mille con
jectures sur la
na tu
re

S
im
ple
enfant du Mont
A par nas
BELLE se se ren
VYONNE dait chez
son
a
mant qui
l'attend en
écoutant le
perroquet du
Lion de Belfort
imiter les tramways

S
é
ci
étaire cubiste du Salon
d'Au
TOM
ne et
DES
indé
pendants
al le
lant mar
pren di
dre à la
son clo
apé se
rif rie
des
lilas

66

T
e
rri
ble
Boxeur
Boxant avec et ses
ses mil
sou le
ve dé
nir sirs
s

42 GUILLAUME APOLLINAIRE,
Calligrammes: 'Montparnasse'

N
ul
ue
Montmartroise qui vient
danser
au
bal
du
sa le dijen le ou et le di
di me man
che

43 GUILLAUME APOLLINAIRE,
Calligrammes: 'L'Horloge de Demain'

E
Trange maison sans portes
Qui et
Flau venir
me l'a
dais,
le dé
gret
tère
avec
poètes
Apolli et
nai peintre
re s
·ooo
·100.
ET SANS FENÊTRES
qui se trouve à Montparnasse et où vivent

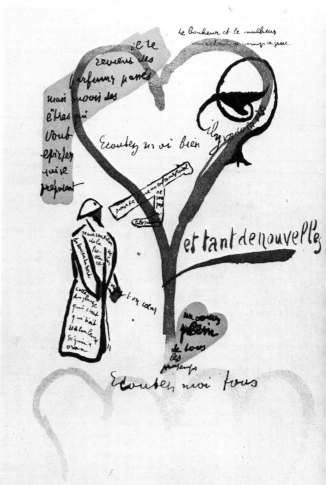

while the surrealists will transform the very notion of the real in making it enter into 'all it can contain of the irrational unto a new order', as well as the truths of the imaginary.[4]

On the other hand, Wallace Fowlie takes the view that Apollinaire

> . . . prolongs the lesson of Rimbaud and Mallarmé, in considering poetic activity as a secret means of knowledge, self-knowledge and world knowledge. . . . A legitimate part of poetry must therefore come from hidden occult forces in us. To seize them, to cause them to rise up, we may have to set traps: play the fool, enact farces, experiment with chance and free association. The image may be seen in its full autonomy when we risk everything in poetic composition on the unpredictable, the unforeseen. Magic exists everywhere around us, and not solely in the artfully contrived. . . . Poetry is perhaps the opposite of literature. The poetic is perhaps the opposite of the formalized.[5]

These opinions illustrate clearly why Apollinaire chose to champion Picasso above all others: for him Picasso embodied, in his lucid handling of ambiguities, both sides of the coin, that is, what Bonnet sees as an aesthetic formulation 'more total than real', and what Fowlie sees as 'a secret means of knowledge' founded upon magic and embracing an 'experiment with chance and free association', based upon what is 'unexpectedly found in the trivial and the commonplace'. Surely Cubism embodied the same duality. It was highly formalized, yet it reached out towards the commonplace, the *coup de thé*; it sought to derange the normal process of vision and it pushed towards a new, psychologically based reality.

Breunig argues that Apollinaire was more proto-Surrealist than Cubist; Bonnet that he was more romantic than Surrealist; Fowlie that he was more full-fledged Surrealist than romantic. But if it was romanticism that drew Apollinaire to Picasso's pre-Cubist paintings (especially those of the Blue Period and the harlequins of 1905), it was his intellectual predilections (perhaps even in the role of proto-Surrealist) that kindled his admiration for *Les Demoiselles*, possibly as much for its vivid faults as for its virtues. He praised the Cubists for their integrity as painters, but demanded something more:

> It is through surprise, through the important place that it gives to surprise, that *l'esprit nouveau* distinguishes itself from all the artistic and literary movements which preceded it. It is not, and would not know how to be, an aestheticism, it is the enemy of formulas and of snobbism. It does not seek to be a school, but one of the great currents of literature encompassing all

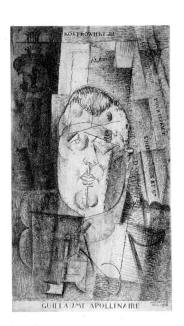

44 LOUIS MARCOUSSIS, *Portrait of Guillaume Apollinaire*, 1912–20

Museum of Modern Art, New York

schools since Symbolism and Naturalism. It struggles for the re-establishment of the spirit of initiative, for the clear comprehension of its time, and to open new sights on the interior and exterior universe which are not inferior to those that the scientists of all categories discover each day, and from which they draw marvels.[6]

It was perhaps in this cerebral projection of possibilities that the Surrealist was engendered. And this cost the Cubists a protector, for in his successive manifestos his praise became qualified; he continued to admire their audacious accomplishments, but found all but Picasso less revolutionary than he had hoped. When Juan Gris appeared upon the scene Apollinaire declared that he was 'too much a painter to renounce painting'. He saw Gris's work as 'the too rigorous and too poor expression of the scientific Cubism born of Picasso'.[7] The judgment was erroneous, but it reflected Apollinaire's disillusionment with painting in favour of other exploratory means.

The Orphic tendency, as Apollinaire conceived it, was exemplified principally by the work of Robert Delaunay, Fernand Léger, Marcel Duchamp and Francis Picabia – which he saw as typifying the dynamics or magic of *l'esprit nouveau*. Apollinaire and the Cubist ideal were substantially divorced, though Delaunay exhibited with the Cubists and adapted some of their

69

methods. 'Simultaneity', a term often used by Apollinaire, originally referred to the Analytical Cubist method of viewing an object from several angles at once. Delaunay's use of this technique, like Apollinaire's use of the term, emphasized a conceptual as well as visually analytical multiplication of perspectives. According to Gertrude Stein, Delaunay was 'the founder of the first of the many vulgarizations of the Cubist idea, the painting of houses out of plumb, what was called the catastrophic school'.[8] But she was referring specifically to painting, whereas Apollinaire was concerned with other values. What remains significant at this point was Cubism's evolving character with regard to Apollinaire's own concept of the New Spirit, or the New Mind. For those two sets of values were in fact to converge in the Synthetic period and later blend with the Surrealist idea.

Not since the Renaissance had a complete spiritual idealism been expressed through a contemporary vocabulary, the city of man expressing an architecture of spiritual revelation, as found in Giotto or Sassetta. Vermeer had touched upon it in the seventeenth century, and Chardin in the eighteenth. But, suddenly, in the development of Cubism, the unyielding wall between the interior force and the external mask was again dissolved, and through a plastic resolution of sensual presences the inner and the outer were united.

In literature, the narrative in time had long been used to adumbrate the myth beyond time, the meanings of words transfigured by the formal properties of language itself, but painting had long been subjected to a duality of appearance and substance. Picasso and Braque evolved the means of unifying that duality, and from 1910 on, they worked at articulating and deepening its expressiveness. Apollinaire, as a romantic, was inevitably bound to the poetry of appearances, however subtly, and deeply committed to a romance with time, but the Cubist sphere was inherently timeless.

To have denied the supremacy of external forms and to have upset the sovereignty of time, and yet to have adhered to reality as opposed to fantasy, was to have presented a new conception of the real, not an unreality, but rather a surreality. And though Cubism did not inspire Apollinaire's term surréel, it in fact embodied the surreal dimension, at least through the First World War. Subsequently, André Breton, Paul Eluard, Philippe Soupault and the other Surrealists adopted the word for their forays into the subconscious, the dream revelation, the astonishing juxtapositions and hallucinatory paths to truth. The most successful experiments of the movement, it can be argued, were secured in linguistic terms. The surreality and the magic of Cubism, on the other hand, are unequivocally founded in the realm of the visual.

70

The Circle Widens: Room 41

Picasso's and Braque's evolution was beginning to have visible effects in Paris. Robert Delaunay's 'Orphic' explorations, Fernand Léger's contribution, quickly saddled with the name of 'Tubism' (because of its tube-like shapes) and the proposed revolution of the Italian Futurists, were the principal developments. There were also those painters, especially Albert Gleizes, Jean Metzinger, Henri Le Fauconnier and Louis Marcoussis, who adopted Cubist theories as a practical guide. It was at this time too that Juan Gris began what was to become one of the most important Cubist manifestations.

For Picasso and Braque 1910–11 was a doubly significant period – the time of an unqualified consummation of the analytical phase, and of the break-through towards Synthetic Cubism. One can approximate in words the uses of structure, reality and abstraction in the earlier work, but in the case of these purest of formulations, language loses its power. Musical or sculptural analogies are perhaps more expressive, for here, as in music, the functions of intellect and the senses cannot be separated. The orchestrated tones assert themselves in terms that defy translation; music speaks to the psyche through a language immediately and fully apprehended or not grasped at all; the aesthetic statement can be called neither descriptive nor abstract. As, say, in a Bach violin partita, an intense spirituality arises from a strict structural scheme that is at the same time lyrical. The analogy becomes especially apt when applied to the fugue-like repetition of formal values.

The analogy with sculpture seems paradoxical, since paintings are flat, with volumes redistributed as planes, whereas sculpture is three-dimensional. Yet this is precisely the key; for whereas painting, which utilizes perspective and volume, differs from sculpture, which is inherently three-dimensional, Analytical Cubist painting maximizes its own physical dimension. Its poetry conforms completely to the two-dimensional plane. In that sense it is directly analogous to sculpture in its concern for the physical reality of space and mass; the visible has been so harmoniously accommodated or digested that an awareness of the invisible is animated. In that Cubism substituted an inner, self-contained identity for imitation or reflection, it maximized the sense of primitive or archaic sculpture and became its equivalent. The 1911 works do

71

not allude; they are. Motion has been so contained that it becomes indistinguish-able from stillness. Again, analogies with the structure of the atom and with relativity become appropriate. There is no real stasis, only an illusion born of the tension between energies. Braque was later to say: 'Repose will never be ours. The present is everlasting.'[1] But in 1911, he and Picasso managed a convincing harmony of the everlasting and the fugitive present.

Picasso and Braque showed extraordinary restraint in not hurrying to exhibit the results of their concentrated investigations, so that when 'Cubism' burst upon Paris in the Salon des Indépendants of 1911 – the famous Room 41 – the work of the heart and soul of the movement was not included; Léger, Delaunay, Gleizes, Metzinger and Le Fauconnier were the exhibitors.

Ill. 45
Ill. 47
Léger was represented by *Nudes in the Forest*, on which he had laboured for two years (1909–10), Delaunay by four canvases, including *The Eiffel Tower* (1911). To the public and almost all the critics, the show was offensive and generally undifferentiated. Even if Picasso and Braque had been represented, it is unlikely that public comprehension would have been greater.

Rousseau's influence was apparent in Léger's *Nudes in the Forest*, even if Léger disclaimed it as a consciously absorbed one. As Apollinaire pointed out, Léger's conceptions tended to be simplifications; but behind his formal concerns there was also, as in Rousseau, a world of dream and symbol, a suggestion of the unseen, a reference to the mythic.

Yet the explicit reference was to Cézanne, and volumes were the key to Léger's explorations. To this end he tried to eliminate colour, though in fact the muted palette produces a strong psychological response and creates a dense atmosphere in which the volumes at once associate and dissociate, blend and collide, in a union of stable and fugitive elements. The *Nudes* can be compared

Ill. 46
to Uccello's *Battle of San Romano* in the Louvre. There, too, the frieze-like flatness is opposed by a perspective in large part invented. There too, a stillness produced by means of strict formalism submits to the dynamic elements of energetic action.

Léger's motion evoked through action differs completely, therefore, from the motion fused in stillness of Picasso and Braque. And the distinction results from the different applications of Cézanne's principles. For Picasso and Braque, Cézanne offered the key to a new vision of physical reality; for Léger, it was the key to a reconstitution of the idea of form itself, which led more directly towards the abstract. Léger was therefore able to move rapidly from the concepts of Impressionism to those of anti-Impressionism and skirt tangentially or altogether transcend local facts in a way quite different from that of Picasso and Braque. Although all of Léger's aims and procedures were diametrically

72

45 FERNAND LÉGER, *Nudes in the Forest*, 1909–10

46 UCCELLO, *The Battle of San Romano*, mid-fifteenth century

opposed to those of romanticism, the results produced an odd link between the two, for in a vastly more abstract way, he created a world of imaginative reverie.

Léger's early work drew so freely from Cubism that much of it can be called authentically Cubist, yet his perspectives and means remained largely alien to the thinking of Picasso, Braque or Gris.

Ill. 47 In complete contrast, Delaunay's *Eiffel Tower* fitted into the Cubist group by something like a stylistic coincidence. Delaunay was fascinated by the ways in which light alters and substantially 'destroys' matter; a preoccupation which led to the term Gertrude Stein repeated, the 'catastrophic school'. Delaunay did not reject the description. He even went so far as to offer the substitute 'destructive', which somewhat indicates how his Eiffel Tower paintings were brought to their particular level of distortion and reconstitution. The tower is in effect besieged and structurally modified by a dominant force – the impact of light. In that sense the link to Impressionist attitudes was considerable and the basic fidelity to external attributes fundamental. When Delaunay substituted a scale of colour intensities for volumes, his work became increasingly abstract, but at no time was it truly Cubist. Even in the comparatively austere Delaunay works of the period the descriptive factor, which brings them a step closer to Impressionist aims, remains prominent.

A painter who was to provide a far more integral link with Cubist thought, although his work was not exhibited in the 1911 show and he continued to Ill. 49 work apart from the movement, was Marcel Duchamp. His *Portrait of Chess Players* (1911) and *Sad Young Man in a Train* (1911) were among the most important works of that year and among the most original and articulate in the development of the new consciousness.

These early Duchamp works were largely metaphysical in their formation. They meshed image and substance, light and mass, foreground and background, space and time, in an ingenious continuum that embraced the conceptual and the physical. In *Sad Young Man in a Train*, predecessor of the famous Ill. 48 *Nude Descending a Staircase* (1912), the figure is actually the compound of successive states of movement. The object in space is modified, anatomized, reconstructed, by the time factor. This postulation of motion and stillness was vastly different from the solution of Picasso and Braque, but no less realized and certainly no less advanced. In Duchamp's case, the concept is so specific and audacious that it risked coming to grief in the face of the plastic challenge of painting, but his resolutions of luminosity and structure were singularly successful.

These early Duchamp works have a monumentality and interior intelligence in common with the work of Picasso and Braque, despite the difference in

74

48 MARCEL DUCHAMP, *Nude Descending a Staircase, No. 2*, 1912

49 MARCEL DUCHAMP, *Portrait of Chess Players*, 1911

means. To deal with space in time, Duchamp composed a chronology of forms
that shuffle across the canvas, but the successive states do not remain distinct;
the fused presence balances the sequential action. Some analogy can be drawn
with early Italian paintings in which successive portions of the Passion of
Christ are joined along a single expanse and fused through a dominance of
golden light, each portion contributing to a formal whole.

Gleizes and Metzinger, who worked wholeheartedly towards a classic *Ill. 50*
Cubist stillness, nevertheless failed. According to Gleizes, the Cubist painter
requires 'that all the parts of his work shall tally with each other logically and
justify each other down to the smallest detail; that the composition shall be an
organic whole as strictly ordered as possible, with all "accidental" elements of
perception ruled out or, in any case, kept under control . . .'.[2] The result

77

unfortunately was antithetical to the stated intention. These diligent theorists of the movement systematically assembled all the fragments of the kaleido-scopic Cubist perception, but were unable to actualize its potential.

In 1912 they collaborated on a treatise, *On Cubism*, long accepted as a hand-book of the movement, but as painters, faithful to the movement's principles, they produced an inadequate and largely artificial image.

In 1912 a group of Italian painters, advocates of the diffuse idea they had labelled Futurism, came into close contact with Cubism and were profoundly influenced by it. In terms of parallel development as well as cause and effect, the Futurist experience makes an illuminating case study.

Cubism was founded upon a bedrock of tradition; Futurism emerged amidst a frenzy of nihilism. At first, as in the 'Initial Manifesto of Futurism' published in the Paris newspaper *Le Figaro* on 20 February 1909, it had nothing to do with painting. It was an outcry against the past, its aesthetic ideals, the dead conventions and moral inertia of a dormant Italy. 'We declare', wrote F. T. Marinetti, father of the movement, 'that the world's splendour has been enriched by a new beauty: the beauty of speed. A racing motor-car, its frame adorned with great pipes, like snakes with explosive breath . . . a roaring motor-car, which looks as though it ran on shrapnel, is more beautiful than the Victory of Samothrace.'[3]

The emphasis was on violence: 'We wish to glorify War – the only health-giver of the world – militarism, patriotism, the destructive arm of the Anarchist, the beautiful ideas that kill, the contempt for woman.'

The Futurist Manifesto was equally vehement and explicit about the past: 'We wish to destroy the museums, the libraries, to fight against moralism, feminism and all opportunistic and utilitarian meanness.'

Still, the seeds of a certain poetry were contained in the exaggerated rhetoric:

We shall sing of the great crowds in the excitement of labour, pleasure and rebellion; of the multicoloured and polyphonic surf of revolutions in modern capital cities; of the nocturnal vibration of arsenals and workshops beneath their violent electric moons; of the greedy railway stations swallowing smoking snakes; of factories suspended from the clouds by their strings of smoke; of bridges leaping like gymnasts over the diabolical cutlery of sun-bathed rivers; of adventurous liners scenting the horizon; of broad-chested locomotives prancing on the rails like huge steel horses bridled with long tubes; and of the gliding flight of aeroplanes, the sound of whose screws is like the flapping of flags and the applause of an enthusiastic crowd.

Shock was the key to nascent Futurism. Revolutionary poetry readings and provocative performances of non-theatre works were declaimed from the

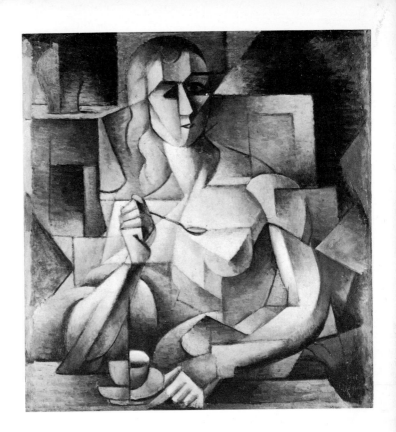

50 JEAN
METZINGER,
Tea Time, 1911

Italian stage. Taste was held to be deplorable, conventions intolerable. But a schism between theory and practice soon became inevitable, and when the painters joined the movement they often found themselves departing from strict Futurist dogma.

In 1910, the paper called *Futurist Painting: Technical Manifesto* was published above the signatures of the five men who embodied the movement, Umberto Boccioni, Carlo Carrà, Luigi Russolo, Giacomo Balla and Gino Severini. Central to the declaration was the thesis: 'That All Forms of Imitation Must Be Despised, All Forms of Originality Glorified.' But it contained a wide range of ideas that demanded explanation in principle as well as in practice. 'To paint the human figure you must not paint it; you must render the whole of its surrounding atmosphere', a statement recalling what Braque was in the process of evolving, especially at La Roche-Guyon. The manifesto continues: 'Space no longer exists: the street pavement, soaked by rain beneath the glare of electric lamps, becomes immensely deep and gapes to the very centre of the

79

51 UMBERTO
BOCCIONI, *Male
Figure in Motion*, 1913

earth. Thousands of miles divide us from the sun; yet the house in front of us
fits into the solar disk.' In other words, space is to be treated in an almost meta-
physical manner rather than in terms of visual perception.

Nevertheless, visual perception is more relevant to the idea that 'A profile is
never motionless before our eyes, but constantly appears and disappears. On
account of the persistence of an image upon the retina, moving objects con-
stantly multiply themselves; their forms change like rapid vibrations, in their
mad career. Thus a running horse has not four legs, but twenty, and their
movements are triangular.' This was a principle which Boccioni and Carrà
were to illustrate concretely.

At another point, the manifesto reverts to entirely conceptualized perspec-
tives: 'We would at any price re-enter into life. Victorious science has nowadays
disowned the past in order the better to serve the material needs of our time; we
would that art, disowning its past, were able to serve at last the intellectual needs

that are within us.' In 1914, a conclusive addendum was issued: 'You think us mad. We are, instead, the primitives of a new, completely transformed, sensibility.'

In practice, each painter had to determine his own appropriate Futurist language. Until 1911, at least, Impressionism carried considerable weight with the Futurists on the grounds that it took cognizance of the transience of objects in response to light. But the Futurists took issue with the Impressionists' total homage to light, an approach that fell short in its contribution to *dynamism*, a crucial term in the Futurist credo. The ideal of *pure painting* lay beyond that adherence; it was defined as being in opposition to objectively perceived reality. Classical perspective was of course false, and representation was to be shunned. Carrà lauded Matisse, Derain and Picasso specifically as the successors to Manet, Renoir and Cézanne, an unorthodox, but in a broad sense, justifiable choice of bedfellows. 'These artists', Carrà wrote, 'effected a reconstruction of pictorial syntheses in total repudiation of all that may be deemed episodic. Breaking through the boundaries of Renaissance perspective they gained access to hitherto unknown expanses of pictorial space which they filled with bodies vitalized by plastic light'.[4]

However, the Futurists insisted upon the significance of subject matter which, as they denied representation, they were forced to define as pictorial matter. Ardengo Soffici, painter and theorist, who laboured at the resolution of these concepts, concluded that 'plastic equivalents' were to embody the sensational or conceptual acceptance of reality. Yet what remained was to put the idea into practice. To this end, until 1911, Impressionism and another Italian movement, Divisionism,* in which colour was made to refract expressively, were accepted as the guiding lights.

The swirls of Art Nouveau, product of a conceptual anti-reality, also came within the pale. Motion, concatenation of various forces, violence, established the tempo.

Of the original Futurists, only Gino Severini had worked in Paris prior to 1911. As a result, he was most in touch with the Cubists, and persuaded his colleagues to come to Paris and see what the French painters were accomplishing. The contact proved fruitful. Boccioni's words denounced Cubism, but his work visibly paid it homage, and Carlo Carrà virtually became a Cubist

*Italian Divisionism was based upon the scientific division of colour developed by the French Post-Impressionist painters, Georges Seurat, Paul Signac and Henri-Edmond Cross. However, the Italian Divisionists, such as Giovanni Segantini and Gaetano Previati, used a systematic separation of colours largely for emotional or subjective effect.

himself. Fixity, not dynamism, Boccioni insisted, characterized Picasso's work,

> His cross-sections, the fanciful variations aroused by a violin, a guitar, a glass, create a sense of marvel analogous to the impression made by a scientific enumeration of the component parts of an object hitherto considered indivisible. His process is not unlike that of the Impressionists who killed light by breaking it up into its spectral components.[5]

In so saying, Boccioni was biting both the hands that fed him. For the Cubist intelligence was already enriching the spirit born of negation in Turin.

In February 1912, at the time of the large Futurist exhibition held at Galerie Bernheim-Jeune, the Futurist-Cubist confrontation reached a climax, and occasioned yet another manifesto, called *The Exhibitors to the Public*. It asserted in a tone characteristically shrill, that the five painters of the *Technical Manifesto* had moved to 'the head of the European movement in painting, by a road different from, yet, in a way parallel with that followed by the Post-Impressionists, Synthesists, and Cubists.'

The Futurists' attitude towards the Cubists was a blend of homage and rejection. 'A laudable contempt for artistic commercialism and a powerful hatred of academicism' were conceded, despite the insistence on their 'absolute' opposition to their art, on the grounds that 'They [the Cubists] obstinately continue to paint objects motionless, frozen, and all the static aspects of nature; they worship the traditionalism of Poussin, of Ingres, of Corot, ageing and petrifying their art with an obstinate attachment to the past, which to our eyes remains totally incomprehensible.'

The terms *simultaneity, physical transcendentalism, renovated sensitivity* were key words for the Futurist ideals, expressed in such tortuous manifesto prose. The Futurists emphasized that, 'In order to make the spectator live in the centre of the picture . . . the picture must be the synthesis of *what one remembers and what one sees*.' Or, again: 'We do not draw sounds but their vibrating intervals.'

The judgments were as unfair to the Cubists as they were inflated in reference to Futurism, but the exhibition had its effect. Gertrude Stein recalled that their show

> made a great deal of noise. Everybody was excited and this show being given in a very well-known gallery everybody went. Jacques-Emile Blanche was terribly upset by it. We found him wandering tremblingly in the garden of the Tuileries and he said, it looks all right, but is it. No it isn't, said Gertrude Stein. You do me good, said Jacques-Emile Blanche.

But apparently there were affinities which, in practice, superseded the mani-
festos, for Gertrude Stein added: 'The Futurists all of them led by Severini
thronged around Picasso. He brought them all to the house. Marinetti came by
himself later as I remember. In any case everybody found the Futurists very
dull.'[6]

Apollinaire, on the other hand, found them very dangerous. Their love of
innovation, of modernity, might have drawn him in their direction – yet he
reviewed the exhibition at length, and disapprovingly, for the newspaper
l'Intransigeant, concluding that the pictorial matter had quite engulfed the pure
painting:

> They want to paint forms in movement, which is perfectly legitimate, and
> they share with most of the 'pompier' painters the mania for painting states
> of soul. While our avant-garde painters no longer paint any subject in their
> pictures, the greatest interest of the pompier canvases is in the subject. Let the
> futurists beware of syntheses which do not at all translate plastically and
> which lead the painter only to the cold allegory of the 'pompiers'.[7]

Apollinaire had pin-pointed the problem. The Futurist manifestos were them-
selves works of ideas in movement, refracting, jostling, accommodating a
plethora of constructive and destructive propositions. Their didactic language
resembled the very academicism they so despised. And some of their painting,
as Apollinaire observed, was not immune to it either.

Boccioni's painting fell into some of the worst academic pitfalls, for example,
whereas his drawing was among the most liberated of his time. Again, his
painting was relentlessly Futurist in its intentions; it produced a dispropor-
tionate aesthetic, especially in regard to colour, and epitomized what Apollinaire
termed the Futurists' 'pompier' mania for depicting states of soul. His drawing,
by contrast, tended to be unhistrionic, structural, articulated, and became
increasingly so following his encounter with Cubist work. The painting was
founded upon what Boccioni called 'physical transcendentalism',[8] conceived
in speed and fused in the kinetic interaction of object and milieu. Non-descriptive
by intention, it became in practice overwhelmingly descriptive of Futurist
dogma.

'The form/force is, with its centrifugal direction, the potentiality of real form,'
Boccioni wrote. In *Table + Bottle + Houses* (1912), or in his studies of the *Male* *Ills. 51, 52*
Figure in Motion (1913), or in the series called *Dynamism of a Cyclist* (1913), the
proposition is carried out fully. In Apollinaire's phrase, it translates plastically.
These drawings are architecturally complete and poetically cogent. They enter
into a dialogue of motion and fixity which relates them to the Cubist experience

52 UMBERTO BOCCIONI,
Muscular Dynamism, 1913
Museum of Modern Art, New York

more than Boccioni ever admitted, or perhaps ever realized. He stressed the difference in motive, but ignored the union in fact. The influence may have been oblique, or relatively unconscious, but the impact of Cubism plausibly accounts for the transition in Boccioni's drawing from the Impressionist and Divisionist past to his later, architectonic development. Indeed, he gave at least partial recognition to the hazards of painterly and theoretical values when he wrote, in 1912:

> I think I might be more advanced (though I may be wrong) if all the inner workings of my evolution had taken place in a more favourable climate such as that of Paris. I feel that many times I have lacked daring because of the spiritual isolation in which I lived. It was not only the solitude but the

continuous corrosion of the indestructible core, now evolving according to its destiny, which contain the full impact of my discoveries in nature.[9]

Apollinaire noted the evolution in his drawing and sculpture in *l'Intransigeant*, but perhaps Boccioni refused to acknowledge any debt to Cubism. He wrote to a friend, in 1913: 'He too [Apollinaire] is strangely taken aback by the intensity, the power, and the violence of my recent works, like a real bayonet attack.'[10]

As the original emissary to Paris, Gino Severini often managed a fine balance between the Futurist intention and the Cubist vision, as in his *Self-Portrait* (1912). His *Pan-Pan 'a Monico* (1909–11) which disappeared in *Ill. 54* Germany during the Second World War, edged closer to the Futurist ideal of movement. The existing copy was done by Severini during 1959–60. His career was to follow an eccentric course in which stylistic resolutions often brought the spirit of the work to grief, though he managed to avoid disaster

53 GINO
SEVERINI,
Composition Still-Life,
1913

85

54 GINO SEVERINI, *Pan-Pan à Monico* (copy), original of 1909–11 destroyed

Ill. 53 during the post-First World War epoch when he took to collage and, in fact,
to pure Synthetic Cubism. But the latter impulse had always been there; in
1913, he wrote that, 'An overpowering need for abstraction has driven me to
put on one side all realization of mass and form in the sense of pictorial relief. . . .
Each drawing is an objective study, an effort in the direction of synthesis and
the absolute.'[11]

It was Carlo Carrà who came closest to the actual Cubist image, though
theoretically he fought the impulse as diligently as he could. *Archaism* was the
word he used to describe his *bête noire*, and *dynamism* his ideal. But it was Carrà
who returned to the nude only two years after the *Technical Manifesto* had cried
out: 'We demand, for ten years, the total suppression of the nude in painting.'
Solidity of form tempted him, and an equilibrium more related to Cubism
than to Futurism transformed and strengthened his work. *Simultaneity* (*Woman
on a Balcony*) (1912–13) arrives at a point midway between Picasso and
Duchamp in its resolution of motion and repose, and the formal poise of
Ill. 55 *Drawing, 1913*, is almost pure Cubism.

86

One of the strongest and certainly the earliest manifestations of a pure Futurism came, curiously enough, from a source entirely remote from the movement. Frantisek Kupka, the Czech painter, had been fascinated by the theme of movement, and even by the example of motion pictures, in the first years of the *Ill. 56* century, when he drew his revolutionary *Riders*. Not later than 1910, he pro-
Ill. 57 duced a series of pastels, *Woman Gathering Flowers*, in which he incorporated successive states of movement in a single composition, unifying the chrono-logical action by a cohesive light – in this case, as opposed to Duchamp's solution, an impressionistic light. Minus a manifesto, Kupka managed to eliminate any disruptive stylistic obstacle; as a functioning colourist, he quite outpainted Boccioni.

It was also at this time that Marc Chagall made his appearance as a Russian painter of the School of Paris, influenced by Cubist suggestions. The case is especially interesting given the great temperamental gap that separates Chagall's Slavic spirit from those of the very French Braque or the very Spanish Picasso.
88

56 FRANTISEK
KUPKA, *Riders*, c.
1900

57 FRANTISEK
KUPKA, *Woman
Gathering Flowers*,
1907–08

It is also interesting because Chagall was not simply captivated by the Cubist methods; he did not appropriate its precepts. Instead, the movement provided him with a line of communication to his own very personal aspirations, a means of liberating the message dictated by his imagination.

It was Chagall's work in Paris that inspired Apollinaire to coin the phrase *surnaturel*, which he later amended to *surréel*. But what Chagall developed after his arrival in Paris from Vitebsk in 1910, was a Cubism tuned to symbolic intent. Chagall was a lyricist with the potentialities of a mystic. His world, which he never abandoned, was the Jewish ghetto of his village, and more particularly its poetry, not fully expressible in visual terms. His first paintings, done before he came to Paris, were folkloristic. But Cubism, in its emphasis on inner structure and its defiance of external coincidence, suggested a richer language. In 1911, Chagall painted *I and the Village* and *Half-Past Three*. The second is closer to Cubism in form and structure, but both are products of a Cubist intelligence. Chagall created, through a dissociation of formal relationships, a new mythic logic, to which he contributed another element – that of

Ill. 58

89

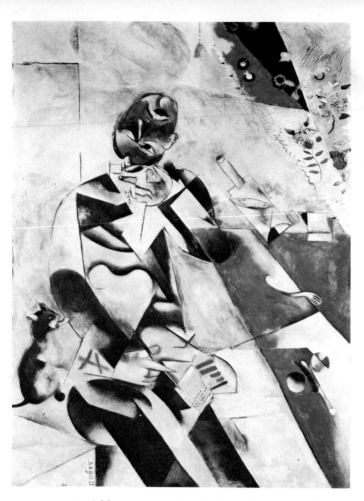

58 MARC
CHAGALL, *Half-
Past Three*, 1911

richly sonorous colour. The result was as vastly different from the paintings of
Picasso and Braque as it was from those of Delaunay. Delaunay's works were
related to perceived realities; Chagall's reconstructions of physical forms were
evocative. In intellectual authenticity, the link to Picasso and Braque is greater,
despite the divergence in plastic means.

If *Half-Past Three* can be called a symbolic brand of Cubism it can also be
described, perhaps more aptly, as an example of intuitive Cubism. It prompted
the extension of Cubist vision to other levels of the imagination, levels domi-
nated by intuition rather than by perception, and whose potentialities were
conceivably limitless. It was at this very time that Picasso and Braque began to
move toward the ideal of Synthetic Cubism.

New Perspectives, New Realities

The work of Picasso and Braque during 1911–12 evolved along two lines which, though they met in practice, must be clearly distinguished. One might be called the metaphorical line, which aimed at the penetration of an existing reality for the purpose of creating another and conceptual one; the other was that of constant striving towards a pure aesthetic. Picasso is generally associated with the first and Braque with the second, but this description tends to minimize Braque's full accomplishment. In fact, both men contributed to the dual character of the experience. Finally, in the following years, a third and equally dynamic voice – that of Juan Gris – contributed a new dimension.

The introduction of collage and *papier collé* transformed the vocabulary of Cubist painting, but it would be a mistake to consider this development a unique phenomenon, separate from the evolutionary process that links it to the preceding works.

Again, the subject-object equation is relevant. As early as 1910 Picasso had painted his *Monk with a Mandolin*, followed by the *Girl with a Mandolin* (*Fanny Tellier*), both of these works being conceptually and plastically rich. From the forties on, Picasso was to incorporate brusquely contrasting styles, even realistic and abstract ones, within a single drawing. And in a more subtle way, this method was used in the *Monk with a Mandolin*. The upper segment of the painting is a dense complex of sharp planes, in part linear and in part a fusion of staccato stippled areas. The lower left area, however, tends to be voluminously three-dimensional rather than flat, transparent rather than dense; in the lower right area, there is a linear superimposition upon almost imperceptibly modulated space. In short, three conceptual modes of form are introduced. The first is physical, the second approaches the metaphysical, the third is descriptive and, in combination with the others, becomes magical.

Girl with a Mandolin is a more tautly constructed composition, in which opposing diagonal forces play a decisive part. But here too the conception is diversified. The upper portion conveys a sense of flatness; the lower is more voluminous. Throughout, the inter-references, whether flattened, linear, or solid, create a counterpoint that continually implies a further level, as if, for instance, an actor, in the course of a play, were to turn and speak directly to the

audience, thus suddenly acknowledging the formal existence of the play in a provocative contradiction to the sense of illusion so carefully developed up to that point.

But in other canvases of the period (1910–11), Picasso remained within the framework of a single level of dialogue. In *The Inkstand* and *The Student*, he unites still-life and portrait in a geometrically precise metaphor of flat planes, as he had earlier equated landscape and figure in a language of aggressive volumes. Throughout 1911, Picasso's formal procedures varied, but always in orchestration rather than theme, and in structural variation rather than concept. *Soldier and Girl* carries its logic through a linear exposition, everywhere modu-lated by the light and the physical surface of the background. In *The Violinist*, the linear, geometrical grid remains strong but the combined density and trans-parency of light behind it are equally prominent and definitive. In *Ma Jolie*, the two are indistinguishable, a painterly light and a sharply faceted line blend on equal terms. In *Le Pont-Neuf*, the linear definition is submerged: light carries the motif. And yet, only the title indicates the subject; the painting would be comprehensible even as a nude. The ambiguity, whether intentional or not, suggests that the subject reference had become as unassertive as the North Star in the heavens – and as essential to the navigator.

Picasso's work in this period is remarkable for its conceptual breadth. For both men, it was one of such intense self-abnegation towards an ideal of purity that the two men's work is easily confounded. Perhaps Braque's *Soda* (or *Battleship*), with its dominating circular movements, suggests the elegant warmth, the fluidity, a certain richness, associated with his works. Both the *Seated Woman* or *The Portuguese* might easily be mistaken for Picasso's work, along with many other of his 1911 paintings, yet Braque's lyric intensity in this series as a whole ranks among the most striking in the history of art.

Again, these purest of distillations were being produced in a well-guarded privacy. Just as Picasso's and Braque's absence had qualified the *Room 41* show of 1911, it again distorted La Section d'Or exhibition of October 1912. Still, this was the show that brought 'Cubism' to public prominence for the first time. Thirty artists were represented, among them Léger, Gris, still in the early stages of his development, Gleizes and Metzinger. The brothers Marcel Duchamp, Jacques Villon and Raymond Duchamp-Villon also participated; Duchamp-Villon may have provided the exhibition's title, a reference to that mathematical harmonic ideal, the Golden Section. Other artists who exhibited, such as Dunoyer de Segonzac and Roger de la Fresnaye, were on the margins of the movement, and Marie Laurencin was not really part of it at all. But when the exhibition opened at the Galerie de la Boétie, Cubism became a recognized

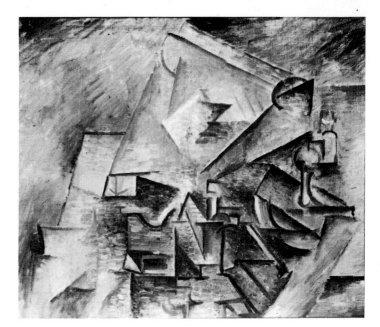

59 PABLO
PICASSO, *The
Inkstand*, 1910–11

60 PABLO
PICASSO,
Soldier and Girl,
1911

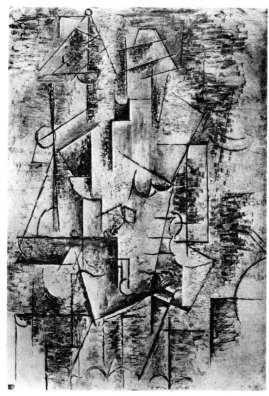

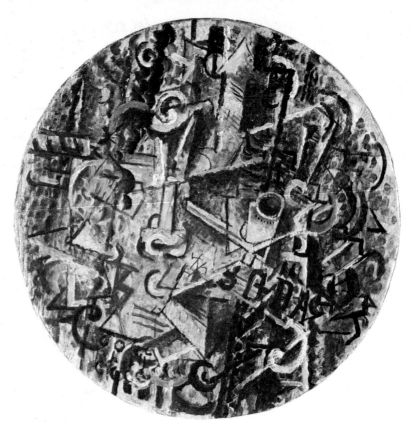

Museum of Modern Art, New York

61 GEORGES BRAQUE, *Soda*, 1911

movement and its sponsors made every effort to explain it publicly. Apollinaire and Gris were among those who gave lectures, and a magazine, of the same name as the exhibition, was founded. One general public impression was that this new art, undecipherable to most eyes, was based on mathematical or perhaps metaphysical principles. Indeed, in the absence of Picasso and Braque and with Gris not yet having come into his own, the essence of the 'movement' remained mysterious.

That year was one of change in several ways for Picasso. Gertrude Stein recalled visiting his new studio in the rue Ravignan: 'He was not in and Gertrude Stein as a joke left her visiting card. In a few days we went again and Picasso was at work on a picture on which was written ma jolie and at the lower corner painted in was Gertrude Stein's visiting card. As we went away,

94

62 GEORGES BRAQUE, *The Portuguese*, 1911 ▶

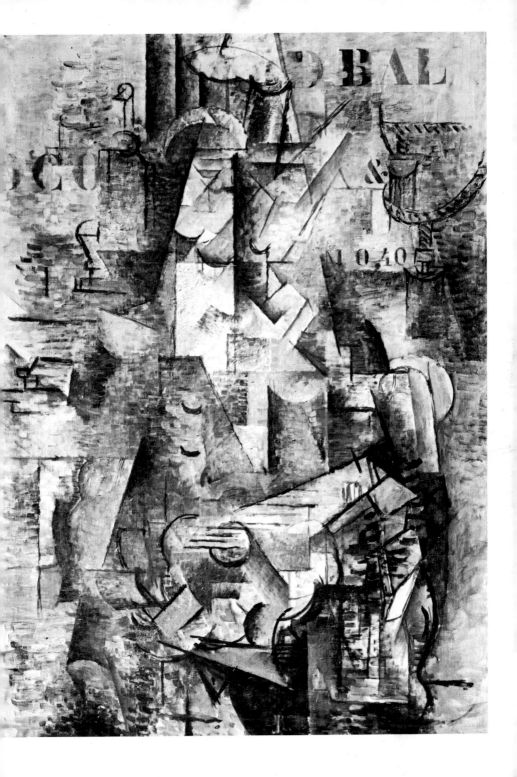

63 PABLO PICASSO, *Still-Life with Pipe Rack, Cup, Coffee-Pot and Carafe*,
1910–11

64 PABLO PICASSO, *Ma Jolie (Woman with Guitar)*, 1911–12 ▶

Gertrude Stein said, Fernande is certainly not ma jolie, I wonder who it is.
In a few days we knew. Pablo had gone off with Eve.'[1]

Eve was in fact Marcelle Humbert, and again the change in companions
paralleled the shift in style. Eve, or Eva, the inspiration of the phrase *Ma Jolie*,
taken from a popular song of the day, was not massive but slender. Picasso and
she made several trips from Paris to Ceret; when his discarded mistress,
Fernande, appeared there unexpectedly, Picasso packed up and moved to a
house in the village of Sorgues-sur-l'Ouvèze in the Midi, where Braque joined
him. The days at Sorgues led to new Cubist accomplishments.

As early as 1910, Braque had attempted a reference to letter abstraction in *The
Match Holder* when he snipped the characters GILB from the title of the news-
paper *Gil Blas*. In Paris, during the winter of 1910–11, Picasso had painted a
horizontal canvas called *Still-Life with Pipe-Rack, Cup, Coffee-Pot and Carafe*,
in which he superimposed the word OCEAN upon a highly geometrical ground,
and in which he inscribed the words LA AUX DUMAS against a line that separates
the geometrical complex from a broad passage of pure space, the words referring
to *La Dame Aux Camélias* by Alexandre Dumas *fils*. Finally, in 1911 he began
incorporating the words MA JOLIE, either as an organic element in the geo-
metrical scheme or, later, as in the title of a sheet of music, as a deliberate
reference to the theme. Braque followed the same course with the words BAL
and VALSE. These works heralded both the artists' recognition of the possi-
bilities of collage and *papier collé* and highlight the transition from Analytical
to Synthetic Cubism. For even in the most integrated of the pure analytical
canvases reality and formal abstraction, volume and plane, definition by line

Ill. 63

96

MA JOLIE

Museum of Modern Art, New York

and by light, density and transparency, thrust and balance, were juxtaposed. Cézanne too had employed these means, but since he kept to the external metaphor, his juggling of, say, luminosity and density, volume and plane, suggests an exploration of its interior values. But in the works of Analytical Cubism these matings of opposite values eliminate any world other than their own, and as they become increasingly self-sufficient and absolute, become their own object.

The incorporation of letters originally provided another formal configuration in counterpoint, its reference blunt, anti-pictorial. On another level, the reference is cryptic and discreetly dissonant, the reflection of another corridor of reality, another confrontation. The Impressionists, instead of mixing colour on the palette, juxtaposed tones on canvas and allowed the eye to 'mix' them in optical vibrations, and so create a new resonance. For the Cubists, this synthesis was not purely optical but psychological and conceptual as well. It was, in fact, the antithesis of Impressionism. Picasso and Braque repudiated illusions produced by technical artifice. Stencilled lettering – or even manu-factured objects – were utilized as elements of the same weight as drawn or painted configurations to conjure up the independent life of the finished product.

Ill. 66 During the spring of 1912, Picasso created an oval composition which he called *Still-Life with Chair Caning*: the first Cubist collage. Picasso had found a piece of linoleum designed in imitation of wicker caning, and made the fragment an integral element of the composition. Once again, he introduced his new device through a variety of means. The still-life references above the caning are sharply linear. The letters JOU, excised from *Jour* or *Journal*, glide above and below the geometrical complex, associated and dissociated at once, the o being misted with colour, the u brightly impaled by a ray of light which is itself the extension of a linear definition. And finally, the chair caning boldly counters all the painterly areas – both by its insistent rhythmic pattern, and as an unexpected incorporation of unreconstructed object. The caning becomes a table surface, but, again, not entirely. For Picasso proceeds to paint over it in lateral and cross strokes that reassert the sovereignty of form over object. The frame of the oval, a length of rope, is a crude material immediately made to function in another rhythmic counterpoint.

Ill. 65 Braque, happening upon a length of wallpaper, was seized with the same idea; he incorporated it into a composition, which became the first *papier collé*. Technically, *papier collé* can be considered collage, though the two methods can be distinguished in practice. The term 'collage' is a general term for the incor-poration of various object material in a painting (Picasso went on to use

98

postage stamps and buttons, Braque introduced nails) whereas *papier collé*
implies the manipulation of printed papers, newsprint clips – themselves
illusory, manufactured images or patterns.

Together, Picasso and Braque discussed the potentialities of collage and
papier collé. Braque's painter-decorator training enabled him to show Picasso
how an area of pigment, for instance, could be combed to produce the illusion
of wood grain. But they differed in their application of the new methods. Braque
aimed at an illusory depiction of the object itself – using the comb technique to
produce the surface of a violin, for example – whereas Picasso immediately
employed the same artifices to create an effect of shock, of ambiguity – a grained
surface to indicate a bottle or an expanse of newspaper, or a fragment of news-
paper to assume the shape of a violin. But Braque too, soon adopted this approach.

During 1912–13, Picasso's work fluctuated typically, while Braque's use of
papier collé grew steadily richer and more subtle. At Sorgues, and back in Paris,
they continued to discuss the subject with Juan Gris and other friends. Though
many of their talks were highly theoretical and technical, the actual work in the
studio was not systematic; instinct, the sure step of the tight-rope walker,

99

66 PABLO PICASSO, *Still-Life with Chair Caning*, 1912

played an indispensable part, and the object-subject equation, the two-pronged simultaneous reference to a reality and an aesthetic, was still negotiated according to sensibility, guided by individual motive and technical and conceptual mastery.

One may debate the extent to which Picasso or Braque were influenced in the case of any given collage, by the will to evoke an unexpected reality, or to work the new expressive formulations into a functioning and harmonic statement *Ill. 68* which in turn suggested new means. In a 1913 *papier collé* and charcoal, *Bach*, Braque utilized three separate strips of texture which neither refer to subject nor assume dimension as object, but serve as a visual *leitmotif* that colours the surface, just as the individual instruments in a string quartet lend variation in voice to the musical theme. Thematically, the Cubist guitar is succinctly delineated in fine charcoal lines. But two important modifications take place

100

through the fusion of the drawing and the bits of paper. The fragment at the left functions as background, and disappears behind the guitar. The centre swatch, wood-grained but transparent, becomes foreground, imposed upon the guitar. The third is neutral. Finally, one of the sound apertures of the violin is heavily drawn to participate in the weight of the paper fragments, and is even made to compete on an illusory basis. It rises up from the guitar's face, casting a fantastic shadow. The effect is faintly echoed on the oblique line that crosses the strings and interrupts their continuity – for it also serves to create an uplifted plane which, in further contradiction, is overcome by the other, smaller, sound aperture. Each of the major elements of the composition, therefore, modifies the others though, physically and conceptually, they meet as independent and aloof entities and scarcely intersect.

Ill. 67 In *Musical Forms* (1913) Braque's linear definitions are reduced to an absolute minimum, and flat or textured areas of colour take over, interlocked in close, sonorous articulation. In oil and cut paper, Braque contrived an image that can be seen either as an interplay of volumes and flats or of flats alone. Foreground and background are confounded through the varying intensities of colour values, but the lyrical consistency of the whole dominates the illusions compounding it.

In *Bottle, Glass and Pipe* or *The Clarinet*, both of the same year, specific references to subject and object again became important, though again in
Ill. 69 varying ways. In *Bottle, Glass and Pipe*, the central, vertical axis, with its two projecting, lateral wings, is given entirely by *papier collé*, in this case neither tangentially related nor interlocked but actually superimposed. The corner of woodwork may be intended to indicate an area of wall or hearth panelling, but refuses to act merely as background to the drawn still-life and thrusts into the foreground instead, though the drawn continuation of its lines again reverts to background. The central mass, including the newspaper, can also be taken as having no subject references at all, in which case it assumes a dissonant orches-tral relationship to the still-life in terms of pictorial association, but a harmonic one in terms of formal association. Another dialogue involves the pipe and newspaper, the pipe receding as a negative shape in conjunction with the dark newsprint – until Braque's modelled shading of the pipe rim and bowl gives it unexpected relief and the negative shape takes on a positive aspect. Braque then maximizes the newspaper as well by continuing the line of the almost spectral drawing of a newspaper page behind it until it intersects with the actual fragment, making it transparent and, in its own way, spectral.
Ill. 70 In *The Clarinet*, Braque employs a similar irony. The instrument itself is the least tangible element of the whole, in the sense of being the least firmly stated; a

102

68 GEORGES BRAQUE, *Bach*, 1913

69 GEORGES BRAQUE, *Bottle, Glass and Pipe*, 1913

transparent, almost negative shape. At the time, it insinuates itself into the lateral bar of grained wood, which is far more self-assertive, and suggestive of the very wood of the instrument. In turn, since it is visible beneath the fragment of newspaper that covers it, it becomes more substantial than the superimposed clipping. The words themselves, L'ECHO D', are appropriate and evocative.

Picasso's use of *papier collé* led, as might be expected, to more conceptual manipulations. He has often been called a more intellectual painter than Braque, but this is not entirely just, given Braque's penetrating application of the method to the problems of pure form and external appearance. To be sure, Picasso made the initial breakthrough in using the paper surfaces to represent objects or take on unrelated associations, and then went on to use *papier collé* to create or induce new realities, whereas Braque chose to explore, transmute and re-orchestrate the existent ones. Picasso's intellectual enterprise, therefore, led most directly to a wholly synthetic concept of Cubism.

But the evolving intelligence, though certainly precipitated by the collage idea, was not limited to it: the drawings of heads Picasso produced as early as the winter of 1912–13 prove an extraordinary progress in a metaphorical direction, variously reinforced during the months to come in *papiers collés* and paintings. More important, Picasso began to evolve a certain identification between still-life formulations and his treatment of the head. In the 1911 paintings, the two had been equated through an architectonic language that transcended both. Here the opposite procedure is used. The still-lifes and heads are each articulated in their own right, rather than as formulations towards pure light or pure structure, but their metaphorical potential is explored to the point at which their anatomies become almost interchangeable.

Ill. 71 For example, in *Head of a Man*, the cranium functions as a perimeter just as in the still-lifes it indicates the plane of a table. Though the head is essentially flat, the mouth becomes a projecting tube, resting on the flat surface like an object upon the table. So too does an elongated trapezoidal shape that indicates convincingly, if ambiguously, the line of nose and forehead. The neck, expressed in two perfectly flat planes, supports the head/table like a slender but powerful stem.

Ill. 72 In another *Head of a Man* of the same series, the double implication is held to a minimum, but the treatment of the head is still more audacious. As early as 1910, in *Mademoiselle Léonie*, Picasso had postulated a daring alignment of the nose and forehead structure as a single, bold mass, but here the liberty – or discipline – becomes complete. The perimeter of the head is no longer a framework but a landmark relegated to the background and also something of a catapult from which the features, particularly nose and cheek, bolt forward

104

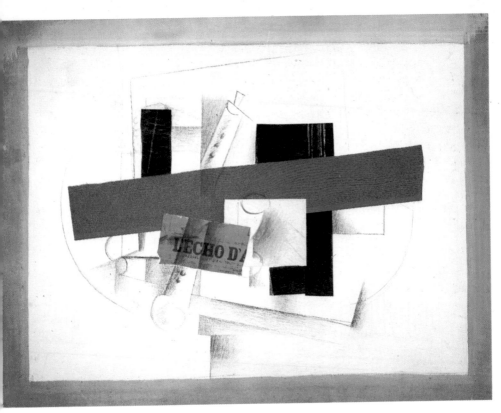

70 GEORGES BRAQUE, *The Clarinet*, 1913

and assume their own definitive anatomy. Curiously, the mouth is the Negroid mouth of earlier works and even the elongated nose structure can be associated with African masks. The eyes, elliptical indications merely, are united along a diagonal axis. They respond antiphonally to each other, and together to the other elements, just as collage references do in harmonic juxtaposition.

Finally, in two other 1912–13 drawings, both called *Head*, the human reference is almost entirely subordinated, and in one of them all still-life association is suppressed as well. But both drawings have a life, a power, that would have been impossible in terms of purely non-objective abstraction. The terms in which the head is reconstructed are as fundamental and as functioning as the skull itself, and in fact, bone and skull were soon to become central to post-Cubist works of Picasso and Braque. But at this point, reconstruction,

re-creation, invention, the synthesizing of new realities, become fundamental to the Cubist experience.

In the *papiers collés*, Picasso's methods varied greatly, and some show a direct analogy to his treatment of head and still-life in the drawings. One can only speculate upon the extent to which the new freedom offered by the *papiers collés* prompted the new structural formulations in drawing, but it seems certain that in the course of the winter of 1912–13 there was a definite interaction.

Ill. 73 In *Sheet of Music and Guitar* (1912–13), the guitar is created entirely through a superimposition of *papiers collés* and immediately assumes the alternate character of a human head, the arm of the instrument being the nose, the sound apertures being the eye, the two curved sides of the guitar becoming hair, at one end, and,

Ill. 74 at the other, jaw and chin. In *Head*, the ambiguities work in reverse. The head is reduced to a series of formal transpositions until it takes on the ap-pearance of a metronome set upon a table. Astonishingly, the totally de-humanized shape appropriates an element of movement, of stance, or bearing, that restores it to its originally human character.

Finally, Picasso has actually gone so far here as to take the instrument apart and set its components side by side. The rectangular shape in the background might just as convincingly indicate a table surface upon which the guitar rests, or the bowl of the instrument itself. The sound aperture, indicated by a smaller,

73 PABLO PICASSO,
Sheet of Music and Guitar,
1912–13

74 PABLO PICASSO,
Head, 1913

◀ 71, 72 PABLO PICASSO,
Head of a Man, 1912–13

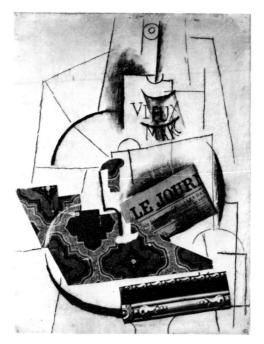

divided rectangle, might also be a lidded eye, in which case the entirety assumes
the character of a head. In any case the elements are completely subjected to the
painter's will.

 The fragment of page in *Sheet of Music and Guitar* indicates just that – a musical
score; in some other *papiers collés*, such as *Head of a Man with Hat*, the pasted
fragments are purely harmonic notations, and correspond to no ulterior or
self-assertive reality at all. Even in the *Bottle of Vieux Marc* (1912), where the
transpositions are clear – wallpaper fragment for tablecloth and moulding
fragment for table edge – their shock value is very muted in favour of the speci-
fically plastic function of the decorative impositions. In two other versions of
Sheet of Music and Guitar (1912), the scores represent only themselves. Here the
subject allusion of each fragment of colour and paper is explicit, and yet,
through a consistent flatness and restraint, Picasso has arranged a pure harmonic
chord, an entirely formal statement rather than a *trompe-l'esprit*.

 In painting, the new impulses sometimes either played a considerable role or
were deliberately disciplined. During 1913, Braque induced a perfect fusion of
the analytical architecture and the new *trompe-l'esprit*, in *La Musicienne*, a

Ill. 75

Ill. 76

108

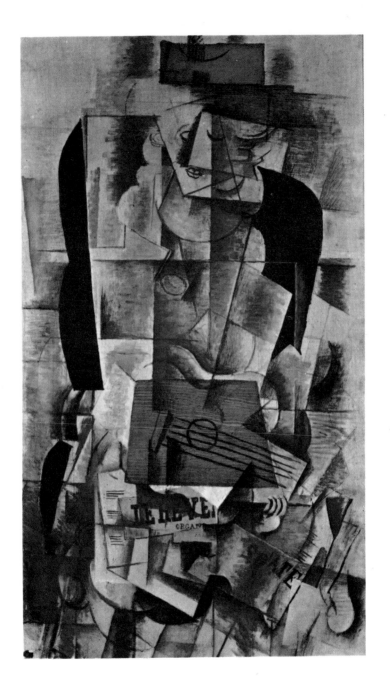

masterly admixture of oil and *papier collé*. In a series painted in 1912–13, Picasso alternated between the analytical and the synthetic approach; the words *Ma Jolie* leap from their discreet position at the bottom of the canvas to the centre, there to explode amid a variety of other lettered and numbered references. *Violin, Glass, Pipe and Inkstand* is an example. Abridgements of *Soirées de Paris*, of *Bal*, of *Ma Jolie*, and the word *fleur* are fairly specific references. There is an element of play in the abridgement of *livre* (book) to *ivre* (drunk). The evocations B O, 75, W, and S are entirely cryptic or at least purely formal. The shapes and planes themselves are out of the pure analytical phase and yet begin to adumbrate the new conception. The violin is revealed through analytical planes but the two sound apertures are imposed upon it, just as the spectral pipe and the sharply defined glass are each articulated with a separate vocabulary.

It may in part have been the suggestion of stencilled letters and numbers, as well as a reaction against the vertical and horizontal Cubist 'grid' which urged Picasso towards a more decorative phase which became known as *Baroque Cubism* (sometimes referred to as *Rococo Cubism*) typical of late 1913 and the following year. In the oval composition called *Our Future is in the Air* (1912), a title that must have pleased Apollinaire immensely, curvilinear but non-geometric forces establish a continuous movement in opposition to other, more familiar forms. The tendrils, perhaps of moulding, in the background at left, the complementary arabesques of the two shells, and even the lettering at right, set the tone. But Picasso, as always, did not move in a straight line; in the midst of advances that might have been all-absorbing, he was able to turn out as classic and as totally analytical a work as the oval *La Pointe de la Cité*, in which the subject is the same as that of *Le Pont-Neuf*, the point at which the tip of the Ile de la Cité begins to bifurcate the Seine.

Ill. 79

Ill. 77

In *The Poet*, too, Picasso expressed his image through a typical refraction of plane surfaces, added a further dimension through the use of the new techniques by 'combing' in the poet's flowing hair and elegant moustache and stippling in a goatee, and with a few curvilinear strokes, above and below, but not integral to the head, completed the effect of poise or gesture.

Picasso and Braque also experimented with modulations in texture produced by mixing sand with pigment, a technique Braque was to return to frequently in years to come. In *Glass and Bottle of Bass* (1913) and *The Guitar* (1913) Picasso makes an integral dimension of sheer surface handling. In the first, the three objects function almost as negative, transparent entities, and the mouth of the glass and sheet beneath the bottle, both done in clipped newspaper, arbitrate the two dimensions. Physically, the background is assertive; the objects in the foreground are simply delineated by its momentary abeyance. In contrast, *The*

110

77 PABLO PICASSO,
The Poet, 1912

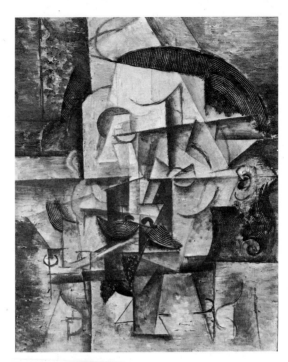

78 PABLO PICASSO, *La
Bataille s'est Engagée (Guitar
and Wineglass)*, 1913

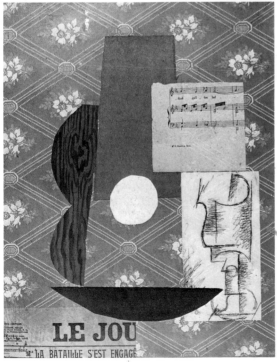

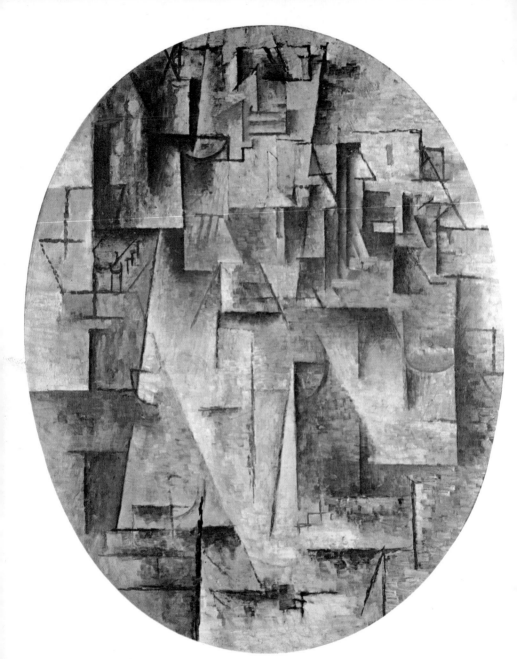

79 PABLO PICASSO, *La Pointe de la Cité*, 1912

80 PABLO PICASSO, *Ma Jolie*, 1914

Guitar speaks from rather than to its object references and, again, a harmonic
statement rather than an inquiry into reality and appearance is the intention.
At the same time, harmony is also expressed in other than usual terms, the
Cubist areas indicated through line and shape, but the important dialogue
taking place through juxtaposed light and colour intensities.

 La Bataille s'est Engagée, was the way Picasso put it in using a newspaper *Ill. 78*
fragment in one particularly resonant *papier collé*. The entire background is one

façade of wallpaper. The Cézannesque glass drawn upon another sheet of paper, a fragment of sheet music, and four shapes, synthesizing a guitar that slips above the headline and the base of the glass but below the music and the mouth of the glass, all exist in 'orbit', held by opposing energies like those brought to bear in the midst of battle. The elements native to the *papiers collés* – the metaphorical, the formal – are so engaged and reconciled that the whole is greater than the parts. Paradoxically, the work of art reasserts itself by means that tend to jolt, and to some degree destroy its pre-eminence.

One of the factors contributing to the reassertion was the return to colour as an independent language – not that colour had previously been ignored – only greatly restrained in order to serve the needs first of volume and later of flattened architectural masses. It had been manipulated in terms of tonal intensities rather than hue, and been used as a sonorous accompaniment to and reinforce-ment of the central statement. But now colour was to be employed for its own sake.

The new regard for colour independent of form precipitated Picasso's transition to more baroque formulations (Baroque's *Bottle of Rum* (1912) may well have been another influence). The result was the still-lifes of 1913–14, *Ills. 80, 81* *Ma Jolie, Green Still-Life, Playing-Card, Glasses, Bottle of Rum, Still Life with Fruit, Glass, Knife and Newspaper*. The way in which colour itself, in its power and reverberations, bites into the Cubist line and structure, organically altering it, creates a new dimension. Picasso developed this technique fully, especially in his use of stippled and pointillist areas which parody strict geometrical shapes. In *Green Still-Life*, for example, the triangular mass of dots above the compote satirizes the organic nature of the shape it describes. The pear on the table is another ingenious parody on the interplay of volume and plane, solidity and transparency, as well as a foil for the scintillating points of colour that play round it. In practice, colour now carries the melody and the Cubist panoply of line; form and illusion take the orchestral role, modulating, reharmonizing and effecting changes in key. Perhaps one can add to the broad concepts of Analytical and Synthetic Cubism the idea of an 'implicit' use of Cubist values and means. For in these paintings the Cubist vocabulary has been thoroughly absorbed, and a new flow of sensual richness released, partly with the direct participation of Cubist disciplines, and partly with their powers in tandem.

Throughout 1914 and into 1915, Picasso's paintings and collages fluctuated between this emergent fluidity in the use of colour and a more rigorous Cubist strictness of line and form – before he bolted off on an entirely different, even 'realistic' tangent. These alternations were directed by two factors. One was

114

81 PABLO PICASSO, *Green Still-Life*, 1914

the onset of the most cataclysmic war Europe had ever known, and the per-
sonal pressure it brought to bear upon the Cubists; another preceded the war
and related solely to art: the consideration that while Baroque Cubism func-
tioned superbly in the context of still-life, it had its limitations when applied to
the human figure. Perhaps in *The Card Player* (1914) of the previous winter
Picasso had arrived at the optimum point at which the new language could
successfully respond to the strenuous demands of the figure. In the *Seated Woman
in an Armchair before the Hearth* (1914), however, this point is exceeded, and the
painting has an intrinsic weakness, especially in comparison with the extra-
ordinary unity of human, still-life and landscape metaphors in *The Card Player*.
The fact that Picasso painted very few human figures during 1914 suggests that
he knew or sensed this, although another *Seated Woman in an Armchair* of that

Ill. 83

115

year is something of an exception. In this case there is in fact a return of concerted volumes which envelop and concretize even the more decorative or baroque allusions.

During 1915, Picasso tried two entirely divergent solutions. One method implied a deliberate dehumanizing of the figure, as in the *Harlequin* series, or even the conscious satirization of the human physiognomy, as in *The Egyptian Woman* or, still more strongly, in *Man with a Bowler in an Armchair*. In *Harlequin* and the several studies for it, the bodies became rigid arches and pillars and the heads are reduced to indicative shapes, purely symbolic notations as opposed to abstraction. In the large version, the smiling mouth is superimposed upon the head/neck pillar, almost in caricature. In the two portraits the same solution to the problem is brought about by an absolutely reverse procedure. Instead of minimizing the humanistic reference, Picasso focuses upon facial detail with a disproportionate scrutiny, given the formal and decorative surrounding areas.

Ill. 82

116

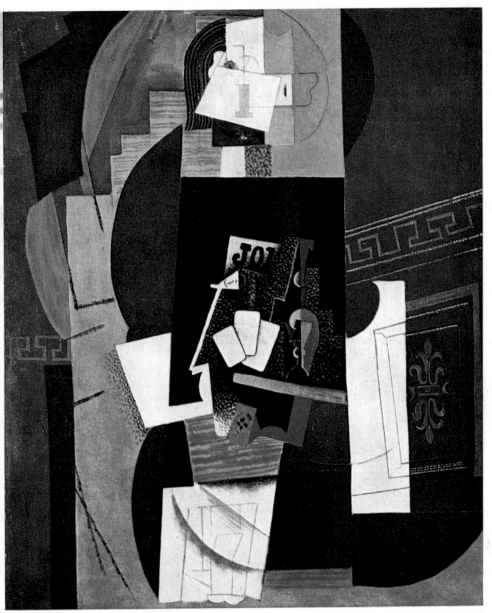

83 PABLO PICASSO, *The Card Player*, 1913–14

In *Man with a Bowler*, Picasso had produced a true caricature. But in all these cases, a balance is restored because the specifically human allusions have been muted.

The other 1915 solution was antithetical. Picasso drew a strikingly realistic portrait of Max Jacob, dropping the Cubist metaphors entirely for direct observation. This reversion was typical of Picasso's sharp characteristic shifts in the use of metaphor, though it may also be credited to the fundamental Cubist doctrine of surprise. But the war pushed Picasso's evolution in yet another direction.

With Braque's departure for the front, where he was wounded in the head and temporarily blinded, continuity was immediately broken. All Europe felt the shock of violent dislocation in the grip of war. Moreover, Cubism now found itself the target of political as well as aesthetic blame. For one thing, two of the Cubists' most vocal defenders, Wilhelm Uhde and Kahnweiler himself, were Germans. For another, the idea became current that the movement, with its precise structures and alien conceptions, was inherently 'anti-national'. Given the mood of the moment, the charges intensified.

Picasso was a neutral because of his Spanish nationality, and he intended to remain so in all respects. His battlefield was of another kind, and his resistance to conformity on any level had always been integral to his thought and work. But his point of view became all the more difficult to sustain when the Cubists, under attack from the jingoists, pressed for greater solidarity within the movement – Picasso did not want to conform to their pressure either.

He continued to work throughout the war, under constant stress and in the face of great misfortune. First, Braque was wounded, and not many months later Apollinaire was struck down as well. As a last blow, his mistress, Eva, became ill and died. Picasso was devastated. Yet he soon began to work again, to invent and, perhaps most remarkable, to observe with the objectivity and lyrical grace manifest in the new portrait drawings.

Jean Cocteau has described the Picasso of this period astutely:

Here, then, is a Spaniard, provided with the oldest French recipes (Chardin, Poussin, Le Nain, Corot) in possession of a charm. Objects and faces follow him where he wishes. A dark eye devours them and they undergo, between that eye through which they go in and the head through which they come out, a strange kind of digestion. Furniture, animals, people mingle like lovers' bodies in love. During this metamorphosis, they lose nothing of their objective power. When Picasso changes the natural order of the numbers, he still reaches the same total.[2]

Juan Gris: The Music of Silence

Cocteau's reminiscence of Juan Gris was rather more diminutive. 'And Gris said, very proudly, "I introduced the siphon into painting." '[1] The statement was typical of Gris's innate modesty and legendary naïveté, but it hardly does justice to his accomplishment. In sum, Gris was the Synthetic Cubist *par excellence*, the painter who came to the movement in its later stages and who based his art on psychological and formal truths that preceded rather than followed Analytic Cubist perceptions.

When Gris arrived in Paris from Madrid in 1906 – where he had studied art with the idea of becoming a mechanical draughtsman – pure chance led him to take a room in the Bateau-Lavoir. At first, his objectives were unclear. He began by doing illustrations for such periodicals as *Le Cri de Paris*, *Le Charivari* and *L'Assiette au Beurre*, drawings influenced by Art Nouveau and in some cases by the Japanese print, probably via Toulouse-Lautrec. But at the rue Ravignan he had found an art school of incomparable quality. He observed, listened and joined in discussions in which a new art was constantly probed and defined. Gris was an introvert, a cool and measured temperament, and he held back from the conviviality of his friends. He reflected at length, and at last everything he saw and heard began to transform his own work.

His progress was rapid, accompanied always by a firm conceptual grasp. Through Picasso, he came to Cézanne, who remained an active influence in his work to the very end. *The Eggs* (1911) comes directly out of Cézanne but with significant accentuations and additions. He used the Cézannesque method of uplifting and refracting his planes, of raising up a table surface and disjointing the line of that plane in its course behind the frontal objects, and he also sharpened and hardened those elements in a way that corresponds as much to his emergent aesthetic identity as to Cubist example. In 1911, the analytical phase of Cubism was already at its peak but Gris, typically, circumvented no step in the development of his work. Yet, even *The Eggs* has its personal innovation. Gris chose to define one shoulder of the bottle with the same density used to paint the wine, save that in the upper portion it becomes linear and, in context, purely determined by idea. The other shoulder derives from an equally predetermined formulation, but as mass rather than line, and the treatment of

Ill. 84

119

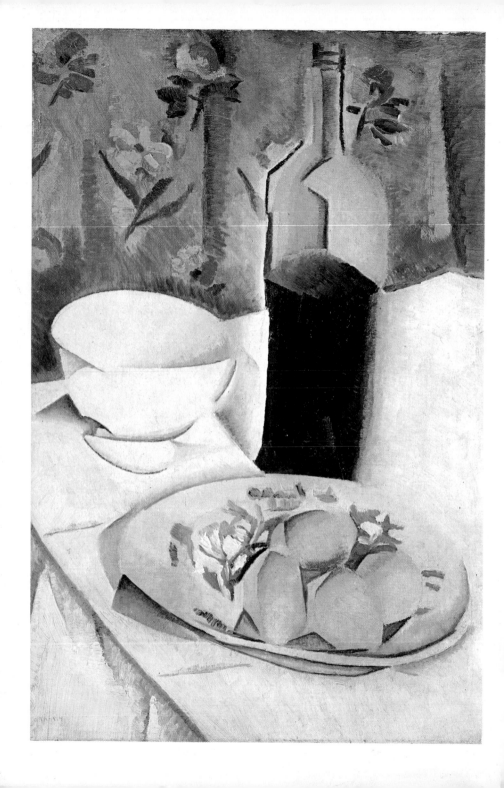

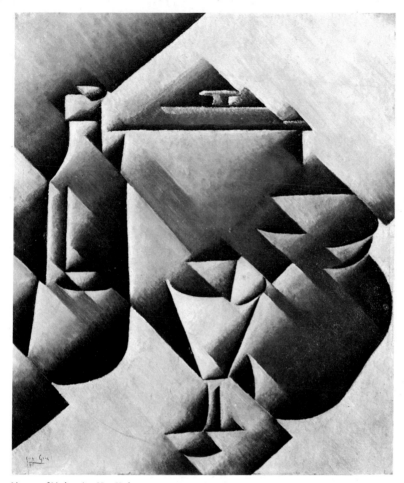

Museum of Modern Art, New York

85 JUAN GRIS, *Still-Life*, 1911

the neck of the bottle continues the essentially Post-Impressionist character of the painting.

However, 1911 was also to produce *Still-Life*. The leap forward is immense and again, totally original. The subject is subsumed in a new life as object and the object presence itself is subsumed in a schematic framework of great skill

Ill. 85

121

◄ 84 JUAN GRIS, *The Eggs*, 1911

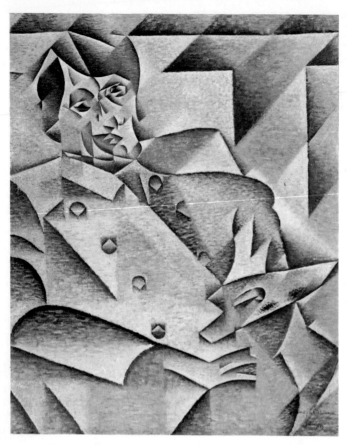

86 JUAN GRIS,
Portrait of Picasso,
1911–12
Art Institute of Chicago

Ill. 87 and sophistication. In *A Table at a Café* (1912) Gris convincingly integrates
the modulated Dubonnet cup as a specific subject reference into a complex of
areas even more schematic or intellectualized than those of the earlier *Still-Life.*
Ill. 86 With his *Portrait of Picasso* (1911–12) Gris brought this episode in his develop-
ment to the point of mastery. The head, for example, incorporates both the
general and the particular, the depersonalized, architectural references and the
relevant attributes of the subject. The challenge could hardly have been more
demanding. A series of diagonal charges establish motion in addition to
delineating form. They define the background, situate the weight of the body
and then go on simultaneously to construct, destroy and reconstruct the head
as a solid but also quite luminous entity.

 In other words, Gris, who was then twenty-four, succeeded in establishing
his own personal transposition of the deepest values suggested by Cézanne. In

122

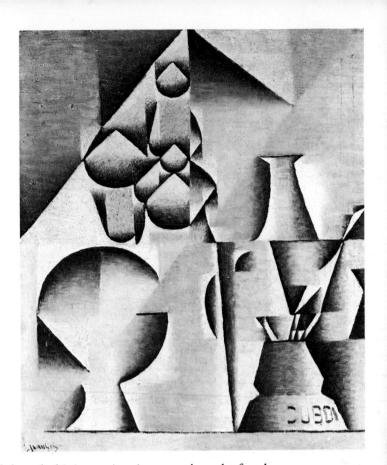

87 JUAN GRIS,
A Table at a Café,
1912
Art Institute of Chicago

painting, he proceeded to take his innovations into new channels of explora-
tion, always to an extent personal and, therefore, less visibly associated with the
source of his inspiration. But the drawings qualify these new advances. The
transition from *Bowl and Carafe* to *Head of a Woman* (both 1911) is logical. But
as late as 1916, Gris turned back to Cézanne and produced two portraits, a
bathers composition, a seated woman, a boy's head and a harlequin, in the
most devoted-disciple manner; unlike Picasso, who recapitulated his own
intellectual progressions, Gris was concerned with a re-exploration of sources,
and evidence of this concern appeared in his work periodically, at least into
1925.

Gris insisted absolutely on the intellectual foundations, and even pre-
conceptions, of the painter's vision. While maintaining his principles actively
in line and colour, he continued to define and redefine them in theory. The

123

lecture he delivered at the time of La Section d'Or was only the first public expression of these disciplines.

Gris stipulated the existence of both a physical and a conceptual reality, united, deformed, or reconstituted through the medium of the observer. He said:

> A table might be considered by a housewife in a more or less utilitarian way. A furniture-maker will notice the way in which it is made and the quality of the wood used in its manufacture. A poet, a bad poet, will associate it with the happiness of a home etc. . . .
>
> For a painter, it will be simply an ensemble of flat, coloured forms. And I insist upon flat forms, for to consider these forms in a spatial world would be more the business of a sculptor.[2]

In other words, Gris assumes that the painter's vision is formed by the two-dimensional quality of his medium. Matter becomes relative, conception the absolute. 'Scientifically, all the vertical lines are convergent towards the centre of terrestrial attraction; humanly, they are parallel.'

Gris also took into account the factor of time, the ways in which the imperceptible moulds the perceptible and mind reconstitutes matter:

> One knows that Vinci thought about the chemical composition of the atmosphere when he painted the blue of the sky. The palpitating flesh of life in the nudes of the Venetian painters, where one senses the blood circulating under golden skin, was due only to the psychological conquests of the Renaissance. . . . Those elements thus influenced, and formed each time, what has been called the aesthetic of each period.

For Gris it was fundamental that the aesthetic procedures involves in translating an emotion into painting must, above all, derive from the optical faculty. And yet, the function of the optic is finally to explicate mind rather than substance. 'The representation of the substantial world, and I say substantial because I consider notions of objects as substantive, can give place to an aesthetic, to a choice of elements which are only proper to the unveiling of this world of notions which exist purely in the spirit.'

To explain the way of the painter, which he saw as parallel to the way of nature, Gris described the integral difference between the idea of 'architecture' and the idea of 'constructions':

> All architecture is a construction, but not all construction is architecture. . . .
> In order for a construction, mental, material, visual or acoustic construction, to be architecture, it must fulfil certain conditions.

All the constructions of the natural world, whether organic or inorganic, are architectures. It is the molecular structure of a body which, in differentiating it from other bodies, gives it its individuality.

A chemical compound is architectural, an automobile is construction. An automobile can be taken apart, a chemical compound exists only in its totality. As for painting: 'The construction is only the imitation of an architecture. It is coloured and flat architecture which is the technique of painting and not construction. It is the *rapports* between the colours and the forms which contain them.'

Elsewhere, he wrote that,

Negro sculptures provide a striking proof of the possibilities of an *anti-idealist* art. Inspired by a religious spirit, they offer a varied and precise representation of the great principles and universal ideas. How can one deny the name of art to a creative process which produces on this basis individualistic representations of universal ideas, each time in a different way? It is the reverse of Greek art which started from the individual and *attempted to suggest* an ideal type.[3]

In consequence, Gris postulated a kind of reverse aesthetic existentialism, linked with classic philosophical existentialism only at a vital central point. Jean-Paul Sartre, writing about life, not art, asserted that *existence precedes essence*, that man is born into a godless universe, free to construct his own ideal since he is not the result of an idea of man or part of any pre-existing ideal. Gris, speaking of art, insists that essence precedes existence, that the mind and the optical system determine the work of art, *anti-idealist* in its structure, a tangible and credible entity, a self-expressive and independent architecture.

He enumerated the elements of the architectural compound according to their ineluctable properties.

There are colours more luminous or expansive and others more sombre or concentrated. . . . There are also forms more expansive than others. The rectilinear forms are more concentrated than the curvilinear forms which are expansive. . . . One cannot find forms more expansive than the circle, nor more concentrated than the triangle. These two forms would be equivalent to the lightest tones and the deepest of the palette.[4]

He also saw forms, like colours, as hot and cold: 'The forms which approach geometric configurations are colder than those which tend away from them. The capricious and complicated forms are certainly the hottest.'

Another parallel set of values applied to density and weight, earth colours tending to be heavier than others. 'The geometrical forms and forms submitted to a vertical axis have more gravity than forms whose axis is not marked or whose axis is not vertical. These last forms . . . would correspond to colours which are not dense but which are not light either.'

Finally, the scale of values becomes more complex in the case of a meeting of values tending in divergent directions, as in 'the more or less acute contrast between two colours which, perhaps, are equivalent to the contrast between two forms'.

If the message called for synthesis, the method and the language were sharply analytical, always under strict intellectual control. Gertrude Stein, recalling the war period, wrote that, 'Juan was in those days a tormented and not particularly sympathetic character. He was very melancholy and effusive and as always clear sighted and intellectual.'[5]

Still, the coldness of Gris's temperament as a painter has been greatly over-emphasized. Few painters have ever produced a body of work so rich in harmonies, sonorities and purely lyrical vibrations; few have ever matched his precision and calculation. But here too, as with Seurat, another rigorous theorist and self-styled mathematician, the relevance of theory to Gris's work must be qualified; both produced masterpieces that owe as much if not more to instinct and sensuality as to principle, a point underlined by comparison with the work of their followers. Cross and Signac were as diligent in their ideology as Seurat, but neither was a painter of the same quality. Gleizes and Metzinger were ardent theorists of Cubism, but not the painters they hoped to be. Gris's friends often had recourse to the word 'mystical' in talking about him. The word is dangerously vague, but it can be applied perhaps to that tense conceptual-perceptual balance typical of his finest work.

In 1913, Gris's mastery of synthetic technique developed along with other characteristic ones. One was the use of what Kahnweiler called a 'dissociation of line end and colour', in describing the junctures of colour and line to specify a given form, which suddenly diverge to assert only their own formal properties or suggest further allusions. Witness the construction of the bottle, the glass and the lemon in the Kröller-Müller Still-Life (1916).

Another device noted by Kahnweiler was the formal indication of objects

Ill. 88

in dense silhouette but at an angle that projects them upward, as in Still-Life with Pears (1913). At times, a single line or area served both to express and unite two distinct entities, as in the formidable Guitar, Glasses and Bottle (1914), in which a single grained surface fuses a common mass of guitar and table-top. The painting shows Gris's ingenuity and his restraint in the use of com-

126

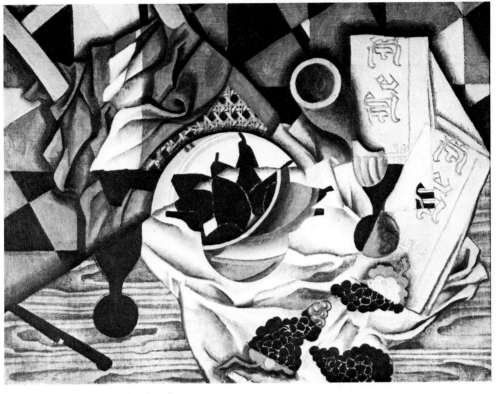

88 JUAN GRIS, *Still-Life with Pears*, 1913

bined or contrasted techniques, collage, gouache and crayon; his ingenuity is
seen in the bottle, for example, which combines several points of subtle dis-
sociation; its neck shifts to an entirely disparate axis, and emerges as a function
of the flat, background table-top in a monochromatic language. The right side
of the bottle refers to the subject in a fairly direct way, but at the left, the bottom
is dissociated at a sharp angle, the top 'melted' to become a tenuous transition.
The glass next to it is again an angular projection, transparent and super-
imposed, its interior shaded to indicate depth, the very same mass of shading
gliding round the mouth to become a surrounding shadow; both indications,
which would be phenomena created by an actual glass, establish, instead, the
existence of this otherwise undefined object.

The glass indicated in the centre has some substance, in part effected by the same spectral procedure, in part conjured up by the shimmer of light on its otherwise invisible rim. In contrast, two other glasses on the tablecloth, like the bottle, also function as the cloth itself, unlike the substantial and voluminous glass on the guitar-table.

Finally, there is the brilliant fusion of volume and plane, foreground and background, objective and spectral or echoing forms. One sinuous line which appears to be an overflow of the table surface grasps it from above, and a corresponding sinuous double line that functions in depth and actually creates a dimension beneath the table while simultaneously cutting through the glass upon the table, clasps it from below. As a last paradox, the spectral guitar conforms to the real shape of a guitar, whereas the more substantially indicated wood-grained instrument is, instead, an abstract rectangle.

But the final synthesis dominated all these inventions and paradoxes, Gris's restraint giving them a sustained poetic coherence.

Ill. 90

During the same year (1914), Gris painted another of his most eloquent works, an oil and collage, *The Bottle of Rosé Wine*, of a similar cogency, marvellously sustained, its impeccable harmony broken at a single point, by the sudden stylized naturalism of the cork thrust into the bottle's mouth. The

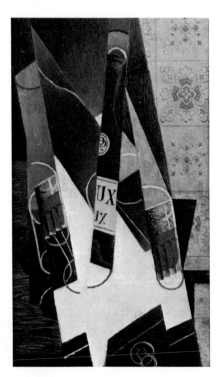

89 JUAN GRIS, *The Bottle of Bordeaux Wine*, 1913

90 JUAN GRIS, *The Bottle of Rosé* ▶
Wine, 1914

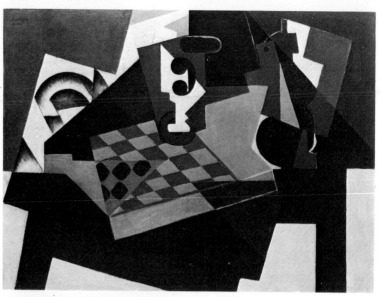

91 JUAN GRIS, *The Chessboard*, 1917

92 JUAN GRIS, *L'Intransigeant*, 1915

93 CAMILLE COROT, *Girl with a* ▶
Mandolin, 1860–65

94 JUAN GRIS, *Woman with a* ▶
Mandolin (after Corot), 1916

dissonance, however, is significant. The white rim picks up the white of the card below and distributes it as a contrapuntal value; if it is covered its presence is missed. The dark areas of the cork are no less important. But this interjection of descriptive local reference permits the cold light of 'construction' rather than 'architecture' to filter through.

In other of the great collages, however, Gris sustained, on varying levels, the transfiguring purity that was his greatest achievement, and never with more magic than in *Roses* (1914). All the subtleties of *Guitar, Glasses and Bottle* are equalled in this painting, but in another key, and the transparencies and echoing forms create a synthesis entirely fluid, almost aerial.

During the summer of 1917, Gris wrote to Kahnweiler, saying 'I would like to continue the tradition of painting with plastic means while bringing to it a new aesthetic based on the intellect. I think one can quite well take over Chardin's means without taking over either the appearance of his pictures or his conception of reality.'[6] In principle, this idea sounds perfectly feasible, but in practice, Gris's work was to decline; it might be said that it was a betrayal of

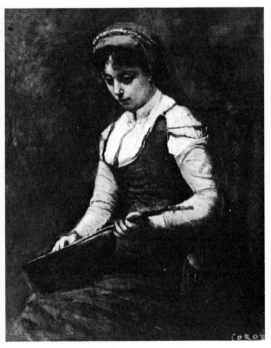

95 JUAN GRIS, *Before the Bay*, 1921

96 JUAN GRIS, *Guitar with Sheet of Music*, 1926 ▶

his personal aesthetic amalgam, or the result of a shift in emphasis from the still-life to the figure. The *Portrait of Picasso* had been a great success but also a largely analytical effort. In subsequent portraits, such as *Woman with a Mandolin* and *Portrait of Josette* (both 1916), the magic equation broke down and became stylized. Both these earlier portraits were adaptations of a Corot, *Girl with a Mandolin* (1860–65). The late still-lifes fluctuate, so that while *Before the Bay* (1921) is stylistically inflated, *Guitar with Sheet of Music* (1926) resurrects Gris's former purity. In the late *Harlequin* pictures, however, stylistic formulas take over once more, and the magic skein disintegrates.

What might have followed is, unhappily, a matter of pure speculation. Gris fell ill in 1925 and died two years later at the age of forty.

His work had been conceived and consummated in a terrible spiritual solitude. Years later, Gertrude Stein wrote of the personal chasm that seems to have existed between even Gris and Picasso, the man who perhaps did more

Ill. 94

Ill. 93
Ills. 95, 96

132

than any other to introduce Gris to his real capacities as an artist, though the rift itself was of Picasso's making.

Picasso by nature the most endowed, had less clarity of intellectual purpose. He was in his creative activity dominated by Spanish ritual, later by negro ritual expressed in negro sculpture (which has an arab basis the basis also of spanish ritual) and later by russian ritual. His creative activity being tremendously dominant, he made these great rituals over into his own image.

Juan Gris was the only person whom Picasso wished away. The relation between them was just that.[7]

But she added:

Later when Juan died and Gertrude Stein was heartbroken, Picasso came to the house and spent all day there. I do not know what was said but I do

know that at one time Gertrude Stein said to him bitterly, you have no right to mourn, and he said, you have no right to say that to me. You never realized his meaning because you did not have it, she said angrily. You know very well I did, he replied.

Juan Gris's 'meaning' was dominated by the two energies that most deeply mark Cubism, which Picasso was certainly the first to realize. One was the impulse towards a reality so pure that it approaches the metaphysical; the other towards painting so plastic and so devoted to the reality of the two-dimensional surface as to be unreservedly physical, a duality which also finds expression in the form of theatre and the written word, as well as in the medium of sculpture.

Cubist Language, Cubist Theatre

There were three poets close to the heart of Juan Gris: the first was Luis de Góngora y Argote, a Spanish poet of the late sixteenth and early seventeenth centuries; the second, the French Symbolist, Stéphane Mallarmé; the third Gris's contemporary and an intimate of the Cubists, Pierre Reverdy. For Gris, the work of these three writers had essential virtues in common – purity of language, an exactitude of expression, an organic structure of purely formal values. They used words as instruments toward syntheses that often entirely dispensed with their connotative function in favour of sensate 'relationships' directly parallel to Cubist shapes and colours. Two of these poets wrote before Cubism was ever dreamt of, of course, but Cubist painting not only had both a direct and indirect influence upon writers of the period; it also functioned as an oblique guide to values that preceded as well as survived the movement, being timeless rather than contemporary.

The impulse took many forms, but the abiding interest in the primacy of the formal presence was common to all of them.

In stating literary aims, Pierre Reverdy took the way of subtle analogy, but Gertrude Stein offered a direct explanation. In *The Autobiography of Alice B. Toklas* (her very device of writing a memoir in the third person through the eyes of another relates the work to the multiple-perspective Cubist recon-structive mode) she said that:

> Gertrude Stein, in her work, had always been possessed by the intellectual passion for exactitude in the description of inner and outer reality. She has produced a simplification by this concentration, and as a result the destruc-tion of associational emotion in poetry and prose. She knows that in beauty, music, decoration, the result of emotion should never be the cause, even events should not be the cause of emotion nor should they be the material of poetry or prose. They should consist of an exact reproduction of either an outer or an inner reality.
>
> It was this conception of exactitude that made the close understanding between Gertrude Stein and Juan Gris.[1]

In *Le Livre de Mon Bord*, a collection of notes produced by Reverdy between 1930 and 1936, he echoed the faith, through parable or analogy, in the good

Cubist tradition of juxtaposition and contrast. 'Poetry is neither in life nor in things. It is what you do with it and what you add.'

'The infinite is the limit that checks our faculties of appreciation and measure.' Here is a statement that might apply to Picasso the inventor, the magician.

'My character does not tolerate constraint, but my mind bridles with disgust in the face of disorder', reflects all Cubism but especially, perhaps, the classic harmony of Braque.

'Memories', he said again, 'disintegrate in my memory. Forgotten objects wither in my closet.' There is a link here to Apollinaire's *Horns of the Chase*. Reverdy balances this reflection with another: 'Whatever is imprisoned in a formula can be immortal – and not at all alive.'

And again, 'For the primitive, art is a means, for the decadent, it becomes an end.' Where then does Cubism fit? Reverdy answers that with: 'Nothing is worth saying in poetry save the unsayable, which is why one counts greatly upon what goes on between the lines.'[2]

In 1908, the first French translation of Walt Whitman's *Leaves of Grass* appeared; its impact was immediate. Whitman's simplicity of language, his technique of enumerating objects and places, his use of contemporary images, his terse rhythms, were all immediately relevant, and almost certainly had their effect upon Apollinaire's *Zone* (1912) and Blaise Cendrars's *Prose du Trans-sibérien* (1913). Undoubtedly, Gertrude Stein had long known the original, and for the 'portraits' in *Camera Work*, she made a direct adaptation of the methods of Cubist painting. Thus, her *Picasso* (1909) imitates a refraction of planes, a dissociation and reconstruction of parts into a word pattern.

> One whom some were certainly following and some were certainly following him, one whom some were certainly following was one certainly working.
> One whom some were certainly following was one having something coming out of him something having meaning and this one was certainly working then.
> This one was working and something was coming then, something was coming out of this one then. This one was one and always there was something coming out of this one then. . . .[3]

The attempt at translation was too literal, however, and did not achieve a true parallel, but it was both original and daring. When Picasso first came to the rue de Fleurus to meet the Steins, he mocked Gertrude's brother Leo, an art critic, for showing the assembled company his Japanese prints. Picasso found that enthusiasm of Leo's precious; it was Gertrude's turn of mind that impressed him more.

Blaise Cendrars's alliance with the Cubist intelligence was far more integral than Gertrude Stein's. He was the true vagabond poet, the ceaseless traveller, the cosmopolitan saint. Son of a Scottish mother and a Swiss father, Cendrars ran away from home at fifteen, crossed western Europe, explored Russia, North and South America. He made and lost fortunes. In London, when he was twenty-one, he was involved in one of those happenstances that so delighted Apollinaire and fits so neatly into the Cubist idea of surprising juxtapositions. Cendrars was working as a clown in a music-hall and living with another of the clowns, a young English Jew who was a medical student during the day. They had much in common, and, when they parted, both switched – in opposite ways – to poetry. Cendrars gave up the stage for the pen; his room-mate medicine for the stage: he was none other than Charlie Chaplin.

The First World War cost Cendrars an arm, but the loss kept him neither from sports, which he loved, nor travel. He was a poet, too, of athletic temper, with a lean style and a crisp rhythm. He chronicled his voyages in verse, of spare images and terse language. In *Notes of the Road* (1924), the poem, *Letter*, reads:

Tu m'as dit si tu m'écris
Ne tape pas tout à la machine
Ajoute une ligne de ta main
Un mot un rien Oh pas grand'chose
Oui oui oui oui oui oui oui oui

Ma Remington est belle pourtant
Je l'aime beaucoup et travaille bien
Mon écriture est nette et claire
On voit très bien que c'est moi qui l'a tapée

Il y a des blancs que je suis seul à savoir faire
Vois donc l'œil qu'a ma page
Pourtant pour te faire plaisir j'ajoute à l'encre
Deux trois mots
Et une grosse tache d'encre
Pour que tu ne puisses pas les lire

You said if you write to me
Don't type it all on the machine
Add a line in your own hand
A word a scrawl Oh nothing much
Yes yes yes yes yes yes yes yes

Still my Remington is beautiful
I love it and work well
My typescript is neat and clear
One can see that I have typed it

There are blanks that only I know how to make
Just see the appearance of my page
And yet to please you I add in ink
Two three words
And a big ink blot
So that you can't read them

The Cubist elements here have become linguistic; they are modified within a context in which the sense of the words themselves are not altered. The machine becomes a poetic instrument; even the typed characters and spaces become voices of personal expression, whereas the handwritten words and the ink blot become cryptic and illegible. Finally, the string of 'yes's', in varying tones, introduces an element of direct Cubist method in their provocative dissociation – credible as they are in context.

In *Bagage* (1924) Cendrars uses the Whitmanesque method of enumeration. The baggage inventory begins with scrupulous, rather ponderous description:

Voici ce que ma malle contient
Le manuscrit de Moravagine que je dois terminer à bord
 et mettre à la poste à Santos pour l'expédier a
 Grasset
Le manuscrit du Plan de l'Aiguille que je dois terminer
 le plus tôt possible pour l'expédier au Sans Pareil
Le manuscrit d'un ballet pour la prochaine saison des
 Ballets Suédois et que j'ai fait à bord entre Le Havre
 et La Pallice d'où je l'ai envoyé à Satie. . . .

Here is what my trunk contains
The manuscript of Moravagine I must finish on board
 and mail at Santos to send to Grasset
The manuscript of the Map of the Needle I must finish
 as soon as possible to send to the Sans Pareil
The manuscript of a ballet for the next season of the
 Swedish Ballet and which I did on board between Le Havre
 and La Pallice and which I sent to Satie. . . .

and ends in a quickened tempo in which the significance of the objects diminishes:

> Une cravate
> Six douzaines de mouchoirs
> Trois liquettes
> Six pajamas
> Des kilos de papier blanc
>
> Des kilos de papier blanc
> Et un grigri
> Ma malle pèse 57 kilos sans mon galurin gris
>
> A tie
> Six dozen handkerchiefs
> Three underpants
> Six pajamas
> Kilos of white paper
>
> Kilos of white paper
> And a fetish
> My trunk weighs 57 kilos without my old grey hat

In a short poem of the same series, *Je Nage*, Cendrars reports swimming in the pool aboard ship, and ends:

> Je plonge je nage je fais la planche
> Je n'écris plus
> Il fait bon vivre
>
> I dive I swim I float
> I no longer write
> That's the life

But the existence of the poem denies its claims. Life and writing are fused in one transparency much like the double-guitar image, half responding to, half denying the other's existence. In this case, it seems hardly likely that any Cubist parallel occurred to Cendrars, but the Cubist intelligence and the Cubist image were insinuating, ubiquitous, in the same sense as is Reverdy's: 'I write in order to live – that is to say, in order to create myself.'

139

Earlier, in *Prose du Transsibérien*, written in the midst of Cubist painting activity, Cendrars had written:

J'ai peur
Je ne sais pas aller jusqu'au bout
Comme mon ami Chagall je pourrais faire une série de tableaux déments
Mais je n'ai pas pris de notes en voyage

I am afraid
I cannot go all the way
Like my friend Chagall I might do a series of mad paintings
But I haven't taken notes while travelling

But, by the time *Notes of the Road* was published, the image had crystallized.[4]

Max Jacob was a very different case – a man of rare and original mind who might yet be called one of Picasso's great Cubist inventions. Jacob, the mystic and the clown, rambled through life in Paris as an unsuccessful businessman, a preposterous art critic, a secretary, cabinet-maker, tutor, art student, legal clerk. His existence was painful, his gifts scattered, until Picasso told him: 'You are the only poet of our time.'

Jacob was a Breton Jew, whose parents had been atheists; he himself burned with the need for spiritual belief. He met Picasso as early as 1901 and the two became intimate friends even before they moved into the Bateau-Lavoir. He was small physically, and subjected to incessant humiliations on that score. Perhaps, as a defence, he chose the role of the archetype dear to Apollinaire and Picasso – the clown. If Cendrars's demon sent him roaming the world, Jacob's sent him in flight to the inner spirit, and beyond it to the occult.

One evening, in autumn 1909, Jacob was returning to his small and symbolically viewless room in the rue Ravignan, when he experienced a vision of God. 'My flesh fell to earth,' he wrote. '. . . Oh, truth! truth! Tears of truth! Joy of truth!'[5] Thereafter, the clown alternated with the mystic, the ascetic; sometimes the two mingled. He was converted to Catholicism; touchingly and absurdly, Picasso became his godfather. His special blend of religious belief and occult explorations, with its strange mixture of solemnity and buffoonery, was intensely personal. He became the clown juggling at the altar. Once he described how he washed: 'I choke, I sob, I cry, I beat my face, my breast, my limbs, my hands; I bleed, I make the sign of the cross with my blood, with my tears. In the end, God is taken in.'[6] And in a description of Eva's funeral in 1916, Juan Gris reported that, 'Max's facetiousness added greatly to the horror.'[7]

140

In his poetry, Jacob's application of the Cubist intelligence was related to the most fugitive and flame-like qualities of the spirit, the very opposite of Reverdy's coldly faceted precisions. Reverdy's work was closer to Analytical Cubism than Jacob's, which partook more of the synthetic aspects. In *Le Cornet à Dés* (1916) a title that echoes Mallarmé and also refers to Picasso's many throws of the dice in his 1916 collages, Jacob wrought a series of images in the Cubist vein. He used striking juxtapositions, odd fusions of the sacred and the profane, the inner and the outer, synthesized by way of word play and a kaleidoscopic refraction of images.

Like the Cubists he was susceptible to the classic vision: he saw its enduring value. He also believed that, 'The mystery is in this life, the reality in the other; if you love me, if you love me, I will make you see the reality,'[8] foreshadowing the approach to Surrealism.

It was Philippe Soupault, the Surrealist writer, who most specifically embodied the transition from the Cubist to the Surrealist view, but the progression was more broadly marked by the accompanying body of poetic thought and criticism that continually produced insights into its meaning and its potential. Especially prominent in this role were two periodicals, *Les Soirées de Paris* and, later, *Nord-Sud*. The professional critics often produced interesting contributions in their analyses of technique or their attempts at definition, but it was the poetic parallels or poetic observations that generally proved more illuminating.

Among the critics, Maurice Raynal, Roger Allard and Olivier-Hourcade are the most important. Hourcade is credited with being the first in a long line to cite Kant in explanation of Cubism. In 1912, he quoted Schopenhauer's opinion that, 'The greatest service Kant ever rendered was to make the distinction between the phenomenon and the thing in itself, between that which appears and that which is; and he has shown that between the thing and us there is always the intelligence.'[9]

Raynal was a staunch defender of Cubism, but he chose to couch his defence in mechanical terms, with reference to optical experience and scientific triumph, and in complete refutation of the Renaissance doctrines of perspective, anathema to him. But his explanation of the movement's means and ideals tends to cloud its more profound poetic significance.

Roger Allard, a poet, stressed method less and ideals rather more, but his language too was that of an outsider. *Les Soirées de Paris* and *Nord-Sud*, on the other hand, functioned from within. Kahnweiler, however, arrived at an effective middle way, and his writings combine a close exegesis of the movement's techniques and philosophy with an intimate and illuminating sympathy.

141

Les Soirées functioned from February 1912 to August 1914. Apollinaire himself published it, and in 1913, he bought out his co-founders, René Dalize, André Billy and André Salmon, after which it was his personal vehicle. The review published Max Jacob, Blaise Cendrars, Alfred Jarry and the Baronne d'Oettingen under two pseudonyms, Roch Grey and Léonard Pieux, and carried black and white reproductions of relevant works.

With the creation of *Nord-Sud* in March 1917, the flavour of the Cubist movement was mirrored in the pages of a magazine. The title was taken from the name of a Métro line that ran across Paris from Montmartre to Mont-parnasse, and alluded to the review's purpose, which was to be as comprehen-sive an anthology of current avant-garde thought as possible. Reverdy, Apol-linaire and Jacob were chief editors. Soupault, together with two young poets soon to be leaders of Surrealism – André Breton and Louis Aragon – were on the staff.

The magazine had competition in *Sic*, founded by Albert Birot, supported by Gino Severini, and totally committed to the ideas of Futurism. 'To seek is to live, to find is to die', wrote Birot, whereas Apollinaire, on behalf of *Nord-Sud*, sought to 'restore the strange magic of words to its role as a poetic means'. The work of art, pure and even, if possible, minus subject, was *Nord-Sud*'s ideal; it pivoted midway between the Cubist present and the Surrealist future.

Nord-Sud's thesis was that there is a conceptual light that helps to illuminate poetry which arises only from the poetic impulse itself. Only a poet like Cendrars could have observed that, 'M. Georges Braque is closer to Versailles than to Paris. . . . Thanks to him, the Cubists are in the true French tradition of cold reason, irreducible stubborness and solemn pomp. . . .'[10] Or seen in Chagall, 'all the exacerbated sexuality of the Russian province'.[11] Or said of Picasso, 'He has the mysterious sense of "correspondences" and possesses the secret number of the world.'[12]

Nord-Sud became, in 1917, the organ of defence for *Parade*, the ballet in which Jean Cocteau, Picasso, Serge Diaghilev, Erik Satie and Léonide Massine combined their talents in one of the most brilliant and controversial adventures of the modern theatre. The spectacle brought Cubism to the stage, and thus to a new dimension, and at the same time gave the early Surrealists food for thought.

Parade had special meaning in contrast to the mostly puerile nihilism of the growing Dada movement and the example of Dada's hero, Jacques Vaché, a nihilist who consummated his career by suicide. The war with its tragic absurdities created an appetite for new forms and produced or encouraged excessive, often hysterical movements. Those who were impressed flocked to

142

the cause of Dada, together with some artists whose contributions were to be distinctly less negative.

The name itself came from infants' language, which implied the meaningless to some, the possible to others. Tristan Tzara, Max Ernst, Hans Arp, Francis Picabia and, in a complete turnabout, Marcel Duchamp, were to find at least temporary sustenance in the movement, which began in Zürich in 1916 in an excess of sound and fury. This was not what Apollinaire had intended as the result of a new language, in which words would be wrenched from their usual sense. After Cubism, with its sonorous silence, came Dada with its stentorian confusion. To a degree, Dada looked to the Cubists for inspiration. They adopted the newspaper as a symbol, and one can detect Cubist precedent, for example, in the episode in which Tristan Tzara recited a newspaper excerpt at unintelligible breakneck speed, while Paul Eluard (a close friend of Picasso's and later a lyrical poet) rang bells in the background. The symbols employed were related to the Cubist ones but the sense was antithetical.

Another and perhaps still more telling sign of change was Cendrars's realization that the Cubist vitality in painting was waning. He developed a growing enthusiasm for Delaunay and Apollinaire's so-called Orphic impulse, announcing that 'Cubism no longer offers enough novelty and surprise to still serve as nourishment for a new generation.'

Jean Cocteau, one of the most inventive imaginations in all of modern poetry, who always endorsed the poetry of surprise, went so far in his intention to separate romantics and classicists as to categorize painters as either *les rapins* (the daubers) or *les anti-rapins*, the victims of this awkward distinction including Michelangelo, Delacroix and Matisse, and its elect Raphael, Ingres, and Picasso. At that moment the Cubists were under attack as decorative painters. Cocteau wanted to establish Picasso's contribution, instead, as embodying a 'higher reality'. To be sure, Cocteau missed, or perhaps chose to ignore, the extent of Michelangelo's, Delacroix's and Matisse's classicism, apart from their other aims, since he was bent on classicism as a truly revolutionary path, opposed to academicism. 'The word "modern"', Cocteau wrote, 'always seems naïve to me. One thinks of a savage prostrate before a telephone.'[13]

This was the period during the war, in which Picasso returned to the pure line and overt classicism of Ingres; Cocteau was impressed, but no more so than by the classical character of the Cubist works. When he suggested that Picasso design costumes and sets for *Parade*, he was in fact at once affirming the Cubist mode and preparing the way out of Cubist determinations. The collaboration between Cocteau and Picasso was a perfect intellectual marriage of two classicists, committed to creative audacity and regeneration.

Ill. 97

143

But the change required courage. Picasso's very French 'Ingreism', in the face of chauvinistic attacks upon the movement as 'anti-national', was regarded by many of the Cubist faithful as treason to the movement. They were also adamant about their thematic material and about the necessity for its containment in a hermetic ambience, so that to design theatrical décor was also a betrayal, a descent from the studio to the boulevard.

The Cubists had spiritually reconstructed the bottle and the pipe, and Cocteau had similar ideas about the boulevard. 'The Café-Concert is often pure,' he wrote, 'the theatre is always corrupt.'[14] Purity of expression was of the essence. Cocteau wanted to oppose Impressionist images with formal lucidities, to replace the baroque with the angular, the discursive with the terse, the lyric with the mimetic, the romantic with the classical. He also wanted to break away from the confines of the Cubist canvas towards a total art, which would include music. He became the founder of the famous group of composers known as Les Six, charging Stravinsky with being too oriental, too impressionistic, too romantic, and corrupted by theatre. To draw the battle lines as sharply as possible, he came out against Debussy as well, and in favour of Georges Auric and Erik Satie. In the theatre, he championed Charlie Chaplin, as the clown, and Mistinguett, as the music-hall entertainer of the boulevards, rather than certain more florid or Gothic cultural phenomena and personnel which he classified as 'harlequin'; he liked Cézanne's and Picasso's harlequins, but not the original conception.

The Call to Order (1926) was the title of the statement in which he praised Picasso as Apollinaire had done, as the magician-craftsman, the man who conjures and who determines, who not only creates images but who also establishes a system of proportion.

In 1917, Cocteau persuaded Picasso to join him in Rome to prepare *Parade*. The idea had been conceived by Cocteau in collaboration with Satie, who had just completed a piano composition for four hands called *Pieces in the Form of a Pear*. Diaghilev agreed to mount the ballet, Léonide Massine undertook the choreography and Léon Bakst the sets. The *première*, in Paris on 18 May, aroused a storm of derision.

In an attempt to explain the origins of the spectacle, Cocteau wrote an open letter to *Nord-Sud*. Few people in the audience understood the totemic Cubist costumes in which Picasso had engulfed his dancers, the Chinese, the American Girl, the Acrobat and the Managers.

Cocteau denied any humorous intention. 'They insisted,' he wrote, 'to the contrary, upon the mysterious side, on a prolonging of these personages, on the obverse of our sideshow booth. The Chinese were capable of torturing

144

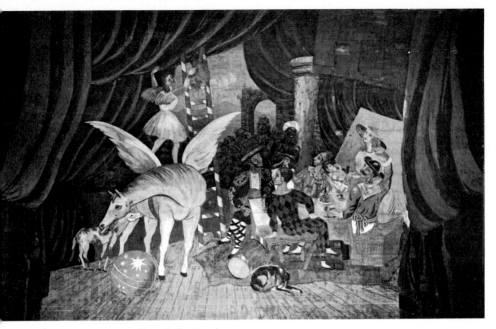

97 PABLO PICASSO, Curtain for *Parade*, 1917

missionaries, the Little Girl of sinking with the *Titanic*, the Acrobat of being in the confidence of the stars.'[15]

The music was equally a subject of public scorn, and Cocteau went on to explain that: '. . . Satie seems to have discovered an unknown dimension thanks to which one listens simultaneously to the parade and the interior spectacle.' As for the costumes, Cocteau explained that they expressed his [Picasso's] '. . . interest in opposing to three real personages, like chromos . . . pasted on a canvas, inhuman, super-human personages of a graver trans-position, which would become in sum false scenic reality in reducing the real dangers to doll-like proportions.'

Apollinaire welcomed the event wholeheartedly and wrote an appreciation for the programme. In lauding *Parade*, he carefully and ingeniously refused to imply any distinction in character or quality between it and Picasso's painting. He accepted the reality independent of its medium:

This realism, or this cubism, as you like, is what has most profoundly agitated the arts during the past ten years. . . . The décor and the costumes of *Parade* clearly shows his [Picasso's] preoccupation with drawing from an

145

object all that it can give of aesthetic emotion. Often, one tried to restore painting to its native elements. There is scarcely anything but painting in most of the Dutch, in Chardin, in the Impressionists . . . Picasso goes further than them all . . . Above all, it is matter of translating reality.[16]

He also mentioned a 'kind of surrealism in which I see the point of departure for a series of manifestations of this new spirit . . .'

Indeed, there were to be many and varied manifestations of it. On 22 July 1919, Manuel de Falla's *Le Tricorne* opened in London, with décor and costumes by Picasso, and choreography by Léonide Massine; the following year, Paris saw the Stravinsky-Picasso-Massine *Pulcinella* and Cocteau's *Le Bœuf sur Le Toit*, with music by Darius Milhaud, décor by Raoul Dufy, and costumes by Fauconnet. In 1921, Picasso designed the décor for De Falla's *Quadro Flamenco*; in 1922, Léger designed sets and costumes for Arthur Honegger's *Skating Rink*, and in 1923 for the Cendrars-Milhaud *La Création du Monde*. During 1923, Juan Gris completed the décor for four of Serge Diaghilev's productions, *La Fête Merveilleuse*, *La Colombe*, *Les Tentations de la Bergère* and *L'Education Manquée*. In 1924 Picasso designed the curtain for Milhaud's *Le Train Bleu*, with décor by Henri Laurens and costumes by Coco Chanel, and Picasso, Satie and Massine joined forces again in *Mercure* at the Théâtre de la Cigale, in Paris.

Yet extensions into 'a kind of surrealism' were not limited to the theatre. Picasso was to move in this direction in his painting, albeit with great metaphorical fluctuations. Cocteau's and Picasso's efforts met with violent opposition from the Dada group, of whom many were soon to become Surrealists themselves. The attacks could hardly have been more savage, and yet they were directed towards a source that these men might have recognized as indispensable to their common goal of a new vision. But they continued unabated, as did Cocteau's defence of the classical attributes he considered indispensable to revolution. When, in 1926, Cocteau undertook the defence of Giorgio di Chirico, the Italian proto-Surrealist, the Surrealists found this trespass on their grounds intolerable. Breton confined his attacks to language but apparently Vaché's nihilistic spirit was not dead. Chirico reported, for instance, that Cocteau's mother had received a telephone report that her son had just been killed in an accident, a sample of Dada humour. But Cocteau and Picasso, Braque and Gris, Jacob and Reverdy, each in his own way, kept the faith.

The Response in Sculpture

As suggested earlier, the very two-dimensional quality of the Cubist paintings from 1911 on produced a plastic equivalent of the three-dimensional articulation of sculpture. Only when the cube was transfigured on a flat surface did the movement assume its true character, in direct opposition to its fortuitous name. To this extent, the very existence of a Cubist sculpture is almost a contradiction in terms.

In addition, there had long been a certain identity of sculpture and pure form in the work of architects. Both solid geometry and a free acceptance of line and volume in architecture preceded Cubism, as did the hieratic formalism of Egyptian, archaic Greek or primitive sculpture, which were among the first sources of illumination to Picasso and Braque.

However, the validity of Cubist sculpture can perhaps be explained in two ways: firstly, through the challenge of utilizing architectural values in the delineation of human references; secondly, by the fact that the Cubist example was able to suggest to sculptors (as well as poets) possibilities not unique to Cubism but flowing from earlier art forms through the Cubist experience. Many deliberately Cubist attempts at sculpture failed, however, whereas some attempts in which Cubism played only a tangential role fared better. One conspicuous case in point is the series of four reliefs, each titled *The Back*, by the *Ills. 98–101* most important non-Cubist artist of the period, Matisse. The series in fact spanned the Cubist years, version I having been completed in 1909, version II about 1913–14, version III in 1914, version IV in 1929. If the reliefs are seen together, it is clear that the actual intent is not Cubist, but versions III and IV seen in isolation parallel and surpass many of Henri Laurens's more overtly Cubist works. And, finally, when reviewed as an ensemble, the series shows that Matisse, by following a very different train of thought, nevertheless employed a Cubist intelligence in sculptural terms.

The series aims towards an internal architecture, and its very powerful tensions arise from the fusion of a formal flatness with the volumes that strive to explode out of it. The negative or background expanse becomes as salient, as integral, as eloquent as the central masses, and the forms become increasingly depersonalized and dynamic, the long hank of hair eventually transformed into

147

a pillar as weighty and as organic as the limbs, which themselves finally become unified with the torso.

The progression might be described as partly analytical, partly synthetic, but the work is couched in sensual and lyrical terms far removed from the Cubist ones. The result, on the other hand, perfectly utilizes the Cubist concepts and energies, which would only have been possible in a flat relief formulation.

Picasso himself approached specifically Cubist sculpture with great reserve. Generally, in sculpture, he worked at most tangentially to the Cubist concept. The one directly Analytical Cubist sculpture he produced was the formidable *Ill. 102* bronze, *Head of a Woman* (1909–10); the eruption of volumes in this work corresponds completely to his painting of the period. Matisse said that 'a sculpture must invite us to handle it as an object, just as the sculptor must feel, in making it, the particular demands for volume and mass'. The Picasso head

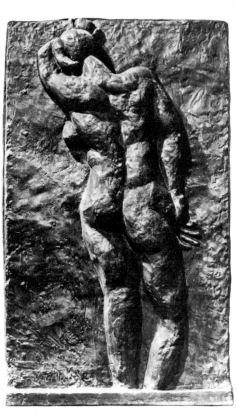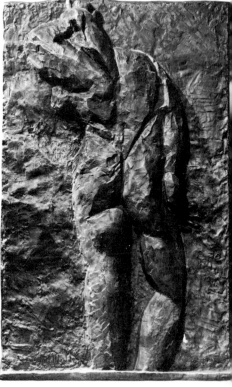

98–101 HENRI MATISSE, *The Back* (I, *c.* 1909; II, *c.* 1913–14; III, *c.* 1914; IV, *c.* 1929)

conforms in concept without reservation to the Cubism strictures; in its violence, its tactile vibrancy, its degree of sensuality as sculpture itself, it ignores them, so that the qualities which differentiate it from the Matisse reliefs are correspondingly minimized.

Picasso, as a sculptor, was able and willing to accept the implicit demands of the medium. Even in 1907, when he was facing the enormous problems posed by *Les Demoiselles*, he had turned to carving and produced three masks related to primitive and Gosol sculpture.

The three sculptors who most explicitly attempted a Cubist language in sculpture were Jacques Lipchitz, Henri Laurens and Alexander Archipenko. All three resolved the challenge in terms of the relationship between the human reference and the presence of pure form, and that between the three-dimensional and the two-dimensional.

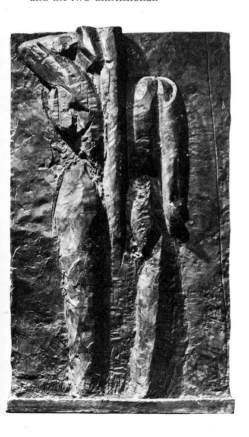 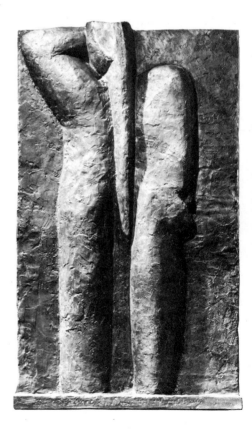

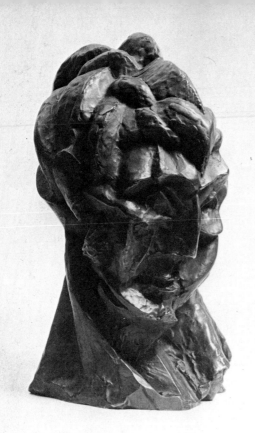

102 PABLO PICASSO,
Head of a Woman, 1909–10
Museum of Modern Art, New York

103 JACQUES LIPCHITZ, ▶
Half Standing Figure, 1915

104 JACQUES LIPCHITZ, ▶
Bather, 1917

105 JACQUES LIPCHITZ, ▶
Man with Guitar, 1920

106 JACQUES LIPCHITZ, ▶
Harlequin with Mandolin, 1920

Lipchitz arrived in Paris from Lithuania in 1909, at the age of eighteen. Until about 1914, he was visibly influenced by archaic sculpture. Though his work incorporated Cubist passages and formulations, its emphasis was still upon the external allusion. From 1915, until the late 1920s at least, Lipchitz shifted to the internal reference, very much as a Cubist; in his work of these years the specific volume is restrained by a severe flatness, giving some masses the effect of being a projection of the wafer-thin plane, qualified further by the crisp linear definition of each. In *Half Standing Figure* or *Sculpture* (1915), the human metaphor is completely subsumed under an architectural entity. In the *Bather* (1917), *Seated Bather* (1917), or *Man with Guitar* (1902), the two elements are balanced, with the latter clearly dominating. In contrast, in *Harlequin with Mandolin* (1920), or *Man with Guitar* (1925), the literal reference breaks through to oppose the sculptural mass, and the work is automatically diminished.

Ill. 103

Ills. 104, 105
Ill. 106

150

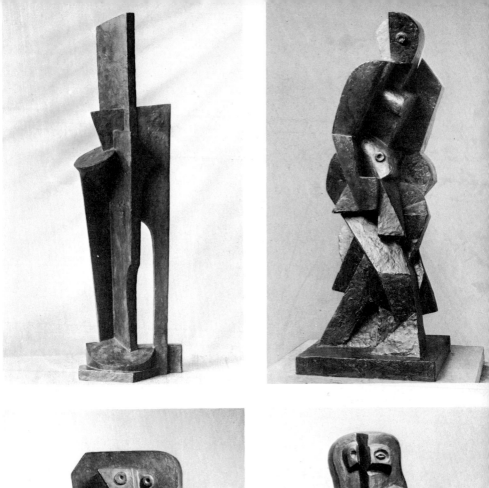
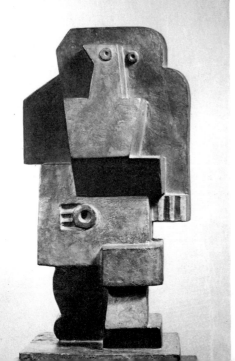
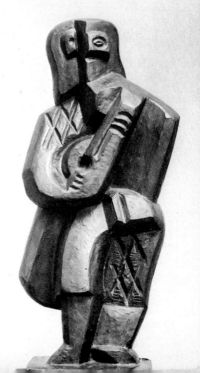

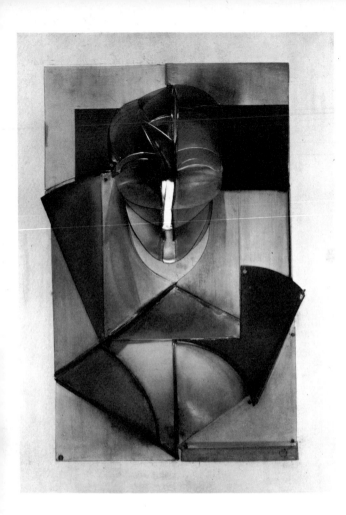

107 ANTOINE
PEVSNER, *Portrait of
Marcel Duchamp*, 1926

108 NAUM GABO, ▶
Construction in Space, 1912

Laurens's most convincing truly Cubist works were the bas-reliefs in which
the statement is also made in two dimensions, and, again, in the standing
figures, where the incorporation of Cubist metaphors tends to destroy the
sculptural or monumental frame of reference. I would suggest that in the case
of both Lipchitz and Laurens, later works, which depart from pure Cubism,
such as Lipchitz's *Mother and Child* or *Benediction I* (1942) and Laurens's
Summer (1940) – fulfil the deeper requirements of Cubist formalism and puri-
fication in proportion to their divergence from canons more appropriate to

152

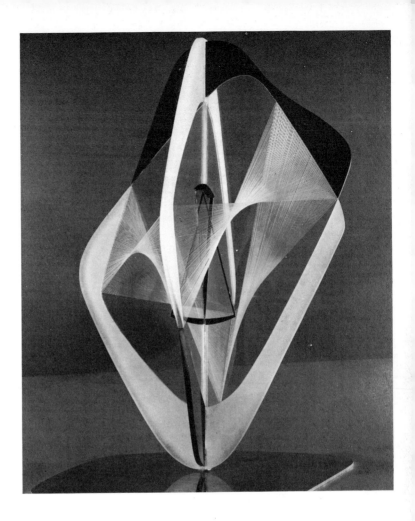

painting. This paradox goes beyond the question of sculpture only, to a consideration of where the frontiers of Cubism actually lie, just when – and, indeed, if – the movement ended, and whether one can speak of a 'Post-Cubist' art.

One of the most successful solutions to Cubist sculpture was achieved by a Czech sculptor, Otto Gutfreund, whose approach to Cubism was less classic or systematic than that of either Laurens or of Lipchitz, and has a great sculptural immediacy and energy. Lipchitz eventually moved from the Cubist to the baroque, and used the classicism of the one to temper the expansiveness of

the other. Gutfreund's original *penchant* was for the baroque, and he in turn used that tendency to animate his Cubist formations. His *Embracing Figures* (1912–13) is a transitional work in which the amalgam is apparent.

The Russian-born Alexander Archipenko and Ossip Zadkine both dealt with the same formal problems, but Archipenko began to evolve an almost mechanically cold style that moved very slightly in the direction of Con-structivism, a movement born in Moscow a few years before the 1917 Revolution, in which the machine and its energies were the basis of inspiration. The move was towards pure abstraction, and the final result was a geometric construction of forces and tensions, precise and existential. The men who promoted this tendency, Vladimir Tatlin, Alexander Rodchenko, Kasimir Medunetsky, Lev Bruni, Kasimir Malevich, and the two who brought it to its most refined and sophisticated development, the brothers Antoine Pevsner and Naum Gabo, were all familiar with Cubism and were to be influenced by Futurism. Tatlin even came to Paris from Moscow expressly to see Picasso. Yet the work of these artists diverged from the original Cubist tenets towards the Futurist and produced an art of pure idealism (projecting a 'universal idea' through totally dehumanized concretizations of space, energy and relationships) and of materialism (presenting the objects as pure entities without personal or psychological echoes). The spiritual hiatus between Cubism and Constructiv-ism is total, and yet Cubism was the latter's indispensable predecessor.

Ills. 107, 108

The Futurists' objections to Cubism were far more relevant to sculpture than painting. Their insistence upon 'dynamism', movement and a force incompatible with stillness, made possible the kind of breakthrough which the Cubist sculptors had not quite managed.

Boccioni's contribution of a 'sculpture of environment' was of great impor-tance. By this phrase he meant that a 'systematization of the vibrations of light and the interpenetration of planes will produce Futurist sculpture whose foundations will be architectural, not only in the construction of the masses, but in such a way that the block of the sculpture will contain within itself the architectural elements of the SCULPTURAL ENVIRONMENT in which the subject lives'.[1] He also reiterated the importance of the Futurist LINES/FORCES concept as applied to sculpture.

In painting, the Futurist credo failed to 'translate plastically'. But whereas the Cubist painters used a flat canvas to re-create solid forms, Boccioni used massive bronze to suggest elusive motion, invisible energy. In each case the inherent resistance of the medium created the plastic possibility. In Boccioni's case, the modification of organic shape towards its reconstitution as a function of energy altered the theme entirely.

154

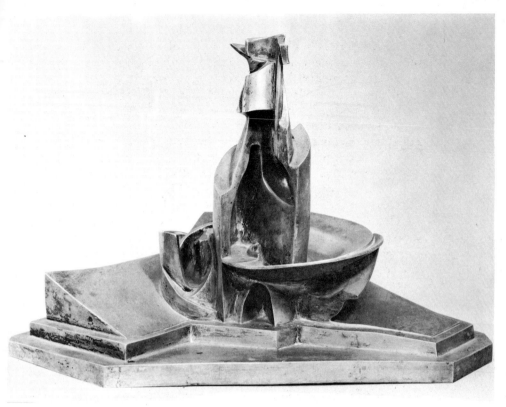

109 UMBERTO BOCCIONI, *Development of a Bottle in Space*, 1912

He handled this variously in *Development of a Bottle in Space* (1912), and in the walking figure called *Unique Forms of Continuity in Space* (1913). In the first, the bottle itself is a still object but it explodes into a spiral conjunction with surrounding space to become a force of helical energy. The destroyed bottle is reconstructed by the pressures surrounding it, and the interior, negative hollow, defined as a sinuous mouth, imitates the delicate and transparent substance of the glass bottle. In sculpture, plasticity and Futurist principle mesh perfectly, because the inner, muscular forces, that strain towards and through the exterior human form and on into surrounding space, necessitate a medium as massive as bronze or stone. Again, the tactile and very immediate quality of sculpture becomes integral and essential.

Ill. 109
Ill. 111

155

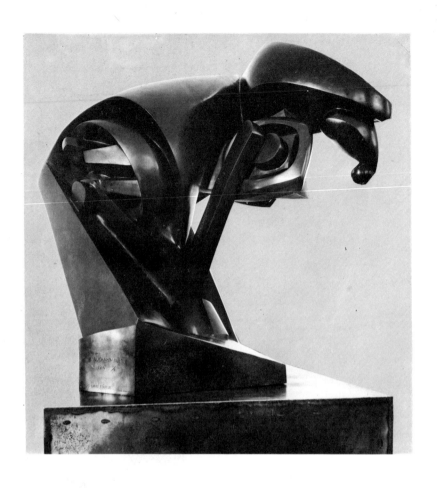

Outside the Futurist group, Raymond Duchamp-Villon, another victim of the war and one of the century's most gifted sculptors, followed a similar course. *Ill. 110* But Duchamp-Villon's masterpiece, *Le Cheval-Majeur* (1914), shows a very special confluence of the energies Futurism most admired, of the severe stillness of Cubism and of the machine-consciousness of the later Constructivists. Its point of thematic departure was the rearing horse, its rider thrust up over the animal's surging mane. Before the war, Duchamp-Villon made countless studies of horses, and the sculpture substantially evolved during 1913. But after his first experience as a cavalry officer had evoked new observations, he returned to the project in 1914.

156

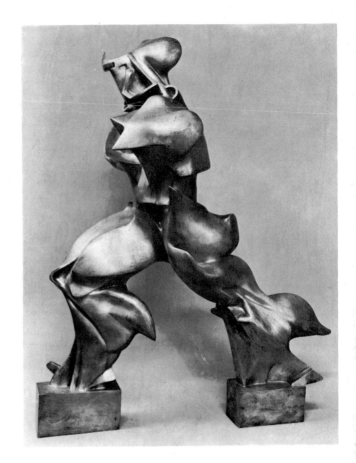

110 RAYMOND
DUCHAMP-VILLON,
Le Cheval-Majeur, 1914

111 UMBERTO
BOCCIONI, *Unique
Forms of Continuity in Space*,
1913

Museum of Modern Art, New York

Duchamp-Villon wrote:

The power of the machine imposes itself upon us and we can scarcely con-
ceive living bodies without it; we are strangely moved by the swift brushing
by of beings and of objects, and we accustom ourselves, without knowing it,
to perceive the forces of the former group in terms of the force they dominate
in the latter one. From that point to an opinion of life such as would make it
appear to us merely under its form of superior dynamism, only one step
remains to be taken – and it is a short step.[2]

Hence, *Le Cheval-Majeur* draws upon the anti-natural energy of the machine as
well as upon the natural forces of muscle and flesh. The two meet in several

157

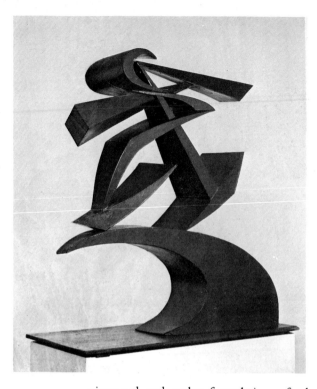

piston-rod and socket formulations of relentless line and resisting curve. Boccioni had stressed a new, Futurist use of the straight line but Duchamp-Villon's solution to that proposition functioned far more dynamically than that *Ill. 112* of the Futurist sculptures – for example, Giacomo Balla's *Boccioni's Fist: Lines of Force* (1915). The fact is significant, for whereas the curve, in its less geometric and more elusive sense, was the domain of Futurism, the power of the straight line lay in the domain of Cubism. In his fusion of action and mass, sensation and pure form, Duchamp-Villon had evolved a dimension that embraces both tendencies.

The Rumanian-born Constantin Brancusi took a contrasting point of view; his pure forms were conceived as the thrust of an internal energy, but one in-duced by the sculptor's own formulations, aiming at the ideal of an organic harmony. Consequently, such a simplified and restrained delineation as *Ill. 113* Brancusi's *Fish* (1930) bears yet another relationship to the currents of Cubism and Futurism. It was at once natural and anti-natural, but not in the same way as *Le Cheval-Majeur*. The natural reference persists as internal, organic energy, and the anti-natural is conjured up by the authority of the conceptualized

158

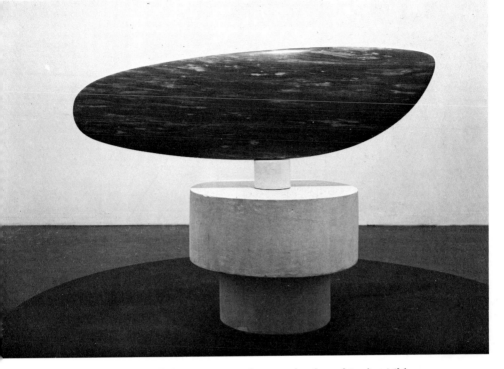

image and the actuality of the stone. In other words, the subject's visible attributes disappear, an inner force is activated, a highly charged metaphor is created. In Brancusi's work, this interplay is very much like that of the molecular forces that produce the sense of repose inherent in any natural form.

This philosophy or impulse carried through into the work of other sculptors, whose forms are, therefore, apparently abstract but in fact animated by the same inner, natural forces; Hans Arp, for one, who took the way of Dada and Surrealism, and Henry Moore, who has always been independent of any group. The impulse applies equally to the contemporary Spanish sculptor Edouardo Chillida, who progressed from the use of very linear and electric forms to that of very massive, architectural and geometrically faceted ones. These last have in fact been called Cubist, but Chillida formally denies the association. He observes that architecture preceded Cubism, and that such urges are universal and timeless.

Still another sculptural category is introduced through the construction and the magical object. In 1933, after the many factional furores had abated and more reasonable reassessments made, André Breton recognized certain 'absolutely

dialectical' efforts of Picasso's as 'extra-pictorial', in which 'An elective magnetism which excludes all previous elaboration alone decides, by means of the substance that lies literally *in hand*, the coming to be of a body or of a head.'[3]

In Picasso's case, this applies equally to sculpture and to construction. But while it reflects upon Picasso's method – the visceral one – in the making of sculpture, it defines the inherent nature of the constructions, which began as a whimsical 'revolution' of Cubist images. The violins and guitars in 1913–14 are strikingly analogous to the costumes later designed for *Parade*. All these works subsist on the unnatural; they conform neither to the image implicit in painting nor to the substance implicit in sculpture. They have a totemic aspect, that of the fetish, but also an eerie twilight quality in relationship to the paintings and *papiers collés* as though one of the guitars in the paintings had actually sounded a note. This is not true, for example, of Henri Laurens's *Head* construction of 1918, which remains a composition whose elements happen to rise into a third dimension instead of lying flat. But the Picasso works, while ceasing to be two-dimensional, insinuate themselves into the third dimension in a half-metaphorical and half-physical way, so that both of those elements are kept in suspension and the object takes on a powerful magic.

Picasso's constructions proceed from the formal to the magical; the Dadaists' objects in the reverse direction. Men like Arp and Max Ernst inevitably re-interpreted the nihilism and anarchism of the movement, giving it a vocabulary that was creative rather than destructive. In Arp's words:

> The important thing about Dada, it seems to me, is that the Dadaists despised what is commonly regarded as art, but put the whole universe on the lofty throne of art . . . we declared that everything that comes into being or is made by man is art. Art can be evil, boring, wild, sweet, dangerous, euphonious, ugly or a feast to the eyes. The whole world is art. To draw well is art. . . . The nightingale is a great artist. Michelangelo's Moses: Bravo! But at the sight of an inspired snowman, the Dadaists also cried bravo.[4]

This implied a considerable revision of the original Dada thesis voiced by Tristan Tzara: 'Art is a pretension warmed up in the timid privacy of the urinary bowl, hysteria born in the studio.[5]

The new impulse resulted both in Marcel Duchamp's 'ready-mades', such as the shovel he bought in 1915 and entitled *In Advance of a Broken Arm* ('. . . to cut short any counter-attack of taste'), and also in the first of Arp's formal constructions, such as *Forest* (1916), in reference to which he wrote: 'I tried to be natural.'[6]

Ill. 114

When, in about 1930, Picasso learned the techniques of metal sculpture from his friend, the Spanish sculptor Julio Gonzalez, his work turned from

114 HANS ARP, *Forest*,
1916

volumes or planes to linear formations, from delineated forms to generated space. Therein, the Cubist determination was reversed, expressed antithetically. In the sculpture of the Swiss Alberto Giacometti, the paring away of flesh, the absence of volume, engendered another spiritual vocabulary. At the same time that Picasso was working with wire sculpture, Giacometti was calling his own early works constructions rather than sculptures, pure object, magic rather than substance. He said that, 'Once the object is constructed, I tend to see in it, transformed and displaced, facts which have profoundly moved me, often without my realizing it. . . .'[7]

Giacometti's interest in space, like Picasso's, had nothing in common with the Constructivists' formal purity and the magical concerns of the Surrealists, though in fact it diverged from both.

161

115 HENRI LAURENS,
Head, 1917

In the course of forty years after the Cubist experiment, Picasso evolved, in sculpture as in painting, an extraordinarily varied command of plasticity and metaphor. And just as Lipchitz or Laurens were to embody the deeper dynamics of Cubism in their later, less specifically Cubist works, those same energies continued to be present in varying degree in Picasso's.

Compare the monumental and voluminous heads of 1932 with *The Bathers* (1956), a stark group of flat figures, almost silhouettes; though very differently motivated, all evoke the formalism and purification of the Cubist vision. The first group is akin to the work of Moore and Miró as well as of Lipchitz and Laurens; the second relates to the austerities of Giacometti; though all deviate from their Cubist origins, their language of formal truths is rooted in them.

Kinships and Consummations

The distinction between the terms 'Cubist movement' and the 'Cubist intelligence' becomes especially pertinent to the post-war years. The movement *per se* may have ended with the First World War, but the 'Cubist intelligence' has continued to generate art to the present day. In the case of Picasso and Braque, Cubist thought remained understandably relevant.

Léger, for example, had his links to an almost Futurist enthusiasm for the machine, yet with an eye to the power of the industrial object itself, its irreducible shape, its organic structure, rather than to the implied energies of the machine as a godly force. After the war, he was able to translate these impulses, through the lyric mechanics of *The Disks* (1918) and on to his great series called *The City* (1919–20), in which the Futurist kinship wanes. As a plastic composition, *The City*, in both its studies and its final form, functions as a façade of pure colour, pure shape. As a theme, it projects an inner life, the electricity, tempo, violence of the modern, industrial metropolis. In the latter sense, the series is a major contribution to Cubism as an urban consciousness, the sense of the city as an architecture of the spirit. *The City* adopts the Synthetic Cubist philosophy of colour and form without, however, embodying its analytical substructure; its plastic forms are used to create a symbolic heraldry. Picasso and Braque drew decorative components out of the organic; Léger did the opposite: 'A work of art is a perfect balance between real and imaginary facts', he wrote. The dual tendency illuminates the metaphorical range of Léger's work: from *Still Life with a Mug* (1921), which reveals similarities to the work of Juan Gris, though at once more blunt and more decorative, to *Butterfly and Flower* (1937) in which pure form tends to metaphor and the surreal factor increases; and finally, to the late figure pieces, in which the original Cubist canons determine Léger's forms, but towards completely new ends, so that they are totally transformed.

In the Léger paintings that immediately followed *Nudes in the Forest* (p. 72), that is, *Three Figures* and *The Wedding* (1910–11), or *Smoke over the Roofs* and *The Woman in Blue* (1912), for example, the precipitant curve of the Futurists bit into the sovereign Cubist line, and in 1913, Léger evolved a new vocabulary of solid volumes that consolidated the two, a vocabulary expressing a growing

Ill. 120

Ill. 121

Ill. 116
Ill. 117

◀ 116 FERNAND LÉGER,
The Wedding, 1910–11

117 FERNAND LÉGER,
The Woman in Blue, 1912

reverence for the object itself as form and as symbol. Of the war years he later wrote, 'I was abruptly thrust into a reality which was both blinding and new. I was dazzled by the breach of a 75 millimetre gun which was standing uncovered in the sunlight, the magic of light on white metal.'*[1]

*The integral difference between Léger's Cubism and that of Picasso or Braque is summed up in the comparison between this statement and one of Picasso's, as recalled by Gertrude Stein: 'All of a sudden down the street came some big cannon, the first any of us had seen painted, that is camouflaged. Pablo stopped, he was spell-bound. C'est nous qui avons fait ça! he said, it is we that have created that, he said. And he was right, he had. From Cézanne through him they had come to that. His foresight was justified.'[2]

Robert Delaunay's contribution was summed up with a keen perception in Blaise Cendrars's poem *Tour*, of 1913.[3]

> *At the heart of Africa it is always you who run*
> *Giraffe*
> *Ostrich*
> *Boa*
> *Equator*
> *Moss*
> *In Australia you have always been taboo*
>
> *You are the gaff that Captain Cook used to guide his boat of adventures*
> *O celestial weight!*
> *For the Simultaneous Delaunay, to whom I dedicate this poem,*
> *You are the brush that he soaks in light*

Structurally, in its almost Impressionist concern for the effect of light itself and in its acceptance of external realities – as well as in the pure abstraction of the

later works – Delaunay's Simultaneism differed from Cubism. Nevertheless, in this broader context, into which the true Cubists themselves moved after the war, the *rapport* is re-established. For Delaunay, as well, areas of pure form, whether conceived as light or not, fitted into a new, conceptual scheme of vision. Delaunay's *Disk* series, as well as Léger's, established an evident link.

The Cuban painter, Francis Picabia, found yet another corridor issuing from Cubism when he joined the Dadaist ranks and transformed his earlier cubed or fragmented compositions into a new physiology that utilized both the machine itself and an imagined and very surreal anti-matter, as in *I see Again* *Ill. 118* *in Memory My Dear Udnie* (1913). But his departure seems less definitive if compared to Marcel Duchamp's progression from the descending nudes and *Young Man* (1911) to *The Bride* (1912); his metaphorical statement becomes *Ill. 119* more literary, yet the synthesis of pure form maintains a firm affinity with Cubism.

It was not through any modification of form, style or metaphor, but only through a total switch to his 'ready-mades' that Duchamp was able to break

121 FERNAND LÉGER, *The City*, 1919

◀ 120 FERNAND LÉGER, *The Disks*, 1918

with Cubism. In these works the artist presented ordinary manufactured objects as self-sufficient works of art. Out of context they took on new and often startling plastic interest.

There were others, however, who developed the Cubist idea by purely painterly means, with varying departures from orthodoxy, some with architectural emphasis, some decorative. The Polish painter, Louis Marcoussis, incorporated both tendencies. Marcoussis's reputation is undeservedly slight, for whereas Gleizes and Metzinger were doctrinaire, Marcoussis's Cubism was *Ill. 122* spontaneous, and he developed a structural cogency from the decorative

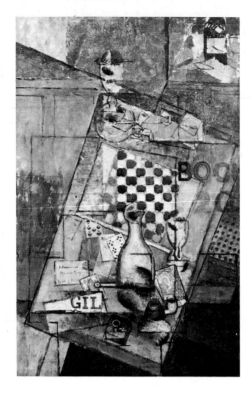

122 LOUIS MARCOUSSIS,
Still-Life with Chessboard, 1912

123 JACQUES VILLON,
Marching Soldiers, 1913 ▶

elements themselves, the vibrant handling of line and pigment. Henri Hayden, like Marcoussis a Pole working in Paris, concentrated on the decorative element almost entirely; his best works impress lyrically, the others succumb to frailty. André Lhote, like Gleizes and Metzinger a conscientious theoretician, fell even further from the mark than they.

The very different Roger de la Fresnaye and Jacques Villon, however, were involved with structural preoccupations. La Fresnaye's earlier Cubist works, through 1912, tended to be earnest explorations of solid form, interpreted *Ill. 124* through angular masses, based upon Cézanne. With *The Conquest of the Air* (1913), he found a new expansiveness, although the treatment of the figures remains limited, laborious, and stylized. But in the surrounding passages, especially the background areas of sheer light and space, La Fresnaye overcame these limitations.

Ill. 123 Jacques Villon's experience differed from those of his brothers, Marcel Duchamp and Raymond Duchamp-Villon. In his case, an essentially lyrical, even mystical, vision was submitted to a framework of angular definitions and

170

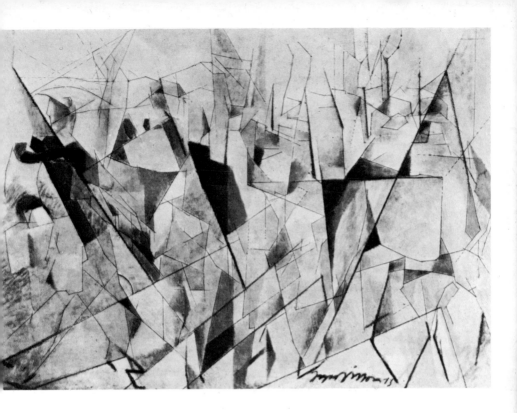

refractions, not identical with but springing directly from Cubist vision. The adaptation might even be called an Impressionist acceptance of Cubism – which implies the synthesis of two apparently opposite tendencies. Subtleties of light were meshed with a linear, sometimes geometrical delineation, a precarious fusion. Where he failed in balancing the two, the result became stylistic. Where he succeeded, the conceptual contradictions dissolved. In Villon's etchings, however, the elimination of colour in favour of an equivalent light produced by the varying quality and density of line facilitated the solution. There, Villon was an undisputed master.

After the war, when Braque recovered from his wounds and Picasso returned, intermittently, from his experiments with theatre, the Cubist path visibly narrowed. The earlier struggle with structure and metaphor was eased, and the decorative element became more prominent. This state of affairs was somewhat more favourable to Braque than Picasso, but created problems for both.

Museum of Modern Art, New York

124 ROGER DE LA FRESNAYE, *The Conquest of the Air*, 1913

125 GEORGES BRAQUE, *The Musician*, 1917–18 ▶

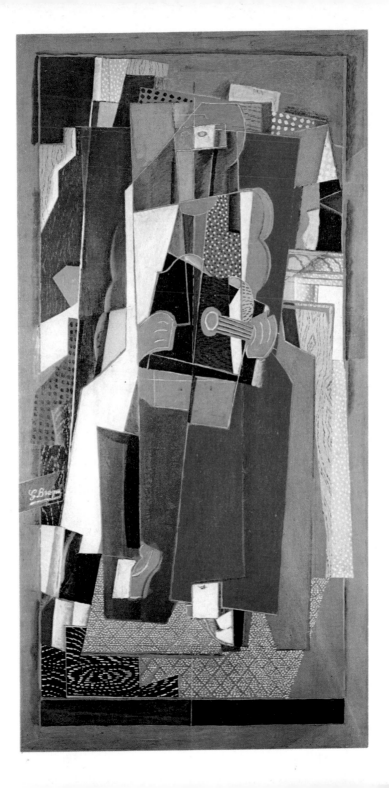

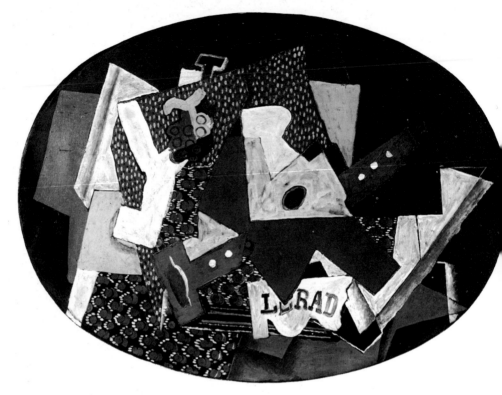

126 GEORGES BRAQUE, *Clarinet, Guitar and Fruit-Dish*, 1918

127 PABLO PICASSO, *Harlequin*, 1917 ▶

Personal disruptions occurred; Picasso (who had meanwhile married Olga Kokhlova, one of Diaghilev's dancers), quarrelled with Braque, and was himself snubbed by Gertrude Stein. There were other difficulties, as well. The Dadaists cried for Promethean assaults, but Cubism was in a singularly Apollonian phase. The movement now had a slightly larger audience, but was still under attack from the right, and even more so from the left.

Ill. 125 Braque's *The Musician* (1917–18) and Picasso's *The Italian Woman* (1917) or *Harlequin* (1918) show the problems inherent in a preponderance of style over deeper architectural or metaphorical content. To solve them, Braque turned to

174

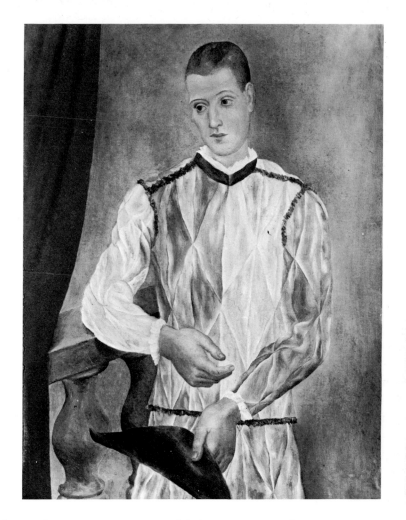

his innate gifts of poetic lyricism, taste, instinct and balance; Picasso to his
extraordinary range of metaphor, never more intense than at this juncture. The
movement proved to be a turning-point in his career.

As one solution, he tackled the element of style itself in a series of small still-
lifes that maximized flat, interlocked areas of decorative surface. In these 1918
works even the surface of pigment, or sand, became integral to a purposefully
diminished harmony; essentially, this was an extreme variation of the solution
to his problem of 1915, which was to incorporate the decorative factor in his
figure compositions as successfully as in the still-lifes. Then, he had reduced

175

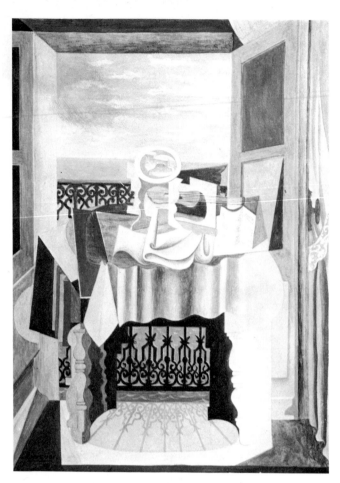

128 PABLO PICASSO,
Table Before an Open Window,
1919

129 PABLO PICASSO,
Dog and Cock, 1921 ▶

the figurative reference by several degrees, as in the *Harlequin* (p. 116). Now, he moved even farther into the area of decorative abstraction and very radically reduced the subject-object reference.

But he had not altogether abandoned that frame of reference, for in the same period he also returned directly to the human form, and in 1917 resurrected

Ill. 127 his *Harlequin* in an entirely different conception; he developed the classicism of Ingres and added a distinctly Greco-like luminosity. The same realism, though without the Greco influence, appears in a series of ultra-realistic portraits of Olga (1917) and in the portrait of Mme Rosenberg and her daughter (1918). These are complete and impressive works of art though Picasso was recharging at heart his energies for more distinctly personal exploits.

176

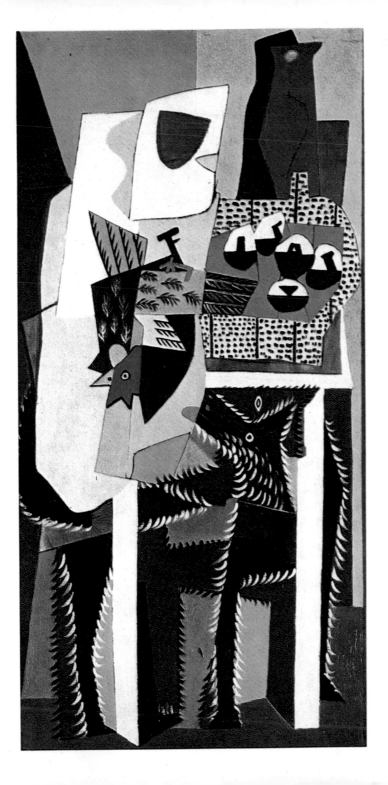

130 PABLO PICASSO, *Table Before an Open Window*, 1920

131 PABLO PICASSO, *The Table*, 1919–20

132 PABLO PICASSO, *Glass, Tobacco Packet and Playing-Card*, 1919 ▶

Ill. 128 Both tendencies play a part in the *Table Before an Open Window* series done at Saint-Raphael on the Côte d'Azur during the summer of 1919. In oil, watercolour, gouache and drawing, Picasso took the theme through a course of anatomization, construction and re-construction. The Cubist formulations are variously united with elements of intense realism or, sometimes, in a very classically conceived, but idealized form situated exactly between the two.

The experience proved enormously strengthening. During the winter of 1919–20 and on into 1921 Picasso was able to return to ostensibly decorative surfaces with new authority – as in three continuations of the summer theme,
Ills. 129–31 *The Table, Table Before an Open Window* (rue de Penthièvre), and *Dog and Cock*.
178

The third strain in Picasso's efforts of these years must be ascribed to the influence of Braque. From the rigidity of *The Musician* Braque moved into another and more personal key. The familiar Cubist austerities began to melt: geometric shapes gave way to fluidities, and the language of colour, rich and resonant, became more important. The Braque still-lifes of 1918–19 inaugurated a series that can be traced at least into the late 1920s, and their vibrations echoed into the 1930s. The Cubist elements of these paintings appear as notations, sometimes as a framework for, sometimes as accents to, those lyrical harmonies, the rhythms of which were now less hermetic, more personal. Of this new voice Picasso later said: 'He never sings off key.' And in works such as *Glass, Bouquet, Guitar and Bottle* or *Glass, Tobacco Packet and* *Ill. 132* *Playing-Card* (both 1919), the influence upon Picasso is evident. The new force that Picasso brought to his still-lifes of late 1919 and 1920 was hard-pressed to serve as well in the direction of human reference. The series of small *Pierrot and Harlequin* gouaches of 1920 resolved the problem handsomely, by the way *Ills. 135–8* of style itself, in the same subdued and concentrated way of the small 1918 still-lifes. Nevertheless, those little gouaches also began to suggest a new, significantly inventive, synthesis of Cubist elements.

In 1921, even as he moved into the vastly different series of figure pieces which constitute his classical period, Picasso painted those two great works, *The*
Ills. 134, 133 *Three Musicians* and *The Three Masked Musicians*. These paintings not only presage the future, but also act as a *grand finale* to the Cubist years *per se*. If *Les*

180

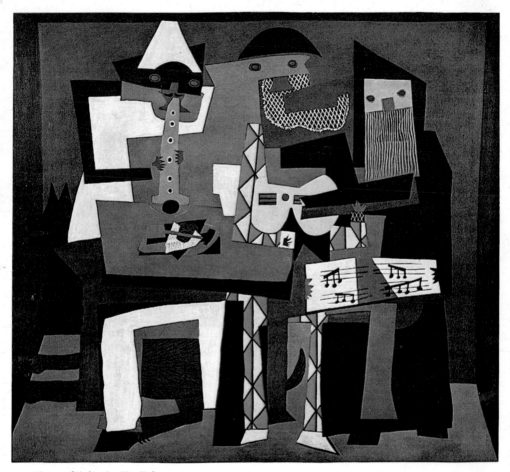

Museum of Modern Art, New York

134 PABLO PICASSO, *The Three Musicians*, 1921

◀ 133 PABLO PICASSO, *The Three Masked Musicians*, 1921

Demoiselles was the great curtain that rose on the first act, these works function as the closing curtain. The harlequin, the clown and the monk act as symbolic presences, fused in a grandiose formulation of the human-cum-still-life admixture, the new architecture and the new theatre. The Cubist credos of

181

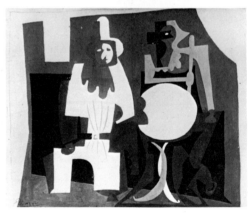

135–38 PABLO PICASSO, *Pierrot
and Harlequin*, 1920

surprise, of formal purities and magical alchemy, are all incorporated. The
masked version inclines rather more to the earlier severities of colour, the other
to the new sonority.

The echoes of Cubism were to resound for some time, the deepest currents of
the Cubist intelligence to find new channels and outlets, yet the movement as
such, the drama that began in the rue Ravignan in 1907, was over.

Echoes and Refractions

During the 1920s, Picasso painted a number of canvases that moved from the Cubist track on to two opposite paths; one led to his Classical Period, the other to a series of obsessional, almost perverse studies of the human head. In his *Head* (1926), and *Harlequin* (1927), Picasso began to demolish the dignity of his forms largely by superimposing upon them comic or grotesque features – nostrils, mouths, noses. *Ill. 143*

Stylistically, the images of the Classical Period deviate completely from Cubism, whereas these flat and greatly formalized heads are Cubism's direct heirs. Spiritually, the exact opposite is the case: the Classical phase reconstructs the essentially classical nature of Cubism, whereas the heads strike out at it. In *The Yellow Belt* (1932), this rejection is so extreme as to approach not only anti-classicism but even anti-art.

To be sure, in other paintings of the decade, such as *The Studio* (1928), or *The Three Dancers* (1925), Picasso resolved the extremes harmoniously: the underlying classical imperative was restored and the Cubist link apparent. In fact, however, a new conflict of the Promethean and the Apollonian was about to occur, a new tension between invention and resolution, metaphor and form. During these years motivations were shifting from the original Cubist concern for what Picasso had seen as 'an anonymous art' beyond the first person singular, to an art based very closely on personal expression, so that many works which still incorporated specifically Cubist formulations and continued to suggest the Cubist experience, actually tended in a diametrically opposed direction. *Ill. 140* *Ill. 139*

One important train of thought can be traced through the 'image of an image' concept in the subsequent work of both Picasso and Braque. The classical works were by definition the image of an ideal in art. For both Picasso and Braque, the painter in his studio or the painter and his model were to become recurrent themes or, in other words, the image of the very activity that simul-taneously produces the image. In other paintings, a classic bust figured as still-life material; in some, epitomized by Picasso's *Woman Before a Mirror* (1932), the image of a mirror image becomes the material of a double reflection. In *Woman Bather on the Beach* (1929), or in the very sexual and again obsessional *Ill. 141*

Museum of Modern Art, New York

140 PABLO PICASSO, *The Studio*, 1927–28

◀ 139 PABLO PICASSO, *The Three Dancers*, 1925

Figures by the Sea (1931), or *Woman Throwing a Stone* (1931), the image of the subject‑object takes on the character of a sculptural pre‑formulation. Finally, from 1950, Picasso began a series that took the 'image of an image' concept into a new dimension by actually adapting, reconstructing and sometimes parodying the *chefs‑d'oeuvres* of old and modern masters. Such were: *Portrait of a Painter After Greco* (1950): *Young Ladies on the Banks of the Seine* (1950), after *Ill. 145* Courbet; three extensive series based upon *The Algerian Women* of Delacroix (1955); *Las Meninas* (1957), after Velazquez; *Le Déjeuner sur l'Herbe* (1960), after Manet; and, finally, *The Rape of the Sabines* (1963), after David. The masterpieces of the Louvre or Petit Palais thus joined company with the Cubist pipe or bottle period as equally usable material, and, once more, the reality and the image were alchemized and re‑created.

141 PABLO PICASSO,
Woman Before a Mirror,
1932

Museum of Modern Art, New York

142 PABLO PICASSO,
Guernica, 1937

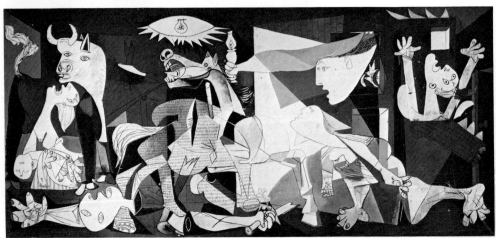

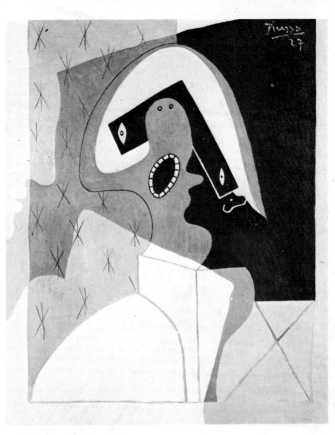

143 PABLO PICASSO,
Harlequin, 1927

During the late 1930s, the Cubist image reappeared in Picasso's work in another form, best exemplified by the *Weeping Woman* (1937). This was the period of the Spanish Civil War and of Picasso's epic answer to it, *Guernica* (1937). It was a period of intensely human concern and personal grief, and the painting was a very formalized treatment – which, in the *Weeping Woman*, echoes Cubism very closely – that restrained and distilled the emotional quality of the experience. Here the Promethean and the Apollonian voices were both given full play, the metaphor becoming aggressive and violent, and the formal element tending towards an almost cold abstraction. In *Guernica* itself, the most savage and emotional of all the works of this period, Picasso returned to the monochromatic colour of Analytical Cubism, but to the opposite end.

In the 1937–38 portraits of Dora Maar, who was then his mistress, the colour intensifies and the Cubist echo is heard again. The new construction of the head, with its projecting nose-forehead mass, recapitulates the head/still-life

Ill. 142

Ill. 144

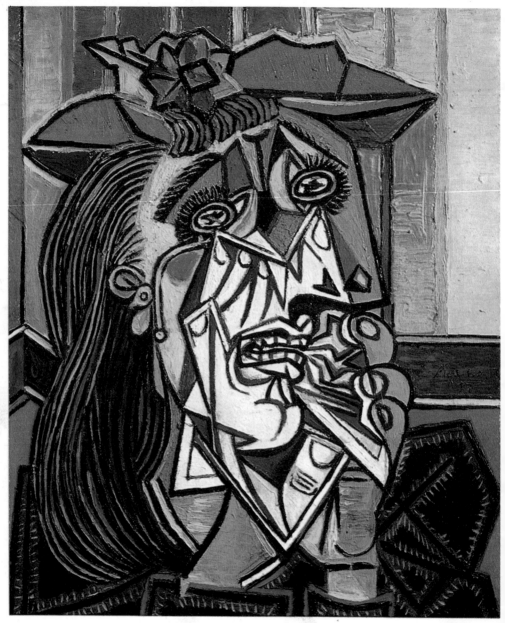

144 PABLO PICASSO, *Weeping Woman*, 1937

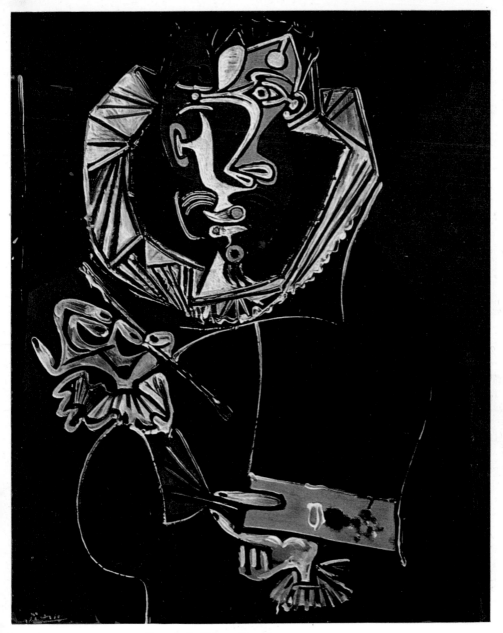

145 PABLO PICASSO, *Portrait of a Painter After Greco*, 1950

drawings of 1912–13. The Cubist image appears to have risen from its context to become a new entity, a new fetish, an echo of the primitive mask in a magical context.

Braque found it possible and congenial to remain close to a Cubist language, though he never returned to its original austerities. As early as 1922, and consistently into 1924, his reaction against Cubist angularities intensified. This was the period of his massive but liquid nudes, the period in which he re-asserted the cold browns and blacks, lemon-yellows and silvery tones that have been associated with his personality ever since. In the early thirties, however, Cubism provided a linear framework for subtleties of transparent colour, and by the mid-thirties, and into the forties, it functioned more specifically in a sequence of rich still-lifes that also utilized Braque's decorative instinct to the

146 GEORGES BRAQUE, *The Round Table*, 1929

147 GEORGES BRAQUE, *The Table*, 1928

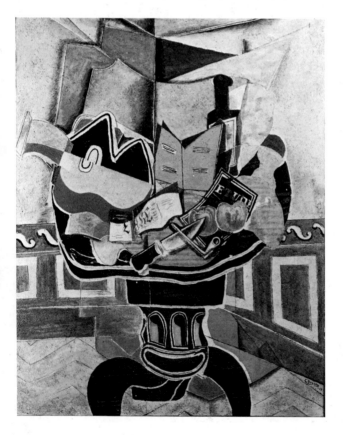

Museum of Modern Art, New York

fullest extent. Nevertheless, in the figure pieces of the late thirties, Braque had
recourse to its formal attributes as well as its magic. Witness *Woman with a* — Ill. 148
Mandolin (1937), in which the whole Cubist vocabulary undergoes a re-
formulation under pressure of taste and temperament. The figure is in fact a
double image whose shadow-silhouette precedes its positive equivalent
behind it, yet bears the literal indications of feature and detail. The Cubist

148 GEORGES BRAQUE, *Woman with a Mandolin*, 1937

149 PIET
MONDRIAN, *Tree*,
c. 1912

still-life on the wall exceeds its frame to assume a dimension of its own, the image of an image of an image. With the greatest discretion, flat decorative indications are countered by the surprise appearance of specifically three-dimensional references in the vase on the table, the music-stand and the mandolin. For Braque these later works may have been spiritual completion of his Cubist experience rather than an epilogue to it. In *Nord-Sud* he had written, in 1917: 'I love the rule which corrects emotion.' In his notebooks of the forties, he repeated this idea but added the reverse: 'I love the emotion that corrects the rule.'

192

Because the Cubist intelligence had become so profound an influence upon modern vision as to affect painters and sculptors whose aims were very different, there is a temptation to associate almost any subsequent handling of pure form, geometric or not, abstract or not, with Cubism. In certain cases, this is justifiable historically, for, were it not for Cubism, many of these later manifestations might not have existed. It is argued, too, that Cubism also had an inevitable influence upon design, fashion and the machine itself, in turn defining a contemporary sense of what is modern. But there were offshoots whose ties to the movement were of course more direct.

Curiously, two men who worked significantly with Cubist values did so in expressed opposition to the movement. The painter Amédée Ozenfant and the architect Le Corbusier (Charles-Edouard Jeanneret) pronounced Cubism dead in their first manifesto, *Après le Cubisme* (1918), and asserted their own fidelity to industrial forms and their antipathy to Cubist interpretations of the self-sufficient object. They called their aesthetic principle 'Purism'. In retrospect, however, Ozenfant's very sensitive linear formulations modify rather than oppose Cubist tendencies. He was later to incorporate Surrealist references in similar works. Painting was never Le Corbusier's most eloquent medium of expression, but, perhaps ironically, he was to utilize his Purist explorations in the domain of architecture itself with revolutionary success.

In contrast, Piet Mondrian's paintings had immediately Cubist origins. Mondrian, born in Holland in 1872, was to make prodigious headway in Impressionist and Pointillist pursuits before turning in the Cubist direction *circa* 1911–12. From that time until his death in 1944, Mondrian's evolution followed a strict and logical course. His successive treatment of *Trees* during 1912–13 pursued an Analytical track similar to Picasso's and Braque's to a point of almost exact coincidence in *Oval Composition with Trees* (1913). Thereafter the difference in Mondrian's objectives became apparent. 'To denaturalize', Mondrian wrote in the periodical *De Stijl*, 'is to deepen.' His ideal was:

Ill. 149

Ill. 150

a new aesthetic based on pure relationships of lines and pure colours because only the pure relationships of pure constructive elements can achieve a pure beauty. Today, pure beauty is not only a necessity for us, it is the only means to a pure manifestation of the universal force that is in everything. It is identical to what was known in the past under the name of divinity.[1]

The label he preferred was 'Neo-Plasticism'.

The statement makes clear both Mondrian's link to the Cubist species of purity and his deviation from it. His work moved steadily towards the exclusion

193

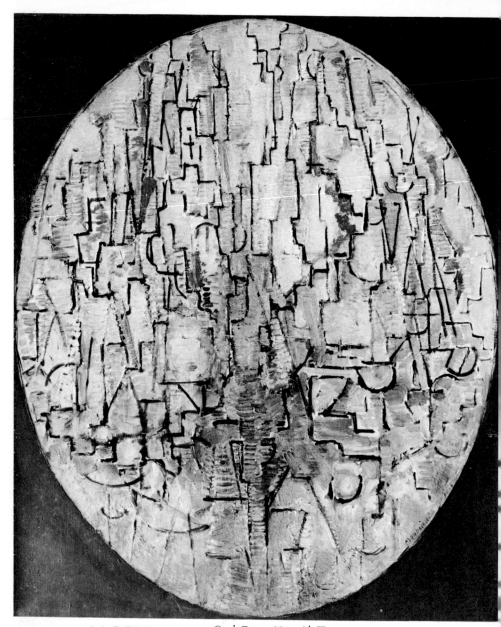

150 PIET MONDRIAN, *Oval Composition with Trees*, 1913
151 PIET MONDRIAN, *Broadway Boogie-Woogie*, 1942–43 ▶

of all recognizable human reference. Obvious brushwork gave way to absolutely
flat areas of colour. Curves were entirely replaced by the square and rectangle, *Ill. 151*
and natural colour references were eliminated. And yet, even in the late and
purest Mondrian paintings, there remained an organic intelligence inseparable
from that of the early *Trees*. In that deeper sense, his bond to a Cubist past is

Museum of Modern Art, New York

152 JOAN MIRÓ, *Dutch Interior I*, 1926

endorsed by a comparison with those who, like Victor Vasarely, or Josef Albers, followed his purist tendencies, and all those of the school of highly geometrical, non-objective abstraction known as Hard Edge. For Mondrian's organic equilibrium came out of nature and, even when it seemed in total opposition, continued to reflect its promptings, substantially though subliminally. Hard Edge, in contrast, begins with the premise of the completely abstract shape. Its references are exclusively formal, so that one would be tempted to call the connection with nature almost non-existent were it not for the principles established by the movement labelled Op Art, which succeeded Hard Edge. If the latter tends to be wholly plastic as opposed to psychological, the eye's natural functions of perception are still, however, called into play, whereas in Op Art the reaction is purely retinal, and the link with Cubism is thus broken entirely.

Joan Miró's debt to Cubism is somewhat ambiguous. In his case, a very formal language encounters the Surrealist dream reality and summons up a psychological experience that goes beyond the implications of form and colour. Therefore, his painting has a double character; it can be seen in terms of a flat surface whose formal arrangements, humours and physical values describe a world of purities akin to those of Cubism, or, on the other hand, in terms of a surreal experience. *Dutch Interior* (1926), is one such painting. Apollinaire had compared Braque's work to that of 'the good period of Dutch painting'; there is much of the same formal clarity in the Miró, yet those same shapes, colours, references, set up vibrations that challenge other portions of the mind. *Ill. 152*

Many other painters chose in their various ways to adopt or adapt Cubism. The American, German-born Lyonel Feininger refracted the light of cities and seascapes into formal, geometrical planes, a Cubist-Impressionist vocabulary distantly akin to that of Jacques Villon. In England, Ben Nicholson has adhered to a muted, flat handling of purified shapes, at times coolly objective, at times non-objective, almost always directly derived from Cubist tone and formulation. In the United States, Stuart Davis's celebrations in primary colour clearly derive from Cubist harmonics.

It has even been pointed out that Cubism served as a partial influence upon the German Expressionists, whose basic aims were totally opposed to those of Cubism. If one excepts Franz Marc, who had experimented extensively with Cubist values before his death in the First World War, painters like Ernest Ludwig Kirchner and Oskar Kokoschka were ultimately deeply indebted to the movement. In their early contacts with Cubism, they absorbed Cézanne's ideas, just as the Cubists had, and quickly realized the possibilities of adapting the concepts, volumes and pure dynamics to their own specifically Germanic,

Notes on the text

I CUBISM: EVOLUTION AND REVOLUTION

1 Pablo Picasso, 'Letter to Marius de Zayas, 1923', published as 'Picasso Speaks', *The Arts*, New York, May 1923.
2 Françoise Gilot and Carlton Lake, *Life with Picasso* (New York 1964). This personal memoir of Picasso's former wife recalls her association with him beginning in 1943. It can be argued that a quotation of this length, recounted after a passage of years, cannot be accurate, that only the sense of Picasso's words has been preserved.
3 Paul Cézanne, letter to Emile Bernard, April 1904. 'Tout dans la nature se modèle selon la sphère, le cône et le cylindre. . . .'
4 'Juan Gris', orig. in *L'Esprit Nouveau*, No. 5, Paris, February 1921; English trans. in D.·H. Kahnweiler, *Juan Gris*, New York 1947, p. 138.

II TOWARDS CUBISM: PICASSO AND *LES DEMOISELLES D'AVIGNON*

1 Pablo Picasso, 'Letter to Marius de Zayas', op. cit.

III PICASSO, BRAQUE, APOLLINAIRE: THE MAGIC TRIANGLE

1 André Billy, *Apollinaire*, Paris 1967, p. 20.
2 Braque, 'Pensées et réflexions sur la peinture', in *Nord·Sud*, Paris, December 1917.
3 Michel Georges·Michel, *De Renoir à Picasso*, Paris 1954, pp. 90–1.
4 Louis Vauxcelles, in *Gil Blas*, Paris, 14 November 1908.
5 Guillaume Apollinaire, *Les Peintres Cubistes*, Geneva 1950, p. 37.
6 Michel Georges·Michel, op. cit., p. 112.

IV LINES PARALLEL, LINES TANGENT

1 L.·C. Breunig, 'Apollinaire et le Cubisme, le Cubisme et l'Esprit Nouveau', *Revue des Lettres Modernes*, Paris 1962, p. 19.

2 Guillaume Apollinaire, *Les Peintres Cubistes*, Geneva 1950, p. 54.
3 Michel Georges-Michel, *De Renoir à Picasso*, Paris 1954, pp. 89–90.
4 Marguerite Bonnet, 'Aux Sources du Surréalisme: Place d'Apollinaire', in 'Apollinaire et les Surréalistes', *Revue des Lettres Modernes*, Paris 1964, pp. 71–2.
5 Wallace Fowlie, *Age of Surrealism*, New York 1950, p. 89.
6 Apollinaire, op. cit., p. 37.
7 Apollinaire, op. cit., pp. 63–4.
8 Gertrude Stein, *Autobiography of Alice B. Toklas*, London 1966, p. 116.

V THE CIRCLE WIDENS: ROOM 41

1 Braque, *Le Jour et la Nuit, Cahiers de Georges Braque, 1917–52*, Paris 1952, p. 9.
2 Gleizes and Metzinger, *On Cubism*, Paris 1912, p. 10.
3 *Technical Manifesto of Futurist Sculpture*, 11 April 1922, in English in Joshua C. Taylor, *Futurism*, New York 1961, pp. 124 ff.
4 Rosa Trillo Clough, *Futurism*, Philosophical Library, New York 1961, pp. 61–2.
5 Clough, op. cit., p. 78.
6 Gertrude Stein, *Autobiography of Alice B. Toklas*, London 1966, p. 108.
7 Apollinaire, in J.-C. Chevalier and L.-C. Breunig, 'Les peintres Cubistes, Apollinaire et les Surréalistes', *Revue des Lettres Modernes*, 1964, p. 101.
8 Boccioni, in Joshua C. Taylor, op. cit., p. 124 ff.
9 Boccioni, undated letter to Vico Baer, 1913, in Taylor, op. cit., p. 134.
10 Boccioni, in Taylor, op. cit., p. 134.
11 Taylor, op. cit., p. 69.

VI NEW PERSPECTIVES, NEW REALITIES

1 Gertrude Stein, *Autobiography of Alice B. Toklas*, London 1966, p. 122.
2 André Fermigier, *Jean Cocteau entre Picasso et Radiguet*, Paris 1967, p. 115.

VII JUAN GRIS: THE MUSIC OF SILENCE

1 Cocteau, *Entretiens avec André Fraigneau*, Bibliothèque 10/18, Paris, 1965, p. 22.
2 Gris, 'Une Conférence de Juan Gris', in catalogue, Juan Gris-Fernand Léger, *Cahiers d'Art*, Paris, May 1933 (exhibition at Kunsthaus, Zurich), pages unnumbered.
3 Gris, in James Thrall Soby, *Juan Gris*, New York, 1958, p. 108.
4 Gris, 'Une Conference de Juan Gris', op. cit.
5 Gertrude Stein, op. cit., pp. 228–9.

VIII CUBIST LANGUAGE, CUBIST THEATRE

1 Gertrude Stein, *Autobiography of Alice B. Toklas*, London 1966, p. 228.
2 Pierre Reverdy, *Livre de mon bord, notes 1930–36*, Paris 1948.
3 Gertrude Stein, *Camera Work*, New York, 1912, pp. 29–30.
4 Cendrars, 'Lettres', in *Au Cœur du Monde, Poésies complètes: 1924–29*, Paris (n.d.), p. 13.
5 Georges Lemaître, *From Cubism to Surrealism in French Literature*, New York 1941.
6 Lemaître, ibid.
7 Pierre Daix, *Picasso*, London 1965, p. 103.
8 Lemaître, op. cit., p. 125.
9 Olivier-Hourcade, 'La Tendance de la peinture contemporaine', *Revue de France et des Pays Français*, Paris, February 1912, pp. 35 ff.; English trans. in Fry, *Cubism*, London, New York 1966, p. 74.
10 Louis Parrot, *Blaise Cendrars*, Paris 1948, p. 29.
11 Cendrars, 'Portrait' (Dix-neuf poèmes élastiques), in *Du Monde Entier, Poésies Complètes, 1912–24*, Paris (n.d.), p. 77.
12 Louis Parrot, op. cit., p. 30.
13 Cocteau, 'Jazz-Band', *Paris-Midi*, 4 August 1919, collected in Fermigier, *Jean Cocteau entre Picasso et Radiguet*, Paris 1967, p. 99.
14 Fermigier, *Jean Cocteau entre Picasso et Radiguet*, p. 49.
15 Cocteau, letter to Paul Dermée, director of *Nord-Sud*, Spring 1917, p. 70.
16 Apollinaire, text for the programme of *Parade*, collected in Fermigier, *Cocteau entre Picasso et Radiguet*, p. 70.

IX THE RESPONSE IN SCULPTURE

1 'Technical Manifesto of Futurist Sculpture', 11 April 1922, English trans. in Taylor, *Futurism*, New York 1961, p. 131.
2 *Duchamp-Villon* (*Le Cheval-Majeur*), introduction by R. V. Ginderstael, Galerie Louis Carré, Paris 1966, p. 19.
3 André Breton, 1933 statement, in *Hommage à Pablo Picasso: Dessins, Sculptures, Céramiques*, Petit Palais, Paris 1967.
4 *Arp*, ed. James Thrall Soby, Museum of Modern Art, New York 1958, p. 13; quoted in Herbert Read, *A Concise History of Modern Sculpture*, London 1964, p. 50.
5 Tristan Tzara, *Manifestes*, 1917, quoted in Hans Richter, *Dada: Art et Anti-Art*, Brussels 1965, p. 31.
6 Herbert Read, op. cit., p. 153.
7 Herbert Read, op. cit., p. 158.

X KINSHIPS AND CONSUMMATIONS

1 Katherine Kuh, *Léger*, Chicago 1953, p. 23.
2 Gertrude Stein, *Autobiography of Alice B. Toklas*, London 1966, p. 99.
3 Cendrars, 'Tour' (Dix-neuf poèmes élastiques), in *Du Monde Entier, Poésies Complètes, 1912–24*, Paris (n.d.), p. 71.

Select bibliography

APOLLINAIRE, GUILLAUME, *Les Peintres Cubistes: méditations aesthétiques*, Paris 1913. Geneva 1950.
Documents Iconographiques, Geneva 1965.
BARR, ALFRED H., *Picasso: Fifty Years of His Art*, New York 1946.
Cubism and Abstract Art, New York 1961.
BILLY, ANDRÉ, *Apollinaire*, Paris 1967.
BONNET, MARGUERITE, 'Aux Sources du Surréalisme: Place d'Apollinaire', in *Apollinaire et les Surréalistes, la revue des lettres modernes*, Paris 1964.
BRAQUE, GEORGES, *Le Jour et la Nuit: Cahiers de Georges Braque, 1917–1952*, Paris 1952.
'Pensées et réflexions sur la peinture', *Nord-Sud*, Paris, December 1917.
BRETON, ANDRÉ, 'Ombre non pas serpent mais d'arbre en fleurs', in *Le Flâneur des deux rives*, No. 1, March 1934.
BREUNIG, L.-C., 'Apollinaire et le Cubisme', in 'Le Cubisme et l'Esprit Nouveau, *Revue des Lettres Modernes*, Paris 1962.
CENDRARS, BLAISE, *Du Monde Entier, Poésies Complètes, 1912–1924,* and *Au Cœur du Monde, Poésies Complètes, 1924–1929*, Paris 1947, 1967.
CERTIGNY, HENRY, *La Vérité sur le Douanier Rousseau*, Paris 1966.
CLOUGH, ROSA TRILLO, *Futurism*, New York 1961.
COCTEAU, JEAN, *Entretiens avec André Fraigneau*, Bibliothèque 10/18, Paris 1965.
DAIX, PIERRE, *Picasso*, London, New York 1965.
Dopo Boccioni, 1915–1919, Rome 1961.
EINSTEIN, CARL, *Braque*, Paris 1934.
ELUARD, PAUL, *A Pablo Picasso, Collection: Les grands peintres par leurs amis*, London, Geneva, Paris 1947.
FERMIGIER, ANDRÉ, *Jean Cocteau entre Picasso et Radiguet*, Paris 1967.
FOWLIE, WALLACE, *Age of Surrealism*, New York 1950.
FRY, EDWARD P., *Cubism*, London, New York 1966.
GEORGES-MICHEL, MICHEL, *De Renoir à Picasso*, Paris 1954.
GLEIZES, ALBERT, *Du Cubisme et des Moyens de le Comprendre*, Paris 1920.
GLEIZES, ALBERT and METZINGER, JEAN, *Du Cubisme*, Paris 1912.
GOLDING, JOHN, *Cubism: A History and an Analysis, 1907–1914*, London, New York 1959.
GRAY, CHRISTOPHER, *Cubist Aesthetic Theories*, Baltimore 1953.
HABASQUE, GUY, *Cubism*, Paris 1959.

KAHNWEILER, D.-H., *Confessions Esthétiques*, Paris 1963.

Juan Gris, Paris 1946; new enlarged edition (trans. Douglas Cooper), London, New York 1969.

KUH, KATHARINE, *Léger*, Chicago 1953.

LÉGER, FERNAND, *Fonctions de la Peinture*, Paris 1965.

LEMAÎTRE, GEORGES, *From Cubism to Surrealism in French Literature*, New York 1941.

MALEVICH, KASIMIR, *The Non-Objective World*, Chicago 1959.

PARROT, LOUIS, *Blaise Cendrars*, Paris 1948.

PICASSO, PABLO, 'Letter to Marius de Zayas' ('Picasso Speaks'), *The Arts*, New York, May 1923.

READ, HERBERT, *A Concise History of Modern Sculpture*, London, New York 1964.

REVERDY, PIERRE, *Le Livre de mon bord, notes, 1930–36*, Paris 1948.

ROSENBLUM, ROBERT, *Cubism and Twentieth Century Art*, London, New York 1968.

ROUSSELOT, JEAN and MAROLL, MICHEL, *Pierre Reverdy*, Paris 1965.

SALMON, ANDRÉ, *La Jeune Peinture Française*, Paris 1912.

SOBY, JAMES THRALL, *Juan Gris*, New York 1938.

STEEGMULLER, FRANCIS, *Apollinaire, Poet Among the Painters*, New York 1963.

STEIN, GERTRUDE, *Camera Work*, New York 1912.

The Autobiography of Alice B. Toklas, London 1933, 1966, New York 1933.

TAYLOR, JOSHUA C., *Futurism*, New York 1961.

The Graphic Work of Umberto Boccioni, New York, 1961.

ZERVOS, CHRISTIAN, *Georges Braque, Cahiers d'Art*, Paris, New York 1933.

CATALOGUES

Apollinaire, ICA Gallery, London 1968. Kunsthaus, Zurich 1966.

Braque (retrospective exhibition), Museum of Modern Art, New York 1949.

Dada, Musée National d'Art Moderne, Paris 1966.

Duchamp-Villon (Le Cheval-Majeur), Galerie Louis Carré, Paris 1966.

Juan Gris, Dessins et Gouaches, 1910–1927, Galerie Louise Leiris, Paris 1965.

Otto Gutfreund, 1889–1927, Grosvenor Gallery, London 1966.

Henri Laurens, Grand Palais, Paris 1967.

Jacques Lipchitz, The Cubist Period, 1913–1930, Marlborough-Gerson Gallery, New York 1968.

Mondrian, 1872–1944, Toronto, Philadelphia, The Hague 1966.

Hommage à Pablo Picasso: Peintures (Grand Palais); *Dessins, Sculptures, Céramiques* (Petit Palais); *Gravures* (Bibliothèque Nationale), Paris 1967.

Le Cubisme: Picasso-Braque-Gris-Léger, Galerie Knoedler, Paris 1962.

Picasso, An American Tribute, Public Education Association, New York 1962.

Picasso/Braque à Prague, et leurs contemporains tchèques, Musée National d'Art Moderne, Paris 1966.

Twentieth Century Paintings, Drawings and Ceramics, Sotheby & Co., London 1968. (Norman Granz Collection)

Impressionist and Modern Paintings, Drawings and Sculpture, Sotheby & Co., London 1967.

Zervos, Christian, *Pablo Picasso*, Vol. 2* *Œuvres de 1906–1912*; Vol. 2** *Œuvres de 1912–1917*, Paris 1942.

List of illustrations

1 GEORGES BRAQUE (1882–1963)
Grand Nu, 1908, oil on canvas,
$55\frac{3}{4} \times 40$ ($142 \times 101 \cdot 5$).
Formerly Collection Mme Cuttoli,
Paris. Photo Galerie Maeght.

2 PAUL CÉZANNE (1839–1906)
Mont Ste Victoire, 1904–06, oil on canvas,
$27\frac{7}{8} \times 36\frac{1}{8}$ ($70 \cdot 7 \times 91 \cdot 6$).
Philadelphia Museum of Art.

3 VICTOR PROUVÉ (1858–1943)
Bowl: Night, 1894, bronze,
$17\frac{7}{8} \times 31\frac{1}{8} \times 18\frac{7}{8}$ ($45 \cdot 5 \times 79 \times 48$).
M. Léon Meyer, Paris. Photo Benno
Kesselitz.

4 PABLO PICASSO (1881–)
Un Coupe de Théâtre, 1912, *papier collé,*
charcoal and gouache,
$24\frac{3}{8} \times 18\frac{7}{8}$ (62×48).
Musée National d'Art Moderne, Paris,
Cuttoli Collection.

5 PABLO PICASSO
Family of Acrobats, 1905, oil on canvas,
$83\frac{3}{4} \times 90\frac{3}{8}$ ($212 \cdot 8 \times 229 \cdot 6$).
National Gallery of Art, Washington,
D.C., Chester Dale Collection.

6 PABLO PICASSO
La Vie, 1903, oil on canvas,
$77\frac{3}{8} \times 50\frac{7}{8}$ ($196 \cdot 5 \times 129 \cdot 2$).
Cleveland Museum of Art, Ohio.

7 PABLO PICASSO
Nude Girl with Long Hair, 1906, oil on
canvas, $31\frac{7}{8} \times 21\frac{1}{4}$ (81×54).
Collection Walter.

8 PAUL CÉZANNE
The Boy in the Red Vest, 1894–95,
oil on canvas, $35\frac{1}{4} \times 28\frac{1}{2}$ ($89 \cdot 5 \times 72 \cdot 5$).
Collection Mr and Mrs Paul Mellon.

9 PABLO PICASSO
Gertrude Stein, 1906, oil on canvas,
$39\frac{1}{4} \times 32$ (98×80).
Metropolitan Museum of Art, New
York.

10 Iberian head from Osuna, limestone.
Museo Arqueologico, Madrid.

11 PABLO PICASSO
Self-portrait, 1907, oil on canvas,
$22 \times 18\frac{1}{8}$ (56×46).
National Gallery, Prague.

12 Mask from the Congo (the Fang mask),
formerly in Braque's studio. Wood,
whitened with kaolin, and fibres;
height $12\frac{1}{2}$ (32).
Musée de l'Homme, Paris.

13 Mask of the Likuala tribe, Gabon, late
nineteenth century, 14×6 ($35 \cdot 7 \times 15 \cdot 2$).
Brooklyn Museum, New York.

14 PABLO PICASSO
Sketch for 'Les Demoiselles d'Avignon',
1907, charcoal and pastel,
$18\frac{7}{8} \times 25$ ($47 \cdot 8 \times 63 \cdot 5$).
Collection Picasso.

15 PABLO PICASSO
Les Demoiselles d'Avignon, 1907, oil on
canvas, 96×92 (244×238).
Museum of Modern Art, New York.

16 PABLO PICASSO
Dancer of Avignon, 1907, oil on canvas,
59 × 39⅜ (150 × 100).
Collection Walter P. Chrysler, Jr,
New York.

17 PABLO PICASSO
Carafe and Three Bowls (Les Bols),
1907, oil on board,
26⅜ × 20½ (67 × 52).
Hermitage Museum, Leningrad. Photo
Arts Council of Great Britain.

18 PABLO PICASSO
Nude with Drapery, 1907, oil on canvas,
60¾ × 40½ (152 × 101).
Pushkin Museum, Moscow.

19 GEORGES BRAQUE
View from the Hotel Mistral, L'Estaque,
1907, oil on canvas,
31½ × 23⅝ (80 × 60).
Josten Collection, New York.
Photo Galerie Maeght.

20 GEORGES BRAQUE
Houses at L'Estaque, 1908, oil on canvas,
28¾ × 23⅜ (73 × 59·5).
Musée des Beaux Arts, Berne,
Collection Hermann Rupf Foundation.
Photo Galerie Maeght.

21 PABLO PICASSO
Nude in the Forest (La Grande Dryade),
1908, oil on canvas,
73¼ × 42⅛ (186 × 107).
Hermitage Museum, Leningrad.

22 PABLO PICASSO
Fruit and Wineglass, 1908, gouache on
wood, 10⅝ × 8⅝ (27 × 22).
Private Collection.

23 PABLO PICASSO
Three Women, 1908, oil on canvas,
78¾ × 70 (200 × 178).
Pushkin Museum, Moscow.

24 PABLO PICASSO
Woman with a Fan, 1908, oil on canvas,
59⅞ × 39¾ (152 × 101).
Hermitage Museum, Leningrad.

25 PABLO PICASSO
Harlequin, 1909, oil on canvas,
36½ × 28½ (92·6 × 72·3).
Collection E. Donati.

26 PABLO PICASSO
Woman with a Fan, 1909, oil on canvas,
39⅜ × 31⅞ (100 × 81).
Pushkin Museum, Moscow.

27 PABLO PICASSO
Woman with Pears, 1909, oil on canvas,
36½ × 24½ (92·5 × 61·5).
Collection Mr and Mrs Samuel A.
Marx, Chicago.

28 PABLO PICASSO
Seated Nude, 1909, oil on canvas,
31¾ × 25 (80·5 × 63·5).
Collection Mr and Mrs Klaus G. Perls,
New York.

29 PABLO PICASSO
Portrait of Braque, 1909, oil on canvas,
23½ × 19½ (57·5 × 49·5).
Collection Edward Bragaline, New
York.

30 PABLO PICASSO
The Reservoir, Horta de Ebro, 1909,
oil on canvas, 23⅝ × 19¾ (81 × 65).
Private Collection, Paris.

31 GEORGES BRAQUE
Le Port (Harbour in Normandy), 1909,
oil on canvas, 32 × 32 (81·3 × 81·3).
Collection Walter P. Chrysler, Jr,
New York.
Photo Galerie Maeght.

32 GEORGES BRAQUE
View of La Roche-Guyon, 1909,
oil on canvas, 36¼ × 28¾ (92 × 73).
Collection Stedelijk van Abbe
Museum, Eindhoven. Photo Galerie
Maeght.

33 GEORGES BRAQUE
Violin and Pitcher, 1910,
oil on canvas, 45⅝ × 29 (117 × 73·5).
Kunstmuseum, Basle.
Photo Galerie Louise Leiris.

34 GEORGES BRAQUE
Violin and Palette, 1910,
oil on canvas, $35\frac{7}{8} \times 16\frac{5}{8}$ ($91 \times 42 \cdot 1$)
Solomon R. Guggenheim Museum,
New York. Photo Galerie Maeght.

35 PABLO PICASSO
Portrait of Ambroise Vollard, 1910,
oil on canvas, $36\frac{1}{4} \times 25\frac{1}{2}$ ($92 \times 64 \cdot 9$).
Pushkin Museum, Moscow.

36 PABLO PICASSO
Seated Woman, 1909, oil on board,
$39\frac{3}{4} \times 28\frac{1}{4}$ (100×73).
Musée National d'Art Moderne, Paris.

37 PABLO PICASSO
Female Nude, 1910, oil on canvas,
$38\frac{3}{4} \times 30\frac{3}{8}$ ($98 \cdot 3 \times 77$).
Philadelphia Museum of Art.

38 PABLO PICASSO
Portrait of Daniel-Henry Kahnweiler, 1910,
oil on canvas,
$39\frac{5}{8} \times 28\frac{5}{8}$ ($100 \cdot 5 \times 72 \cdot 6$).
Art Institute of Chicago.

39 PABLO PICASSO
*Girl with Mandolin (Portrait of Fanny
Tellier),* 1910, oil on canvas,
$39\frac{3}{8} \times 28\frac{3}{4}$ (100×73).
Private Collection, New York.
Photo Charles Uht.

40 GEORGES BRAQUE
Woman with Mandolin, 1910,
oil on canvas, $36 \times 28\frac{1}{2}$ ($91 \cdot 5 \times 72 \cdot 4$).
Private Collection, Switzerland.
Photo Sotheby and Co. Ltd.

41 MAURICE DE VLAMINCK
(1876–1958)
*Guillaume Apollinaire au Restaurant
Watrin,* 1905, pen and ink.
Ex collection Apollinaire.
Photo courtesy Simon Watson-Taylor.

42 GUILLAUME APOLLINAIRE
(1880–1918)
Calligrammes: 'Montparnasse', in *Poèmes
de la Paix et de la Guerre,* 1913–16.
Photo courtesy Simon Watson-Taylor.

43 GUILLAUME APOLLINAIRE
Calligrammes: 'L'Horloge de Demain',
in *Poèmes de la Paix et de la Guerre.*
Photo courtesy Simon Watson-Taylor.

44 LOUIS MARCOUSSIS (1883–1941)
Portrait of Guillaume Apollinaire, 1912–20,
etching and drypoint,
$19\frac{1}{2} \times 11$ ($49 \cdot 4 \times 27 \cdot 8$).
Museum of Modern Art, New York.

45 FERNAND LÉGER (1881–1955)
Nudes in the Forest, 1909–10,
oil on canvas, $47\frac{1}{4} \times 67$ (120×170).
Rijksmuseum Kröller-Müller, Otterlo.

46 PAOLO UCCELLO (*c.* 1396–1479)
The Battle of San Romano, mid-fifteenth
century, panel, $70\frac{7}{8} \times 124\frac{3}{8}$ (180×316).
Musée du Louvre, Paris. Photo Bulloz.

47 ROBERT DELAUNAY (1885–1941)
The Eiffel Tower, 1910–11,
oil on canvas, $78\frac{1}{2} \times 50\frac{3}{4}$ ($195 \cdot 5 \times 129$).
Kunstmuseum, Basle.

48 MARCEL DUCHAMP (1887–1968)
Nude Descending a Staircase, No. 2, 1912,
oil on canvas, 58×35 ($148 \times 88 \cdot 9$).
Philadelphia Museum of Art.

49 MARCEL DUCHAMP
Portrait of Chess Players, 1911,
oil on canvas, $39\frac{3}{4} \times 39\frac{3}{4}$ (100×100)
Philadelphia Museum of Art, the
Louise and Walter Arensberg
Collection.

50 JEAN METZINGER (1883–1956)
Tea Time, 1911, oil on wood,
$29\frac{3}{4} \times 27\frac{3}{8}$ ($75 \cdot 5 \times 70 \cdot 4$).
Philadelphia Museum of Art.

51 UMBERTO BOCCIONI (1882–1956)
Male Figure in Motion, 1913, gouache on
white paper, $12 \times 8\frac{1}{8}$ ($30 \cdot 5 \times 20 \cdot 7$).
Collection Bertarelli, Milan.

52 UMBERTO BOCCIONI
Muscular Dynamism, 1913, charcoal on
white paper, $34 \times 23\frac{1}{4}$ ($86 \cdot 4 \times 59$).
Museum of Modern Art, New York.

53 GINO SEVERINI (1883–1966)
Composition Still-Life, 1913,
collage, $26\frac{1}{2} \times 19$ $(67\cdot2 \times 48\cdot3)$.
Collection Eric Estorick.
Photo Grosvenor Gallery, London.

54 GINO SEVERINI
Pan-Pan à Monico (copy), original of
1909–11 destroyed, oil on canvas,
108×156 (280×400).
Musée National d'Art Moderne, Paris.

55 CARLO CARRÀ (1881–)
Drawing, 1913: the Boxers, pen and ink,
$17\frac{1}{2} \times 11$ $(44\cdot5 \times 28)$.
Collection Eric Estorick.
Photo Grosvenor Gallery, London.

56 FRANTIŠEK KUPKA (1871–1957)
Riders, c. 1900, indian ink on white
paper, $15\frac{3}{4} \times 21\frac{1}{4}$ $(39\cdot9 \times 53\cdot9)$.
Musée National d'Art Moderne, Paris.

57 FRANTIŠEK KUPKA
Woman Gathering Flowers, 1907–08, pastel
on grey paper, $16\frac{1}{2} \times 15\frac{3}{8}$ (42×39).
Musée National d'Art Moderne, Paris.

58 MARC CHAGALL (1889–)
Half-Past Three, 1911, oil on canvas,
$77\frac{1}{2} \times 57\frac{1}{2}$ (197×146).
Philadelphia Museum of Art.

59 PABLO PICASSO
The Inkstand, 1910–11, oil on canvas,
$18\frac{1}{8} \times 13$ (46×33).
Collection A. Vömel, Düsseldorf.

60 PABLO PICASSO
Soldier and Girl, 1911, oil on canvas,
$45\frac{3}{4} \times 32$ (116×81).
Private Collection.
Photo Arts Council of Great Britain.

61 GEORGES BRAQUE
Soda, 1911, canvas, diam. $14\frac{1}{2}$ $(36\cdot7)$.
Museum of Modern Art, New York.

62 GEORGES BRAQUE
The Portuguese, 1911, oil on canvas,
$45\frac{7}{8} \times 32$ (116×81).
Kunstmuseum, Basle.

63 PABLO PICASSO
*Still-Life with Pipe Rack, Cup,
Coffee-Pot and Carafe,* 1910–11,
oil on canvas, $19\frac{7}{8} \times 50\frac{1}{4}$ $(50\cdot6 \times 128)$.
Collection Mr and Mrs Klaus G. Perls,
New York.

64 PABLO PICASSO
Ma Jolie (Woman with Guitar), 1911–12,
oil on canvas, $39\frac{3}{8} \times 25\frac{3}{4}$ $(99\cdot9 \times 65\cdot3)$.
Museum of Modern Art, New York.

65 GEORGES BRAQUE
Fruit-dish and Glass, 1912, pasted paper
and charcoal on paper,
$24 \times 17\frac{1}{2}$ $(61 \times 44\cdot3)$.
Private Collection.
Photo Galerie Maeght.

66 PABLO PICASSO
Still-Life with Chair Caning, 1912,
oil and oil-cloth pasted on canvas,
$10\frac{5}{8} \times 13\frac{3}{8}$ (27×35).
Collection Picasso. Photo Arts
Council of Great Britain.

67 GEORGES BRAQUE
Musical Forms, 1913, oil, pencil charcoal,
on canvas, $10\frac{5}{8} \times 13\frac{3}{4}$ (92×59).
Philadelphia Museum of Art.

68 GEORGES BRAQUE
Bach, 1913, *papier collé,*
$24\frac{1}{2} \times 19$ $(62\cdot3 \times 48\cdot3)$.
Kunstmuseum, Basle.

69 GEORGES BRAQUE
Bottle, Glass and Pipe, 1913, *papier collé,*
$18\frac{7}{8} \times 23\frac{1}{8}$ $(48 \times 58\cdot6)$.
Collection Lady Hulton, London.
Photo Arts Council of Great Britain.

70 GEORGES BRAQUE
The Clarinet, 1913, pasted paper,
charcoal and oil paint,
$39\frac{3}{8} \times 51\frac{1}{4}$ $(99\cdot3 \times 130)$.
Private Collection. Photo Arts
Council of Great Britain.

71 PABLO PICASSO
Head of a Man, 1912–13, drawing.
Collection Roger Dutilleul, Paris.

72 PABLO PICASSO
Head of a Man, 1912–13, drawing.
Collection Roger Dutilleul, Paris.

73 PABLO PICASSO
Sheet of Music and Guitar, 1912–13,
papier collé on cardboard,
$18\frac{7}{8} \times 16\frac{3}{4}$ ($48 \times 42 \cdot 5$).
Musée National d'Art Moderne, Paris.

74 PABLO PICASSO
Head, 1913, collage,
$17\frac{1}{8} \times 13\frac{1}{8}$ ($43 \cdot 4 \times 33 \cdot 2$).
Penrose Collection.

75 PABLO PICASSO
Bottle of Vieux Marc, 1912, charcoal,
papier collé, pins, $24\frac{3}{4} \times 19\frac{1}{4}$ (63×49).
Musée National d'Art Moderne, Paris.

76 GEORGES BRAQUE
La Musicienne (*Woman with a Guitar*),
1913, canvas, $36\frac{1}{4} \times 28\frac{3}{4}$ ($130 \times 73 \cdot 9$).
Musée National d'Art Moderne, Paris.

77 PABLO PICASSO
The Poet, 1912, oil on canvas,
$23\frac{5}{8} \times 18\frac{7}{8}$ (60×48).
Kunstmuseum, Basle.

78 PABLO PICASSO
La Bataille s'est Engagée (*Guitar and
Wineglass*), collage and charcoal,
$18\frac{7}{8} \times 14\frac{1}{4}$ ($47 \cdot 8 \times 36 \cdot 4$).
Marion Koogler McNay Art Institute,
San Antonio, Texas.

79 PABLO PICASSO
La Pointe de la Cité, 1912, oil on canvas,
$36\frac{1}{4} \times 28\frac{3}{4}$ (92×73).
Norton Simon, Inc., Museum of Art,
Los Angeles. Photo Sotheby and Co.

80 PABLO PICASSO
Ma Jolie, 1914, oil on canvas,
$17\frac{3}{4} \times 15\frac{3}{4}$ (45×40).
Collection Lefèvre.

81 PABLO PICASSO
Green Still-Life, 1914, oil on canvas,
$23\frac{1}{2} \times 31\frac{1}{4}$ ($59 \cdot 7 \times 79 \cdot 3$).
Museum of Modern Art, New York.

82 PABLO PICASSO
Harlequin, 1915, oil on canvas,
$72\frac{1}{2} \times 41\frac{3}{8}$ (184×105).
Museum of Modern Art, New York.

83 PABLO PICASSO
The Card Player, 1913–14, oil on canvas,
$42\frac{1}{2} \times 35\frac{1}{4}$ ($107 \cdot 8 \times 89 \cdot 5$).
Museum of Modern Art, New York.

84 JUAN GRIS (1887–1927)
The Eggs, 1911, oil on canvas,
$22\frac{1}{2} \times 15$ (57×38).
Staatsgalerie, Stuttgart.

85 JUAN GRIS
Still-Life, 1911, oil on canvas,
$23\frac{1}{2} \times 19\frac{3}{4}$ ($59 \cdot 6 \times 50 \cdot 1$).
Museum of Modern Art, New York.

86 JUAN GRIS
Portrait of Picasso, 1911–12, oil on
canvas, $36\frac{1}{4} \times 28\frac{3}{4}$ ($92 \times 72 \cdot 9$).
Art Institute of Chicago.

87 JUAN GRIS
A Table at a Café, 1912, oil on canvas,
$18 \times 14\frac{7}{8}$ ($45 \cdot 8 \times 37 \cdot 7$).
Art Institute of Chicago.

88 JUAN GRIS
Still-Life with Pears, 1913, oil on canvas.
Collection Mr and Mrs Burton
Tremaine, Meriden, Conn.

89 JUAN GRIS
The Bottle of Bordeaux Wine, 1913,
oil and *papier collé* on canvas,
$21\frac{1}{2} \times 12\frac{3}{4}$ ($54 \cdot 4 \times 32 \cdot 5$).
Acquarella Galleries, New York.
Photo Sotheby and Co. Ltd.

90 JUAN GRIS
The Bottle of Rosé Wine, 1914, oil, collage
on canvas, $17\frac{1}{4} \times 10\frac{1}{4}$ ($44 \cdot 5 \times 26$).
Galerie Tarica, Paris.
Photo Sotheby and Co. Ltd.

91 JUAN GRIS
The Chessboard, 1917, oil on wood,
$28\frac{3}{4} \times 39\frac{3}{8}$ (73×100).
Museum of Modern Art, New York.

92 JUAN GRIS
L'Intransigeant, 1915, oil on canvas,
$25\frac{1}{4} \times 17\frac{3}{4}$ (64×45).
Photo Sotheby and Co. Ltd.

93 CAMILLE COROT (1796–1875)
Girl with a Mandolin, 1860–65,
oil on canvas, $20\frac{1}{4} \times 14\frac{1}{2}$ ($51 \cdot 3 \times 36 \cdot 9$).
City Art Museum of St Louis, Mo.

94 JUAN GRIS
Woman with a Mandolin, 1916, oil on
board, $36\frac{1}{4} \times 23\frac{1}{2}$ ($92 \cdot 1 \times 59 \cdot 7$).
Kunstmuseum, Basle.

95 JUAN GRIS
Before the Bay, 1921, oil,
25×38 ($63 \cdot 5 \times 96 \cdot 6$).
Private Collection, England.

96 JUAN GRIS
Guitar with Sheet of Music, 1926, oil on
canvas, $25\frac{5}{8} \times 31$ (65×81).
Collection Mr and Mrs Daniel
Saidenberg, New York.

97 PABLO PICASSO
Curtain for *Parade,* 1917, mixture of
gum and paint on canvas, 394×630
($10 \cdot 00 \times 16 \cdot 40$ m.); composition only,
315×551 ($8 \cdot 00 \times 14 \cdot 00$ m.).
Musée National d'Art Moderne, Paris.

98 HENRI MATISSE (1869–1954)
The Back, I, *c.* 1909, bronze relief,
$74\frac{3}{4} \times 46 \times 7\frac{1}{4}$ ($189 \times 117 \times 18 \cdot 4$).
Tate Gallery, London.

99 HENRI MATISSE
The Back, II, *c.* 1913–14, bronze relief,
$74\frac{1}{2} \times 47\frac{1}{2} \times 7\frac{1}{2}$ ($188 \times 120 \times 19$).
Tate Gallery, London

100 HENRI MATISSE
The Back, III, *c.* 1914, bronze relief,
$74 \times 44\frac{1}{2} \times 6\frac{3}{4}$ ($187 \times 113 \times 17$).
Tate Gallery, London.

101 HENRI MATISSE
The Back, IV, *c.* 1929, bronze relief,
$74\frac{1}{2} \times 44\frac{1}{2} \times 6\frac{1}{4}$ ($188 \times 113 \times 16$).
Tate Gallery, London.

102 PABLO PICASSO
Head of a Woman, 1909–10, bronze,
height $16\frac{1}{4}$ ($41 \cdot 4$).
Museum of Modern Art, New York.

103 JACQUES LIPCHITZ (1891–)
Half Standing Figure, 1915, bronze,
height 38 (99).
Marlborough-Gerson Gallery,
New York.

104 JACQUES LIPCHITZ
Bather, 1917, bronze, height 35 ($88 \cdot 8$).
Marlborough-Gerson Gallery,
New York.

105 JACQUES LIPCHITZ
Man with Guitar, 1920, bronze,
height $20\frac{5}{8}$ (55).
Marlborough-Gerson Gallery,
New York.

106 JACQUES LIPCHITZ
Harlequin with Mandolin, 1920,
bronze, height 26 (66).
Marlborough-Gerson Gallery,
New York.

107 ANTOINE PEVSNER (1886–1962)
Portrait of Marcel Duchamp, 1926,
celluloid on copper, high relief
construction, $37 \times 25\frac{5}{8}$ (94×65).
Yale University Art Gallery.

108 NAUM GABO (1890–)
Construction in Space, 1912, plastic,
stainless-steel springs, aluminium base,
$25\frac{3}{4} \times 37$ (58 high) ($65 \cdot 3 \times 94$).
Collection Mrs Miriam Gabo,
Middlebury, Conn. Photo
Rudolph Burckhardt, New York.

109 UMBERTO BOCCIONI
Development of a Bottle in Space, 1912,
bronze, height 15 ($38 \cdot 1$).
Museum of Modern Art, New York.

110 RAYMOND DUCHAMP-VILLON
(1876–1918)
Le Cheval-Majeur, 1914,
height 59 (150).
Galerie Louis Carré, Paris.

111 UMBERTO BOCCIONI
Unique Forms of Continuity in Space, 1913,
bronze, height 43½ (110).
Museum of Modern Art, New York.
Photo Soichi Sunami.

112 GIACOMO BALLA (1871–1958)
Boccioni's Fist: Lines of Force, 1915,
wood and cardboard painted red,
33 × 31 × 12½ (83·9 × 78·8 × 31·8).
The Lydia and Harry Lewis Winston
Collection (Mrs Barnett Malbin,
Birmingham, Michigan).

113 CONSTANTIN BRANCUSI
(1876–1957)
Fish, 1930, grey marble,
21 × 71 (53·4 × 83), on a pedestal of
one marble and two limestone cylinders,
height 29½ (74·5).
Museum of Modern Art, New York

114 HANS ARP (1888–1966)
The Forest, 1916, painted wood,
12⅝ × 8¼ (32 × 21).
Penrose Collection, London.
Photo John Webb.

115 HENRI LAURENS (1885–1954)
Head, 1917, stone, height 25⅝ (65).
Stedelijk Museum, Amsterdam.

116 FERNAND LÉGER
The Wedding, 1910–11, oil on canvas,
100½ × 81¼ (257 × 206).
Musée National d'Art Moderne, Paris.

117 FERNAND LÉGER
The Woman in Blue, 1912, oil on canvas,
76 × 52 (194 × 130).
Kunstmuseum, Basle.

118 FRANCIS PICABIA (1878–1953)
I See Again in Memory My Dear Udnie,
1913, oil on canvas,
98½ × 78¼ (250 × 199).
Museum of Modern Art, New York.

119 MARCEL DUCHAMP
The Bride, 1912, oil on canvas,
35⅛ × 21¾ (89·1 × 55·1).
Philadelphia Museum of Art.

120 FERNAND LÉGER
The Disks, 1918, oil,
94½ × 70⅞ (240 × 180).
Musée National d'Art Moderne, Paris.
Photo Bulloz.

121 FERNAND LÉGER
The City, 1919, oil on canvas,
91 × 117½ (231 × 302).
Philadelphia Museum of Art.

122 LOUIS MARCOUSSIS
Still-Life with Chessboard, 1912, oil on
canvas, 59¾ × 36½ (139 × 93).
Musée National d'Art Moderne, Paris.

123 JACQUES VILLON
Marching Soldiers, 1913, oil,
25½ × 36 (64·8 × 91·5).
Galerie Louis Carré, Paris.

124 ROGER DE LA FRESNAYE
The Conquest of the Air, 1913, oil on
canvas, 92⅞ × 77 (234 × 196).
Museum of Modern Art, New York.

125 GEORGES BRAQUE
The Musician, 1917–18, oil on canvas,
86¾ × 44¾ (219 × 113).
Kunstmuseum, Basle. Photo Hinz.

126 GEORGES BRAQUE
Clarinet, Guitar and Fruit-Dish, 1918,
oil on canvas, 28¾ × 39⅜ (73 × 100).
Kunstmuseum, Basle. Photo Archives
Photographiques, Paris.

127 PABLO PICASSO
Harlequin, 1917, oil on canvas,
Museum of Modern Art, Barcelona.
Photo Mas.

128 PABLO PICASSO
Table before an Open Window, 1919,
gouache, 13¾ × 9¾ (34·8 × 24·7).
Private Collection, U.S.A.

129 PABLO PICASSO
Dog and Cock, 1921, oil on canvas,
60⅞ × 30⅛ (153 × 76·4).
Yale University Art Gallery, Gift of
Stephen C. Clark.

130 PABLO PICASSO
Table before an Open Window, 1920,
gouache, $64\frac{1}{2} \times 43$ ($164 \times 109 \cdot 3$).
Norton Simon, Inc., Museum of Art,
Los Angeles.

131 PABLO PICASSO
The Table, 1919–20, oil on canvas,
$50 \times 29\frac{1}{2}$ ($127 \times 74 \cdot 8$).
Smith College Museum of Art,
Northampton, Mass.

132 PABLO PICASSO
Glass, Tobacco Packet and Playing-Card,
1919, oil on canvas,
$7\frac{1}{2} \times 10\frac{1}{2}$ ($19 \cdot 1 \times 26 \cdot 7$).
Private Collection, U.S.A.

133 PABLO PICASSO
The Three Masked Musicians, 1921, oil on
canvas, $79\frac{7}{8} \times 74$ (203×188).
Philadelphia Museum of Art.

134 PABLO PICASSO
The Three Musicians, 1921, oil on
canvas, $79\frac{1}{2} \times 87\frac{3}{4}$ (201×223).
Museum of Modern Art, New York,
Mrs Simon Guggenheim Fund.

135 PABLO PICASSO
Pierrot and Harlequin, 1920, gouache,
$8\frac{1}{4} \times 10\frac{1}{2}$ ($20 \cdot 9 \times 26 \cdot 7$).
Private Collection, U.S.A.
Photo Paul Rosenberg and Co.,
New York.

136 PABLO PICASSO
Pierrot and Harlequin, 1920, gouache,
$8\frac{1}{4} \times 10\frac{1}{2}$ ($20 \cdot 9 \times 26 \cdot 7$).
Private Collection, U.S.A.

137 PABLO PICASSO
Pierrot and Harlequin, 1920, gouache,
$10\frac{1}{2} \times 8\frac{1}{4}$ ($26 \cdot 7 \times 20 \cdot 9$).
Private Collection, U.S.A.

138 PABLO PICASSO
Pierrot and Harlequin, 1920, gouache,
$8\frac{1}{4} \times 10\frac{1}{2}$ ($21 \cdot 1 \times 26 \cdot 7$).
Private Collection, U.S.A.
Photo Paul Rosenberg and Co.,
New York.

139 PABLO PICASSO
The Three Dancers, 1925, oil on canvas,
$84\frac{5}{8} \times 56\frac{1}{4}$ (215×143).
Tate Gallery, London.

140 PABLO PICASSO
The Studio, 1927–28, oil on canvas,
59×91 (150×231).
Museum of Modern Art, New York.

141 PABLO PICASSO
Woman Before a Mirror, 1932, oil on
canvas, $63\frac{3}{4} \times 51\frac{1}{4}$ (162×130).
Museum of Modern Art, New York.

142 PABLO PICASSO
Guernica, 1937, oil on canvas,
$137\frac{1}{2} \times 305\frac{3}{4}$ (349×775).
Museum of Modern Art, New York,
on loan from the artist.

143 PABLO PICASSO
Harlequin, 1927, oil,
$31\frac{3}{4} \times 25\frac{1}{2}$ ($80 \cdot 5 \times 64 \cdot 7$).
Collection Mr and Mrs Klaus G.
Perls, New York.

144 PABLO PICASSO
Weeping Woman, 1937, oil on canvas,
$23\frac{1}{2} \times 19\frac{1}{4}$ ($59 \cdot 6 \times 48 \cdot 8$).
Penrose Collection, London.

145 PABLO PICASSO
Portrait of a Painter, After Greco, 1950,
oil on wood, $39\frac{3}{8} \times 31\frac{7}{8}$ (100×81).
Collection Angela Rosengart, Lucerne.

146 GEORGES BRAQUE
The Round Table, 1929, oil over gesso on
canvas, $57\frac{1}{2} \times 44\frac{3}{4}$ (145×120).
The Phillips Collection, Washington,
D.C. Photo Galerie Maeght.

147 GEORGES BRAQUE
The Table, 1928, oil on canvas,
$70\frac{3}{4} \times 28\frac{3}{4}$ ($180 \times 72 \cdot 9$).
Museum of Modern Art, New York.

148 GEORGES BRAQUE
Woman with a Mandolin, 1937, oil on
canvas, $51\frac{1}{2} \times 38\frac{1}{4}$ (145×120).
Museum of Modern Art, New York.

149 PIET MONDRIAN (1872–1944)
Tree, c. 1912, oil on canvas,
37 × 27½ (94 × 69·9).
Museum of Art, Carnegie Institute,
Pittsburgh, Pennsylvania.

150 PIET MONDRIAN
Oval Composition with Trees, 1913, oil
on canvas, 37 × 30¾ (94 × 78).
Stedelijk Museum, Amsterdam.

151 PIET MONDRIAN
Broadway Boogie-Woogie, 1942–43,
oil on canvas, 50 × 50 (127 × 127).
Museum of Modern Art, New York.

152 JOAN MIRÓ (1893–)
Dutch Interior I, 1928, oil on canvas,
36⅛ × 28¾ (91·6 × 72·9).
Museum of Modern Art, New York.

214

Index

Numbers followed by the letter 'n'
indicate a reference to a footnote

African art 9, 10, 22, 26, 28, 34,
105, 125
Albers, Josef 197
Allard, Roger 141
Analytical Cubism 9, 71, 96, 98,
141, 193
Apollinaire, Guillaume 28 n., 31,
34–5, 38, 42, 44, 59 ff., 83, 85,
94, 118, 136, 142, 143, 145, 197
Après le Cubisme 193
Aragon, Louis 142
Archipenko, Alexander 149, 154
Arp, Hans (Jean) 143, 159, 160
Art Nouveau 12, 81, 119
Auric, Georges 144

Bakst, Léon 144
Balla, Giacomo 79, 158
Ballet 142, 143, 144, 145, 146, 160
'Baroque Cubism' 110, 114, 115
Bateau-Lavoir (Montmartre) 38,
119, 140
Baudelaire, Charles 31, 35
Beckmann, Max 198
Bernard, Emile 24
Billy, André 35, 142
Birot, Albert 142
Blanche, Jacques-Emile 82
Boccioni, Umberto 79, 81, 82,
83–5, 88, 154–5
Bonnat, Léon 32
Bonnet, Marguerite 65, 68
Bouguereau, William-Adolphe 7
Brancusi, Constantin 158–9
Braque, Georges 7, 9, 10, 13, 18,
19, 24, 30, 31–4, 35, 38, 39, 42, 44,
50, 52, 54, 56, 57, 58, 70, 71, 72,
79, 90, 91, 92, 98 ff., 108, 110,
114, 118, 142, 163, 171, 174, 179,
183, 190–3, 197
Breton, André 35, 70, 142, 146,
159
Breunig, L.-C. 59–60, 68
Bruni, Lev 154

Carrà, Carlo 79, 81, 86
Cendrars, Blaise 136–40, 142, 143,
146, 166
Cézanne, Paul 7, 9, 10, 15, 18–19,
21, 25, 26, 28, 31, 35, 39, 42, 43,
46, 50, 59, 72, 81, 98, 119, 122,
123, 170
Chagall, Marc 88–90, 142
Chanel, Coco 146
Chaplin, Charles 137, 144
Chardin, Jean Baptiste Siméon 59,
131
Chillida, Eduardo 159
Chirico, Giorgio di 146
Cirque Medrano 38
Cocteau, Jean 14, 118, 119, 143–5,
146
Collage 9, 10, 91, 96, 98 ff., 127–31
Constructivism 154
Corot, Jean Baptiste Camille 44
Courbet, Gustave 185
Cross, Henri-Edmond 126

Dada 142–3, 146, 159, 160, 167,
174
Dalize, René 142
David, Jacques-Louis 7, 185
Davis, Stuart 197
Debussy, Claude 144
Delacroix, Eugène 31, 185
Delaunay, Robert 69–70, 71, 72,
74, 90, 143, 166–7
Derain, André 35, 39, 81
Diaghilev, Serge 142, 144, 146
Divisionism 81, 84
Duchamp, Marcel 69, 74, 77, 88,
92, 143, 160, 167
Duchamp-Villon, Raymond 92,
156–8
Dufy, Raoul 146

Eluard, Paul 70, 143
Ernst, Max 143, 160
Exhibitors to the Public, The 82
Expressionism 197

Falla, Manuel de 146
Feininger, Lyonel 197

Fowlie, Wallace 68
Fresnaye, Roger de la 92, 170
Futurism 71, 78 ff., 142, 154, 158,
163
Futurist Painting: Technical Manifesto
79–81, 86

Gabo, Naum 154
Galerie Bernheim-Jeune 82
Galerie de la Boétie 92
Gauguin, Paul 22
Georges-Michel, Michel 28 n., 38,
62
Giacometti, Alberto 161, 162
Gide, André 31
Gleizes, Albert 72, 77, 92, 126, 169,
170
Golding, John 26, 28 n.
Góngora y Argote, Luis de 135
Gonzalez, Julio 160
Gosol (Catalonia) 15–16, 28
Greco, El 176, 185
Gris, Juan 10, 13, 38, 69, 71, 91,
92, 94, 119 ff., 140, 146, 163
Gutfreund, Otto 153–4

Hard Edge 197
Hayden, Henri 170
Horta de San Juan (Horta de
Ebro) 44, 46
Hourcade, Olivier 141
Humbert, Marcelle (Eva) 96, 118,
140

Impressionism 7, 12, 81, 84, 98, 193
Ingres, Jean Auguste Dominique 7,
143, 176
Intransigeant, L' 83, 85

Jacob, Max 38, 118, 140–1, 142
Japanese art 13, 119
Jarry, Alfred 142

Kahnweiler, Daniel-Henry 30, 39,
58, 118, 126, 131, 141
Kant, Immanuel 141
Kirchner, Ludwig 197
Kokhlova, Olga 174, 176

Kokoschka, Oskar 197
Kostrowitzky, Wilhelm de *see*
 Apollinaire, Guillaume
Kupka, František 88

La Roche-Guyon 44, 50, 79
Laurencin, Marie 38, 92
Laurens, Henri 146, 147, 149, 152,
 160, 162
Le Corbusier (Charles Edouard
 Jeanneret) 193
Le Fauconnier, Henri 71, 72
Léger, Fernand 10, 14, 69, 71, 72,
 74, 92, 146, 163, 165
L'Estaque 39
Lhote, André 170
Lipchitz, Jacques 149–50, 162

Maar, Dora 187
Malevich, Kasimir 154
Mallarmé, Stéphane 64, 68, 135,
 141
Manet, Edouard 25, 31, 81, 185
Marc, Franz 197
Marcoussis, Louis 71, 169
Marinetti, F. T. 78, 83
Massine, Léonide 142, 144, 146
Matisse, Henri 31, 35, 39, 42, 81,
 147, 148
Medunetsky, Kasimir 154
Mercure de France 24
Metzinger, Jean 71, 72, 77, 92, 126,
 169, 170
Milhaud, Darius 146
Miró, Joan 162, 197
Mistinguett 144
Mohdrian, Piet 193–7
Moore, Henry 159, 162
Musset, Alfred de 34

'Neo-Plasticism' 193
Neo-primitivism 26
Nerval, Gérard de 35
Nicholson, Ben 197
Nord-Sud 141, 142, 144, 193

Oettingen, Baronne d' 142
Olivier, Fernande 15–16
Op Art 197
Orphic impulse 35, 59*n*., 69, 71,
 143
Osuna, Iberian reliefs from 21, 23,
 28
Ozenfant, Amédée 193

Papier collé 9, 14, 92, 96, 98 ff.
Pevsner, Antoine 154
Picabia, Francis 69, 143, 167
Picasso, Pablo 7, 9, 10, 13, 14, 15 ff.,
 34, 35, 38, 39, 42–3, 44, 46 ff.,
 59, 60, 65, 68, 70, 71, 72, 81, 82,
 83, 90 ff., 119, 132–4, 140 ff.,
 154, 160–2, 163, 171, 174, 175 ff.
Pointillism 193
Poussin, Nicolas 59
Primitive art 21–2; *see also* African
 art
'Purism' 193

Raynal, Maurice 141
Renaissance 10, 11, 12, 70, 141
Renoir, Pierre Auguste 81
Reverdy, Pierre 135–6, 141, 142
Rimbaud, Arthur 68
Rodchenko, Alexander 154
Rousseau, Henri 'le Douanier' 38,
 72
Russolo, Luigi 79

Sade, Marquis de 34
Salmon, André 38, 142
Salon d'Automne (1906) 25;
 (1908) 39; (1911) 10
Salon des Indépendants (1911) 10,
 72
Sartre, Jean-Paul 125
Satie, Erik 142, 144–6
Section d'Or, La (exhibition, 1912)
 92
Segonzac, Dunoyer de 92
Seurat, Georges 126

Severini, Gino 79, 81, 83, 85–6,
 142
Sic 142
Signac, Paul 126
'Simultaneity' 70
Six, Les (group) 144
Soffici, Ardengo 81
Soirées de Paris, Les 35, 141, 142
Sorgues-sur-l'Ouvèze (Midi) 96
Soupault, Philippe 70, 141, 142
Spain 15–16, 28, 44, 46; Civil War
 187
Stein, Gertrude 21, 28*n*., 38, 70,
 82, 83, 94, 96, 126, 132–5, 136
Stein, Leo 136
Steinlen, Théophile 15
Stravinsky, Igor 144, 146
Surrealism 34, 35, 59, 62, 65, 69, 70,
 89, 141, 146, 159, 197
Synthetic Cubism 9, 62, 71, 90, 96,
 104, 119 ff., 163

Tatlin, Vladimir 154
Toklas, Alice B. 38, 135
Toulouse-Lautrec, Henri de 15, 24,
 119
'Tubism' 71
Tzara, Tristan 143, 160

Uccello, Paolo 72
Uhde, Wilhelm 118

Vaché, Jacques 142, 146
Vasarely, Victor 197
Vauxcelles, Louis 39
Velazquez, Diego 185
Verlaine, Paul 34
Villon, Jacques 92, 170–1
Vollard, Ambroise 53–4, 58

Whitman, Walt 136, 138
Wilde, Oscar 34

Zadkine, Ossip 154
Zola, Emile 31